ARTS

&

CRAFTS

of

SOUTH

AMERICA

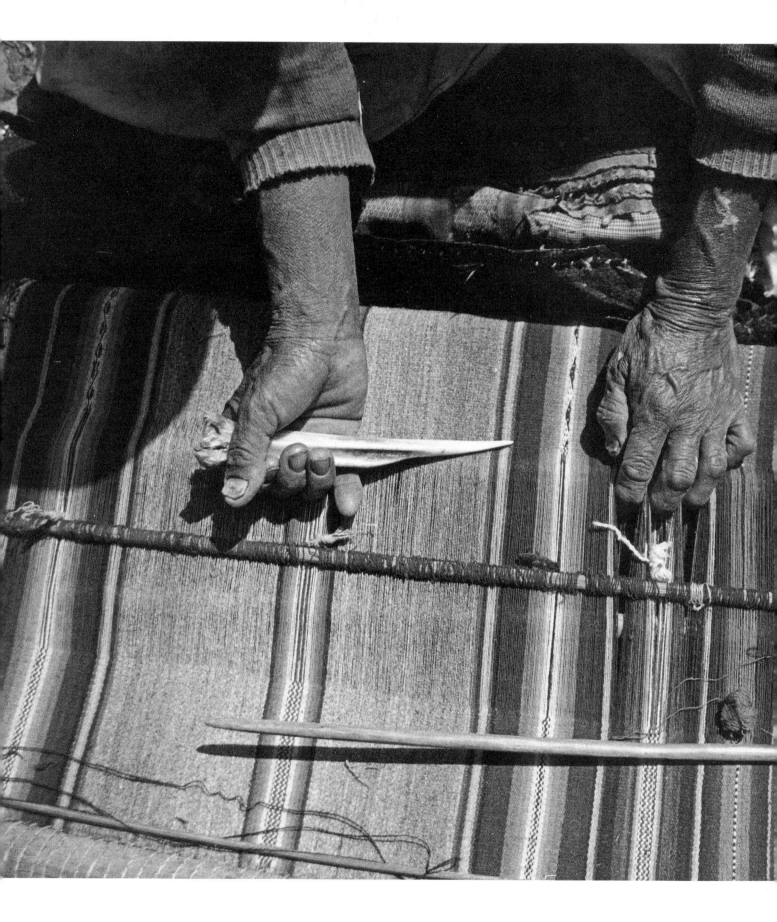

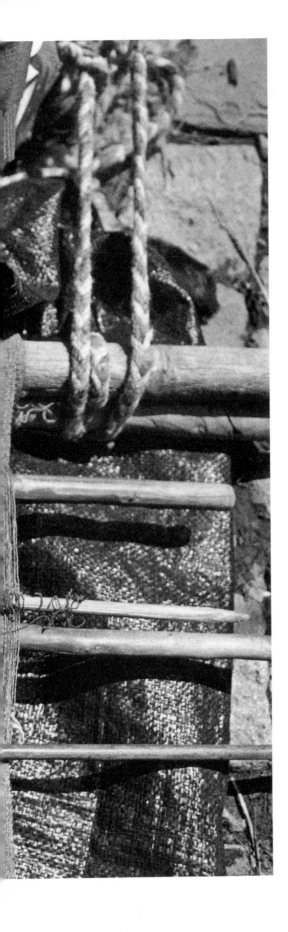

ARTS
&
CRAFTS
of
SOUTH
AMERICA

LUCY DAVIES

MO FINI

CHRONICLE BOOKS
SAN FRANCISCO

Previous page: The horizontal loom used
in Peru since pre-Columbian times.

Frontmatter drawings in the semblance of a
Moche vessel, illustrating musical instruments.

First published in the United States
in 1995 by Chronicle Books.
First published in Great Britain in 1994
by Thames and Hudson Ltd., London.

Printed in Singapore by C. S. Graphics

Library of Congress
Cataloging-in-Publication
Data available.

ISBN 0-8118-0812-2 (hc)
ISBN 0-8118-0837-8 (pb)

Book design by Lawrence Edwards
Cover design by Sarah Bolles

Distributed in Canada by
Raincoast Books
112 East Third Avenue
Vancouver, B.C. V5T 1C8

10 9 8 7 6 5 4 3 2 1

Chronicle Books
275 Fifth Street
San Francisco, CA 94103

CONTENTS

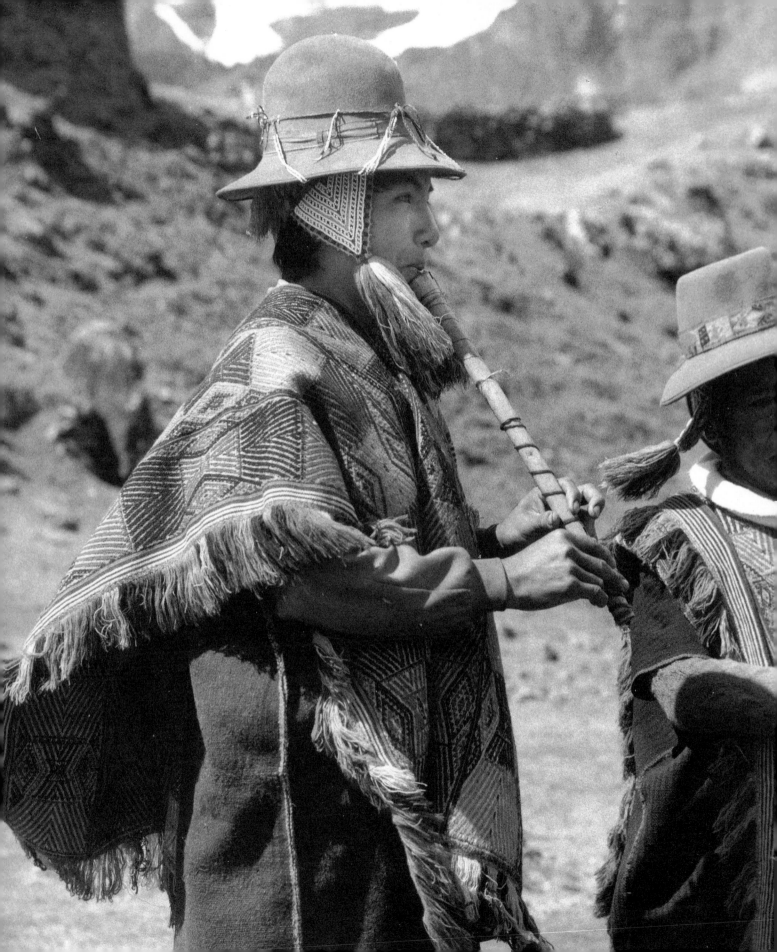

INTRODUCTION

THE PRE-HISPANIC CHIBCHA PEOPLE of the Colombian high Andes, renowned for their gold objects, speak of Bochica – 'A grey-haired sage dressed in a cotton tunic, who mysteriously appeared among the inhabitants. He taught them how to work the gold from their rivers into extraordinary objects, turn the earth from their mountains into bowls and statues, carve stone and wood into tools and sacred images and weave themselves splendid garments and baskets. Before he left, Bochica carved the patterns for these crafts into the side of the mountains, lest his teachings be forgotten – and they have not been.' The fact may be observed in virtually any Andean house, where handmade products are scattered throughout. Broom, pot, seat or carpet, all are probably made by the same family – peasant by definition, artist by profession.

The passage of the Andes separates many of the South American countries into four distinct regions: the coast, the mountains, the valleys and the Amazon basin. This geographic division, accompanied by cultural differences, has resulted in variations in technique and design of handicrafts. Each province and each community has developed its own style of weaving or carving. Thus it is often possible to distinguish the crafts of a coastal region from those of the Andes or Amazon. Climate, altitude and availability of raw materials all help to determine this diversity. For example, intricately woven cloth is found in the Andes where the cold produces a need for warm textiles, while hammocks are usually woven in the hot coastal regions rather than in the mountains where they would be of little use.

The Incas inherited three thousand years of skills and traditions from their predecessors – the gold, metal and precious stonework of the Chimu (AD 1200–1450), the feather textiles of Nazca (100 BC–AD 900); and the sophisticated and intricate textiles of Paracas (700 BC–AD 100). All of these played important roles in political, social and religious ceremonies. Gifts of specially woven cloth were used to strengthen social and political bonds, and the dead were buried with the most precious stone necklaces of turquoise and coral wrapped in a woven cloth. The exquisite weavings found in the graves of Paracas bear witness to the tireless patience associated with textile traditions then.

Cajamarca, in northern Peru, played an important role as the artistic centre of the Incas and their predecessors. It has also become the symbolic focal point of the transition from the world of ancient Peru to that of the Spanish Conquest. About AD 1470 the king of Cajamarca, Chuquimanco,

Flute (quena) player of Q'eros, the last of the Inca tribes in the Peruvian high Andes

was overthrown by the Incas. Less than seventy years later the Inca high command at Cajamarca was defeated by Francisco Pizarro's meagre force of 102 foot soldiers and 62 horses. Of the Inca army it was observed: 'They wore a livery of white and red squares, like a chess board, then came a number of men with armour, large metal plates and crowns of gold and silver. Among them was Atahualpa [the Inca ruler] in a litter lined with plumes and macaw feathers of many colours and adorned with plates of gold and silver.'

The Spanish and Portuguese found a land immensely rich in artistic tradition, much of which they exploited. Yet thousands of lives were lost, and with them the knowledge and expertise of entire cultures. Beautifully worked gold pieces were melted down by the Spanish in their unquenchable lust for gold. Large-scale mining, deforestation and agricultural plantations ensued. To the indigenous population this was rape of their sacred mother earth; in many areas today, the same belief survives. A labour force was made up of what remained of the indigenous population, combined with African slaves. Despite everything, artistic traditions evolved in numerous ways, absorbing new methods, concepts and materials while maintaining ancient techniques and symbols. Although much was lost, a creative process occurred: old and new co-existed and at times combined to produce the variety found in the Americas today, incorporating both the native and more popular traditions.

The distinction between native and popular arts and crafts is an important one. Native crafts revolve around simple, often domestic needs and aspirations: decorations in the home, clothing, preparing food and making music, activities which are inseparable from the experience of being alive and part of a community. At their best there is a special quality in them that transcends time, place and 'taste', and speaks directly to the soul. Popular crafts, however, are often developed by the artist for commercial reasons. Frequently evolving out of the native arts, they lose some of their original qualities while gaining new ones. The beautiful *werregue* baskets of the Cholo Indians of the Pacific coast of Colombia, for example, have become far more colourful than they used to be, but no longer serve their original purpose of holding water. Their role has become more decorative than functional.

This book is the result of over a decade of travelling in Latin America, searching both for crafts and for the people who make them. It includes not only artefacts made by South American Indians through the centuries for their everyday lives, but also pieces of European and African origin or influence, some of which are purely ornamental and should be looked upon as works of art worthy to be seen in any museum.

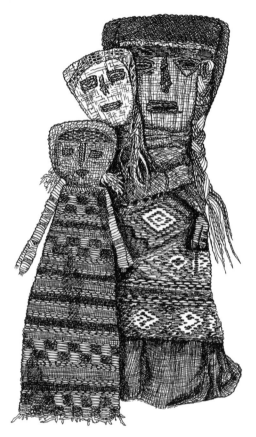

Dolls of the Chancay culture of central Peru (100 BC–AD 1200), renowned for their sophisticated textiles. The dolls were placed in tombs, often surrounding the mummified dead, and are believed to have had magical significance

1 RIGHT *The absorption of different cultures into South America has created a wealth of knowledge in many fields of craftsmanship*

2 LEFT *Tururi bark painting, made on the bark's inner layer by the Indians of the Amazon basin. The colours used are all natural pigments. L 31⅛" (81 cm)*

3 BELOW LEFT *Carved wooden head or carrancas from north-east Brazil. The grimacing figure was originally placed on the prow of a boat to ward off evil spirits. H 25¼" (64 cm)*

4 BELOW *Silver filigree figure made by Cezar Quinde Renteria in Catacaos, northern Peru. The art of filigree evolved during the Colonial period, and is practised today in various centres in Peru and Colombia. H 4½" (11.5 cm)*

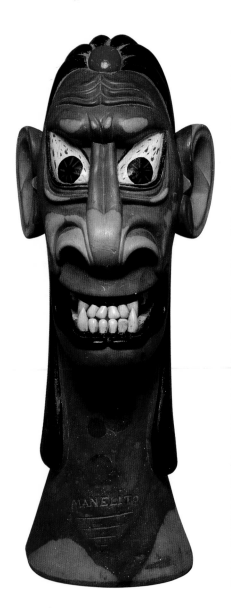

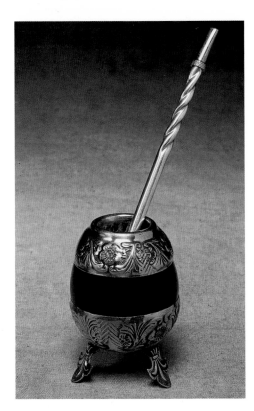

5　LEFT　*Máte or gourd for drinking tea, decorated with silver in Colonial style. The spoon or bombilla acts as a straw through which the tea is drunk. H of gourd 3⅞" (10 cm)*

6　BELOW LEFT　*Pre-Hispanic loom and textile of the Paracas culture of southern Peru (c. 700 BC–AD 100). L 9¾" (25 cm)*

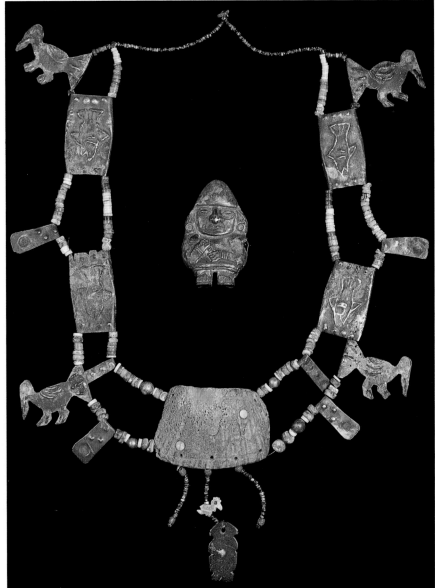

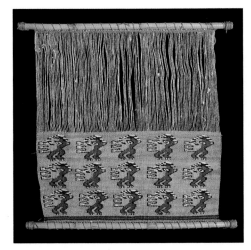

7　*Pre-Columbian necklace of gold and silver with coral beads and sea-shell. Valuable possessions such as this were placed in the tomb to accompany the dead to the other world. L 15¾" (40 cm). Centre: silver figure holding a tumi (sacrificial knife). H 3⅛" (8 cm). Both were found in the tombs of northern Peru*

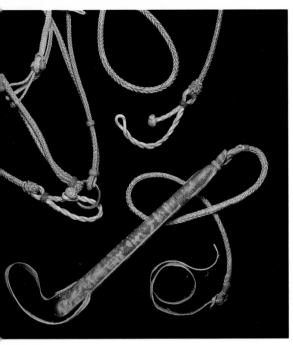

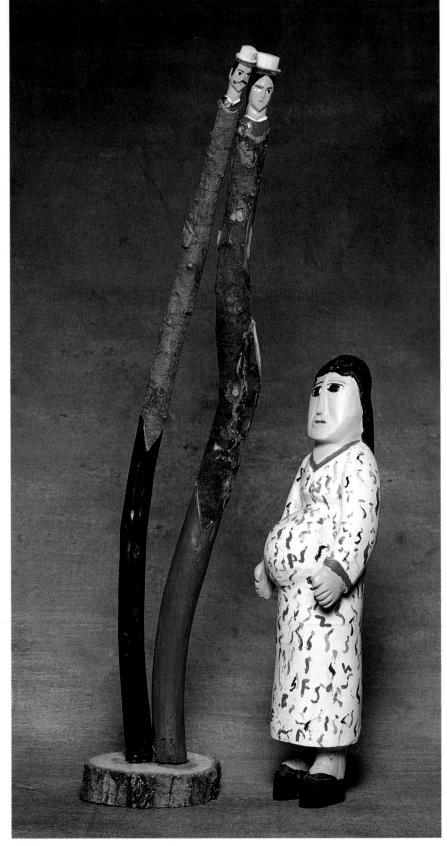

8 ABOVE *Gaucho whip and harness made of cowhide. Colonia Hapebi near Salto, Uruguay. L of whip-handle 16½" (42 cm)*

9 RIGHT *Woodcarvings from Tabay, near Mérida, Venezuela, by Francisco Ranjel. H of woman 20¾" (53 cm)*

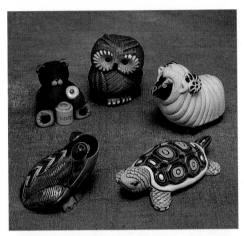

10 LEFT *Glazed animal figures made in the Rinconada workshop in Montevideo, Uruguay. L of tortoise 5⅞" (12.5 cm)*

11 BELOW LEFT *Batik painting by the Mendes family of São Paulo, Brazil. Hot wax has been applied to the cotton to create the designs by resisting the various coloured dyes. H 20¾" (78 cm)*

12 RIGHT *Ceramic figures of three gossiping women from Quinua, Peru. This piece made by Virgilio Ore also acts as a whistle. H 4½" (11.5 cm)*

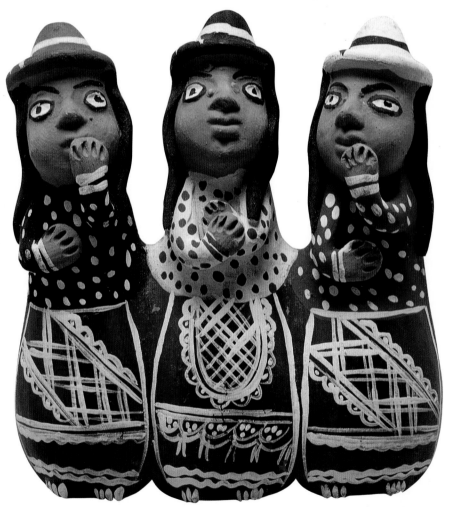

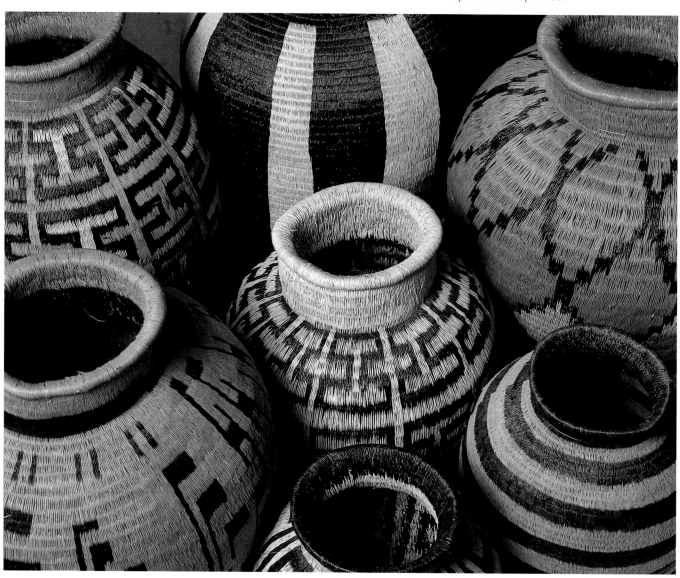

13 ABOVE *Baskets woven from* werregue *palm fibre by the Cholo Indians in the Colombian Chocó. Coils of fibre are sewn together tightly, and the designs are created by introducing different coloured threads*

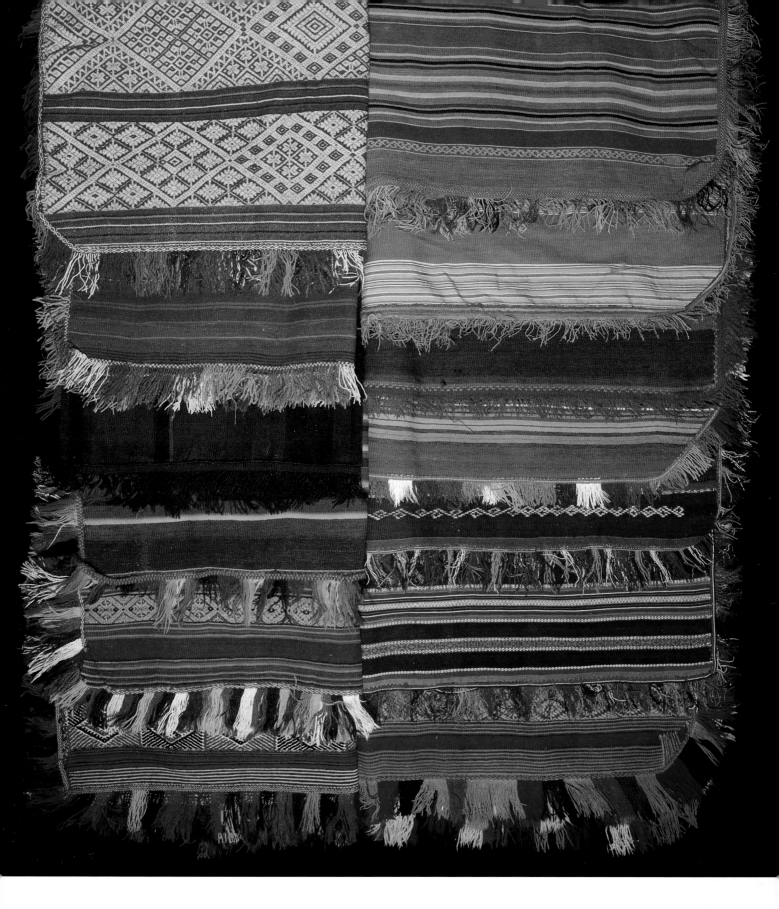

A CRAFT MISCELLANY

THE MIXING OF INDIGENOUS, EUROPEAN AND AFRICAN cultural elements in South America has brought into being a huge diversity of artistic traditions and crafts. While some indigenous forms and techniques have remained intact since pre-Hispanic eras, other ancient traditions have received modern influences, evolving into exciting and innovative forms. Artisans work with the materials available to them, and these are as varied as the contrasting landscape and climate – local varieties of wood, dried gourds, resin extracted from seed-pods, a mixture of flour and water, or even mashed potato; the simplest and sometimes strangest of materials are transformed into objects of intrinsic value.

Musical instruments

During the pre-Columbian era sound-making objects and wind instruments were used for numerous of occasions, many of them religious. Warrior-dances and rituals for deities particularly were celebrated with music. The gods worshipped represented the forces of nature, controlling earth, rivers and lakes, sky, mountains and sea. There were creator divinities too, associated with the earth, the sun, and mountains which touched the sky.

Remains of a variety of ceramic wind instruments have been found along the coast of Peru, from the Moche and Nazca cultures; these have included *antaras*, pipes made of seven joined ceramic tubes, and flutes decorated with the image of the Central Andean creator goddess, Wiracocha. Similar ceramic instruments have been discovered around Lake Titicaca dating from the Pucara and Tihuanaco cultures (1500 BC–AD 1200), both pre-Inca, Aymara-speaking peoples of the altiplano, and the same areas have yielded flutes carved from llama, condor and human bones.

The Incas used the *pututu* or conch shell as a ceremonial instrument, and today the *Varayocs* or Indian chiefs who attend the Sunday market in Pisac, near Cuzco, blow *pututus* to announce their arrival. The Incas also used many instruments adopted from cultures they had conquered: *quenas* and *quenachos* (flutes), *k'epas* (horn trumpets), *huacrapucu* (a twisted horn played like a trumpet), *tarkas* (shrill wooden recorders), *tambor con charchillo* (a type of war-drum with vibrating cactus spines), *cha'jchas* (llama hooves twisted together and shaken) *bombos* and *wankaras* (drums).

The Spanish introduced stringed instruments such as the guitar, harp and violin to South America. The *bandurria* and the *charango*, a ten-stringed instrument, are versions of the Spanish guitar. Until recently the body of the

15 LEFT *Wooden furniture, boxes and candlesticks carved and painted in the workshop of Humberto Urquizo in Lima, Peru*

charango was made from armadillo shell, but today wooden *charangos* are replacing the older form.

On the eastern side of the continent the Portuguese brought African slaves to Brazil who contributed their cultural beliefs and rituals, still intact. Musically the richest inheritance is from the Yoruba, the Congo and the southern area of present-day Angola, strong in dance and percussion. Today the varied Afro-Brazilian instruments include drums and bongos, shakers, and the *berimbao*, a bow-like instrument which is twanged, and accompanies the *capoeira*, half dance, half martial art, performed by two people, and popular in the city of Salvador in Bahía. Many of the African rhythms were everyday dances, but some were connected with voodoo cults such as *Macumba*, the best known being the Bahían *candomblé*.

No other South American country has so great a variety of music as Colombia. Colombia is the fourth largest country in South America, and its vast territory embraces four main geographical areas: the Pacific and Caribbean coasts, the Llanos western plains, and the mountain highlands. Distinctive forms of music and dance have evolved from this geographical diversity. The Pacific coast gives us some of the best music in the whole continent. Here, virtually everybody plays the bongos, the drums made from hollowed-out tree trunks and stretched skins, and it is also the home of the *marimba*, a xylophone-like instrument.

From the Caribbean lowlands come the most popular dance-rhythms of Latin America, *cumbia* and *vallenato*. The *cumbia* is a strongly black-influenced rhythm and a powerfully sexual dance. The instruments which traditionally accompany this rhythm are flutes called *gaitas*, backed by a single maraca and drums. *Gaita* flutes are made from dried cactus stems with beeswax heads, and are considered male or female, depending on the number of holes made in them – two holes for a male flute, five for a female flute. In the village of San Jacinto in the south of Colombia the Lara family continue the tradition of making *gaita* instruments begun by their family over a hundred years ago.

Maracas and rattles play an important role in Afro-Caribbean music, and *cumbia* is no exception. They are usually made from the fruit of the *tutuma* tree, or, in Peru, from carved gourds, and will be decorated in a variety of colours.

In the Colombian state of Boyacá where stringed instruments play an important role in local dances, the town of Chiquinquirá is the centre for the region's most celebrated woodcarvers. Guitars, mandolins and *requintos* (ten-stringed guitars) are made here. The fine quality of these instruments reflects many years of experience, as musicians and instrument-makers.

Venezuela is also rich in rhythms and dances. The most famous form of

An Inca messenger or chaski *blowing a ceremonial conch-shell or* pututu, *from a sixteenth-century Chronicle*

Blind harp-player in Cuzco, Peru

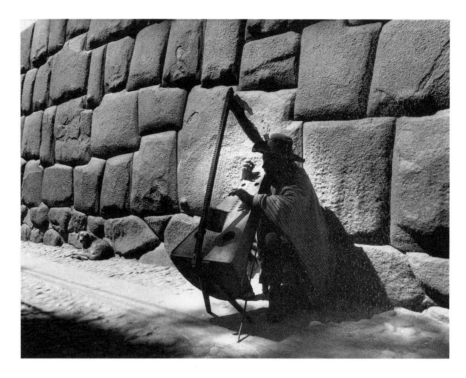

music is that of the Llanos region, known as *llanero*. Couples dance to it with enthusiastic heel-tapping, their arms hanging loosely by their sides. Here as in Paraguay, the harp is an important instrument, backed by maracas, *cuatro* (a four-stringed version of the guitar) and the guitar itself. In the high Andes of Peru, musicians of Ayacucho and Huancavelica play the traditional Andean harp for the dances of the region. Solka, a blind harp-player of Ayacucho, now in his nineties, still tours the villages around Ayacucho carrying his harp.

The highlands of Peru alone can lay claim to some two hundred different dances. Here every single Latin American instrument has been assimilated to create new rhythms. On the altiplano, where most of the indigenous Aymara- and Quechua-speakers of Bolivia and Peru still live, long, thick bamboo reeds are fashioned into beautiful instruments which are accompanied by various *bombos*, or hollow tree-trunk drums. The most common instruments of the altiplano are *pinquillos*, bamboo whistles of three octaves, *moseños*, long, thick bamboo instruments played from the side, and *tarkas*, square wooden instruments with a shrill sound.

The popular music of the Andes as we know it in the West has very little to do with traditional Andean music. Nevertheless, the instruments used are traditional, even if the tunes played are refined for Western performance.

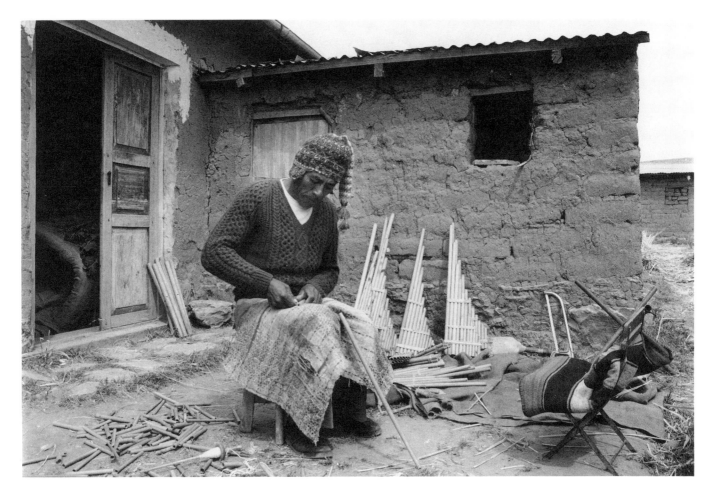

The most popular instruments are *quenas* and *quenachos* – end-blown flutes made from bamboo or carved wood, and *zampoñas* – a range of panpipes joined to give several octaves. Two rows of pipes is usual, each of a different number, such as six and seven, nine and ten, eleven and twelve, the lower notes being played on the right. All these instruments are generally accompanied by the *bombo* and *charango*, the ten-stringed smaller version of the guitar. *Charangos* are traditionally made in the village of Aiquile, near Cochabamba in Bolivia, where every house is a *charango* workshop. Cuzco, the old capital of the Incas, also has a variety of workshops producing *charangos*, but all sorts of stringed Andean instruments are made there by Alejandro del Castillo, one of the most respected of all instrument-makers. His work is known in the musical world for the clarity of sound produced, and for the high level of craftsmanship.

A member of the Quilla family making panpipes for the May festival, Huancane, Peru

The raw material for most of the wind instruments is bamboo, grown in the lower valleys and tropical rainforests of South America. The workshops where they are made, however, are usually in towns and cities, such as La Paz in Bolivia, and around Lake Titicaca. For the Fiesta del Cruz, which takes place on the third of May each year and is celebrated all over the Andean world, thousands of people come together to play all sizes of bamboo flutes, some of them, known as *toyos* and typical of the Lake Titicaca region, more than a metre long.

Woodcarving

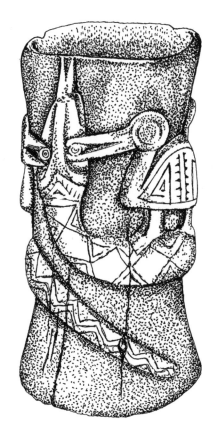

Wooden keros, *carved by the Incas for drinking* chicha *(fermented corn beer). The wooden vessels continue to be used today during Andean festivals and ceremonies*

Nearly half of South America is covered with forest, and it is therefore hardly surprising that wood is one of the most commonly used craft materials. Sought-after species are laurel, mahogany and cedar which grow in the Amazon basin and along the Orinoco river on the Pacific coast of Colombia. In the Andean highlands *nogal* (South American walnut), *naranjilla*, and more recently eucalyptus trees are commonly cultivated. Pines cover the foothills of the Andes in southern Chile and Argentina, and in the semi-tropical rainforest of northern Argentina and Paraguay, where the Pilcomayo river divides the two countries, native trees such as *palo santo* (*Bulnesia Sarmiento*) grow freely.

Ceremonial and utilitarian items have been carved since pre-Hispanic times and continue to be made today. Along the coast and in many tropical areas, tree-trunks are still hollowed out for canoes, and woodcarving produces blow-pipes and bows and arrows for hunting as well as plates and spoons. Carved ceremonial objects include drums used in rituals, carved sticks with healing properties, masks, and the Incas' *keros*, wooden vessels for drinking *chicha*, fermented corn beer. *Keros* came in all shapes and sizes and were traditionally decorated with scenes of war or local dances, or harvesting or picking coca leaves. The Chancay who lived along the Pacific coast of Peru between 100 BC and AD 1200 used ceremonial wooden *keros* carved with sea-birds and fishes. Chroniclers reported the carving of *keros* from Ica in southern Peru to Chile, Cuzco and Bolivia. Today they are used in some Andean ceremonies and especially during the Fiesta del Cruz, the May festival celebrated all over the Andes.

The Shamans or medicine men of the Noanamá and Emberá Indians of the Pacific coast of Colombia (also known as Cholo Indians) use carved wooden sticks to establish links with the supernatural world. Such sticks are also pressed gently against the stomachs of sick people in the belief that they will isolate the evil spirits and cure the illness. The sticks are roughly 50 cm long, and one end is carved with the figure of a naked man or woman, or an animal such as a monkey, or a bird.

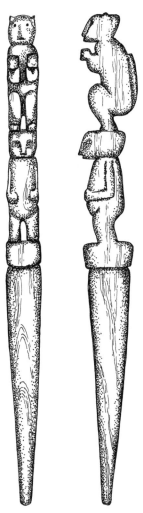

LEFT AND BELOW *Healing sticks carved by shamans of the Cholo Indians of the Colombian Chocó. The sticks have magical as well as healing properties, and are highly valued by the Cholo community*

Masks have been carved and used in ritual since pre-Columbian times. Indigenous groups continue to use masks in this way, but the *mestizo* population of towns and cities also wear them during their many fiestas and celebrations. By wearing a mask they take on the identity of that mask, be it animal, god or mythical being.

The Guaraní Indians, who during pre-Columbian times occupied an immense South American region, used masks not only in their various ceremonies but also for war. Their conquered territory extended from the Caribbean coast of Colombia as far as Panama, and right through the foothills of the Andes and the semi-tropics of Paraguay to the river Plate. Even after the arrival of the Spanish the Guaranís' greatest enemy remained their fellow-Indians, the Guaikuru Chaquean of northern Argentina. In war the Guaraní disguised themselves with Guaikuru Chaquean masks, so borrowing the identity of their enemies. Such scenes of conflict are re-enacted in many Indian and *mestizo* mask festivals.

The Chane Arawak Indians who today live in the *Missiones* in Salta province of northern Argentina still wear warrior masks during their argricultural rituals. The Chane Indians of Campo Duran use the naturally hollow trunks of the *Palo Boracho* tree to make their wooden masks. Across the Pilcomayo river in Paraguay, during the Chiriguanos' carnival (known as *Arete guasu*) the male dancers never reveal their identities, slipping away to abandon their masks anonymously in the undergrowth at the end of the celebrations. The *Arete guasu* is a ritual encounter with the souls of the Chiriguano ancestors, who are believed to be reincarnated in the dance as foxes, rats and other beings.

In June each year the Feast of San Pedro and San Pablo in Paraguay attracts thousands of visitors from all over the country. Ysanne Gayet, an English researcher and writer who lives and works in Asunción, describes the scene after darkness as the masked Guaikurus, dreaded in Colonial times for their ferocity, rush out from a corner of the field in which they have been waiting silently and run like lightning among the dancers, seizing the women and often falling with them to the ground.

The Kogi Indians of northern Colombia, descendants, like the Kuna of the Tairona of the Sierra Nevada de Santa Marta, honour their goddess the Great Mother with masked dances to ensure the fertility of their fields. In the jungles of the Amazon masks are associated with a variety of groups: the 'Makuna wear them in harvest celebrations, the Yacuna for fertility rites and the Ticuna for ceremonies connected with rites of passage.

Charming wooden masks are carved by the Sibundoy Indians of Putumayo, southern Colombia, incorporating religious images and scenes of daily life. Some of the masks are sold to the artisans of Pasto who decorate

them with *barniz*, or dyed resin. Mask-wearing rituals are also commonly practised in smaller towns such as Riosucio and Baranquilla in the north of Colombia.

At Paucartambo, near Cuzco, Peru, on 16 July each year the Fiesta del Carmen brings together many groups of Indians and *mestizos* who travel from all over the province to take part. The festival is a vast display of colourful masked dances, with numerous different themes and characters. Here one can observe a mixture of old and new customs creating an identity which is neither wholly indigenous nor wholly European.

In north-east Brazil woodcarving and sculpting techniques are an African heritage, although the original significance of the masks has been lost over the centuries. A famous sculpture is the *carrancas*, a horrific grimacing face once placed on the prows of boats to scare off evil spirits. Now these distinctive carved heads are sought after by collectors throughout Brazil.

Corpus Christi is the time to visit San Fransisco de Yare in Miranda, Venezuela, to see some hundred or so *diablos* or devils of all ages, dressed entirely in red and wearing large, hooded masks. They dance to the sound of their own music and rattles. The traditional masks are carved from wood, although more recently papier mâché masks have become popular. Another important fiesta celebrated all over Venezuela takes place on 28 December each year. For Los Santos Inocentes or 'Los Locos' (the Mad Ones), men and women change sex for the day and wear one another's clothes. The festival of *El Mono*, the monkey, takes place on the same date in Caicara de Maturin in Monagas province. Monkey-masked men and women dance everywhere in the town, while the local musicians with their brass bands follow the main *Mono* or masked monkey figure, who leads all the other monkeys to dance and behave foolishly. Small children wear tiny monkey masks, delighting in the exciting atmosphere. Each family makes its own masks which may be of wood, leather, papier mâché or cardboard.

During the Colonial era the uses of woodcarving were extended to provide the Catholic Church with elaborately carved pieces to adorn church interiors. Wealthy families commissioned colonial benches and chairs for their lavishly carved balconies, wood-framed mirrors, and enormous *barqueños* or chests. Skilled woodcarvers were employed to embellish salons with high, ornately carved wooden ceilings. In the sixteenth and seventeenth centuries woodcarvers from Spain settled to the north of Quito, where the town of San Antonio de Ibarra has become the largest and most important woodcarving centre in South America.

Initially the *mudejar* or Spanish-Moorish styles were imported to the New World, but as the workshops of San Antonio expanded and more spread north to Colombia and south as far as Chile and Argentina, they

evolved their own unique styles. Following Spanish introduction of horses, sheep and cows to the continent, the ready availability of leather led to its decorative use on many types of carved objects, one of them furniture. Dark, elaborately carved wooden seats were covered with finely engraved and polychromed leather; chairs made for monasteries in particular were embellished in this way. Although after independence the demand for such furniture temporarily declined, today the style is popular, and centres such as Lima and Cuzco in Peru and Pasto in Colombia produce a wide range of seats, benches, wardrobes and *barqueños*.

Glass mirrors were unknown before the arrival of the Spanish, although there is evidence to suggest that obsidian and metal, especially silver plates, were used as mirrors by the Chimú and Lambayeque cultures of the Peruvian Pacific coast. The Inca *chaskis* or messengers used reflective stones or polished metal to communicate between hilltop forts, relaying information some 200 kilometres from their capital, Cuzco, to Machupicchu. The Spanish brought mirrors which today can be seen in churches, museums and a few private houses. Transporting glass from Spain to South America proved a costly business, and within a relatively short time mirrors were being produced in the new Colonial cities such as Lima, Peru, and Quito, Ecuador. Initially, as with other products, the artisans copied the Spanish models, but gradually they developed their own styles. In particular Cuzco and Cajamarca, in the north of Peru, became the centres of production. In Cuzco the frames were carved, covered in gold leaf and decorated with tiny pieces of cut mirror. Cajamarca artisans incorporated painted glass into the frames. During the post-Colonial period the tradition lapsed, and the present production of Peruvian mirrors and similarly decorated trays, boxes, picture frames and candlesticks goes back less than twenty years. Cajamarquiño (also known as Andahuayliño) mirror-frames are not carved, but decorated with patterns transferred on to pieces of glass by the silkscreen process. Watercolour painting is applied to the patterns and they are sealed before being set into the frame.

Cuzceña-style mirrors use techniques several hundred years old. The frame is carved with a chisel and covered with a thin layer of plaster and gold leaf, or else painted. Tiny pieces of mirror are then fitted into precisely carved niches in the frame. Among the many artisans working today in and around Lima, Umberto Urquizo, Krikor Alarcon and Eladio Varrientos produce truly inspired pieces. Thanks to them and people like them, such crafts are enjoying a popular revival in Peru today. Urquizo and Varrientos also produce furniture: modern tables, dressers and chairs are painted white and decorated with flowers and birds.

Carved religious figures, usually made from hardwoods, were a central

influence in the development of woodcarving. Figures of saints and other religious figures were finished by being carefully painted to achieve a high degree of realism. Even today the best-known artisans devote much of their time to religious sculpture. In Cuzco, the woodcarvers who abound in the *barrio* of San Blas chiefly produce religious figures.

The small and brightly painted wooden saint-figures of the village of Tobati in Paraguay have a more popular charm than the sophisticated Cuzco pieces, and the wood used – *palo santo* (*Bulnesia Sarmiento*) – is sweetly scented. In Paraguay as in north Argentina and Brazil, the tradition of carving and painting religious figures originates with the Jesuits, whose seventeenth-century *Missiones* or *Reducciones* gathered the Indian population into settlements. The Jesuit brothers saw their role as not just to convert the Indians but to protect them from the *encomienda* system of virtual slavery which was the only alternative to the Missions. The Indians were set to work to build churches and produce handicrafts – earthenware for use in the *Reducciones*, paintings and woodcarvings to adorn the churches, as well as other crafts.

After the Jesuits had been expelled in 1767 and the Indians were left to fend for themselves, they retained the craft techniques and traditions that had been passed on to them, and from these evolved the style of woodcarving found today.

In addition to the colourful figures of saints, Tobati carvers produce pieces such as representations of people, ox-carts and similar everyday subjects. The talented carver Zenon Paez and his wife Hermina Gonzalez de Paez have dedicated their lives to this art form, and produce some beautifully worked objects.

In the Chaco area of Paraguay, the Guaraní Indians carve naive figures of animals, birds and naked Indians. Of all the Guaraní groups, the Ava-Chiripa produce woodcarvings so original that they may be considered as contemporary sculptures, carved by extraordinarily talented artists.

In the province of Salta in the north of Argentina there remain isolated groups of Toba, Chane and Mataca Indians who continue to live in Missions. Some twenty years ago a talented Anglican priest who came to the Chaqueña Mission revitalized the life of the whole community. Soon the Indians were using the various colours of wood in their immediate surroundings to produce exquisite carvings of birds and animals. The community also became virtually self-sufficient by developing its agriculture, and was on its way to prosperity. However, with the outbreak of the war between Britain and Argentina the priest was ordered to leave the country, and once again the lives of the Indians seemed in jeopardy. Today, fortunately, the project has been revived, and pieces are being exported.

Among woods used are the greenish, scented *palo santo*, reddish *quebracho* (*Schinopsis Balansae*), brown or black *guayacan* (*Caesalpina Paraguariensis*) and a yellow wood, locally known as *mora* (*Chorophora Tinctoria*). Cow-bones are also used to make beaks and feet, and as an inlay to decorate spoons and other utilitarian items.

In Brazil woodcarving is widespread, in this unlike pottery which is concentrated in particular centres. In Bahía, Olinda, and around Rio de Janerio, there are contemporary artists whose work is shown in galleries and museums all over the country. Benedito, who lives in a tiny village on the outskirts of Olinda and carves religious subjects in a simple style in plain wood, decorated with areas of colour, is one of these. Other celebrated artists who live in Olinda include Maria Jose, who makes utilitarian items in the shape of local animals, and Adriano, who carves pictures and boats. His work is strongly influenced by the Amerindian artist Nhocaboclo who died in the mid-1970s.

Painting a balsa wood parrot in a workshop in Puyo, in the Ecuadorian Amazon

The village of Embu, on the outskirts of São Paulo, is an important craft centre of the region, producing furniture and sculpture. Silveiras, roughly 200 kilometres north of São Paulo, is noted for an imaginative style of woodcarving using tree-roots and branches to fashion animals and birds.

In La Paz and Cochabamba in Bolivia the woods most commonly used are *guayacan*, *nogal* (South American walnut), mahogany and cedar. Images of Indians, mountains, condors, and especially the pre-Columbian site of Tihuanaco are carved on wooden plaques. In La Paz the carvers specialize in representing male and female Indian heads.

Villarica in southern Chile is a woodcarving centre where artisans produce a variety of pieces, including jointed snakes and other animals, made from readily available pine. After being roughly carved into the shape of the animal the pieces are cut in half lengthwise and glued on to a strip of leather to give flexibility. After the final stage of cutting through the joints, the piece is painted and varnished. These animals were first produced in the early 1980s by the Monsalve family, and today various large workshops make all sorts of creatures, both large and small, for export.

While these animals were taking off in Chile, Nelson Sante, an Achuara Indian of the Ecuadorian Amazon, hit on the idea of brightly painting the traditional, naive balsa wood figures of tigers, parrots, toucans and other birds that are carved by Indians deep in the heart of the Amazon and brought to the forest-edge to be sold. The painted figures are tremendously popular but traditional pieces continue to be carved, often in the form of seats based on tropical animals. These larger items are generally carved from a single piece of wood, usually anis, which has a pleasing scent. The very simple decoration brings out the characteristic features of the animal.

Naive pieces are carved in many different areas, but Tabay, in the state of Mérida, Venezuela, has developed its own unique style. Here talented carvers form pieces of wood into imaginative figures. The skill is not merely in the carving but in incorporating the natural features of the wood into the finished pieces. They are decorated in bright colours, again in an unsophisticated fashion, but one which harmonizes with the carving. Artists Francisco Ranjel, Lauriano Ranjel and Avra Marquina are three among many talented carvers.

San Antonio de Ibarra in northern Ecuador has already been mentioned as the original place of settlement of woodcarvers from Spain in Colonial times, and as the most important craft centre where nowadays artisans and artists live side by side. Everyone in San Antonio is in some way or other involved with the art, and almost every shop sells carved wooden skulls, chess sets, toys, or life-size dancers or carnival figures. Whatever you want can be made for you in San Antonio.

Barniz-*work*

Pre-Hispanic peoples covered wooden objects with resin to render them impermeable, according to the early chroniclers, but today the use of dyed resin or *barniz*-work is a purely decorative art, and is practised exclusively in the Colonial town of Pasto, Nariño, in the south west of Colombia, not far from the Ecuadorian border.

The term *barniz* originated in the sixteenth century with the Spanish, who confused the resin with European 'varnish', although the two processes are quite different. For *barniz*-work resin is obtained from the seed-pods of a tree (*Eleagia Utilis*) which grows at altitudes of over 2,000 metres and produces seeds twice a year, in May and June and November and December. The *barniz* artisans must buy the seed-pods, for the tree grows only in certain areas of the province of Putumayo.

The resin is separated from the seed-mass by a combination of heating and hammering, or sometimes the seed-mass will be passed through a handmill. Originally this cleansing process was achieved by chewing the seed-pods, and the common name for the seed-pods, *mopa mopa*, is said to have originated in the strange sounds produced when people chewing them attempted to speak at the same time.

Next the resin is dyed, using analine and natural dyes, including seeds from the *achiote* tree and various mineral extracts. The mass is boiled, and beaten again to fix the colours, and then the dyed resin is expertly stretched between two people, who use their hands and mouths to draw out a paper-thin sheet. From this sheet are cut the designs which decorate wooden objects: trays, candlesticks, boxes, ducks and owls among others. The

traditional wooden masks carved by the Sibundoy Indians of Putumayo and sold to the *barniz* artisans to be decorated have been mentioned.

The *barniz* sheets are cut freehand, and the shapes are applied to the wooden surface using both the warmth of the hand and exposure to a direct heat-source. Each area of colour must be individually cut and applied in this manner, so that intricate designs take many hours, if not days, to complete. Designs are varied, but the two main types are *paisaje* or landscapes and abstract or floral designs. Finally, the piece is sealed with a layer of protective lacquer.

Production today is based around the *Casa del barniz*, a cooperative set up by the Museo de Arte Popular in Bogotá. At present there is concern about the future supply of resin, for rich mineral sources have recently been discovered in the region where the trees grow, and the area is becoming increasingly populated with people eager to exploit the land.

Gourd-carving

Gourd-carving, or *máte burilado* as it is known, is one of Peru's most popular and traditional handicrafts. Its origins lie deep in the pre-Hispanic past when gourds were used as vessels for food and liquids. It may even precede pottery: engraved gourds found on the northern Peruvian coast have been dated to some 3,500 years before the present. During the time of the Inca empire gourd-carving became a valued art form. Workshops were set up and supported by the Inca state, with finished gourds destined for the household of the Royal Inca. Gourds were used in rituals and ceremonies, and also to make *poporos* – containers for the lime used while chewing coca leaves. The Arhuacao and Kogi Indians of the Sierra Nevada de Santa Marta in northern Colombia continue to use gourd *poporos* today.

Gourd-carving decreased dramatically after the arrival of the Spanish, who destroyed the Inca system of production and prevented the use of gourds in ritual practices. However, with the evolution of Colonial society, limited gourd-carving continued and new styles were developed as decoration became strongly influenced by European elements. Images from paintings and other decorated objects from Europe were carved on the gourds, replacing the earlier more geometric designs. Some gourds were even inlaid with silver for the use of a social élite. With independence a new style developed which incorporated traditional and narrative scenes into the carving. This style made the gourds both more commonplace as objects and more meaningful to greater numbers of people, since the motifs used were part of their everyday lives. Different areas of production evolved their own unique styles. Today carving is centred around the small communities of Cochas Grande and Cochas Chico near Huancayo.

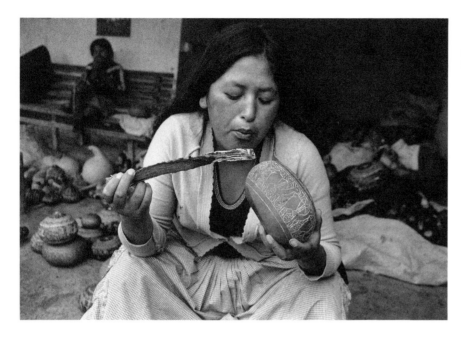

Using a red-hot stick to burn areas of a carved gourd and add different tones to the decoration, in Cochas, Peru.

It is believed the art reached Cochas from the earlier centres of Huanta and Mayocc in the Ayacucho region when the gourds were sold in the famous Huancayo market. Luis Vilca, a muleteer, is said to have been the first in the Cochas region to carve a gourd in the Huanta style.

The gourds come from a creeping plant (*Lagenria Vulgaris*) which grows only in warm, dry regions such as the coastal valley of Ica in northern Peru, and the carvers of Cochas therefore have to buy their raw material. The decoration is produced by a combination of carving and burning. The outlines are carved freehand by skilled craftspeople, and a red-hot stick is used to burn and blacken areas of the surface. Finally the gourd is rubbed with lime and protected with a layer of oil.

Ingenuity is evident not only in the range of designs but also in the way the shapes of the gourds are used to advantage, as when gourds with elongated necks become humorous birds, with minimal carving. Some carvers take a jungle theme with tropical vegetation entwined around monkeys and exotic birds. Sometimes the carving is so fine and the narrative detail so great that to appreciate the full meaning of the piece takes considerable time and effort. The tops of gourds may be cut open in a zigzag fashion, enabling them to be used as containers. Today the carvers continue to sell their art in Huancayo, as well as in Lima from where it is exported.

A few of the carvers are true artists who might take as long as six months to finish a large, finely carved gourd. Davia Laureano de Canchomuni,

Eulogio Canchomuni Sinche and members of the Garcia family are in this category.

Although Peru has the richest tradition of gourd-carving, other countries also decorate them in various ways. In Uruguay, where *mátes*, as the gourds are called, are used for drinking *máte* tea, they are sometimes carved with simple motifs. Uruguayan artists have transformed gourds into amusing caricatures of people, joining two gourds together to form a body and head, and adding leather accessories and decorations. In Petare, in the state of Miranda, Venezuela, gourds are decorated by painting them with delicate floral motifs.

Retablos *of Ayacucho, Peru*

Ayacucho, meaning 'City of Blood', was one of the last towns in Peru to fall into the hands of Pizarro's army in 1532, and the first to declare independence from Spain. In the interim the Spanish found the region suitable for their cattle-breeding and agriculture, and built an astonishing thirty-three churches in the town. It is here that the tradition of *retablo*-making originated.

Retablos, or 'St Mark's boxes', as they were originally known, were introduced to Latin America by the Spanish in the sixteenth century. Simple portable altars containing religious images, they were intended to aid in the task of converting the native population to Catholicism. Early examples often contained images of St James, the patron saint of the Spanish army, interpreted as a fine soldier on horseback.

Retablos were made from a variety of materials, and two distinct styles evolved to suit different needs. Those of clay, leather and plaster were destined for the native rural population, while those for the use of the Colonial hierarchy were made of gold and silver, or the famous alabaster of Ayacucho, also known as 'Huamanga stone'. The traditional *retablos* had two floors inside a box. On the top floor were the patron saints of animals: St Mark, patron saint of bulls, St Agnes, patron saint of goats, St Anthony, patron saint of mules, and so on. On the lower floor was a scene of a cattle-thief being reprimanded by a landowner.

From the seventeenth century onwards the *retablo* came to be used by the native rural population in a way far removed from its original purpose of inspiring Catholic devotions, for it occupied a central place in the ceremonies accompanying the branding of cattle. During August, a ritual believed to have its origins in pagan fertility festivals was enacted, in which the *retablo* was placed on a table and surrounded by offerings of food and coca leaves. People danced and sang in front of the box, asking for protection for their animals, and celebrating their well-being. After the branding the

offerings were taken to the hills and left for the spirits, and the *retablo* was put away until the following August. The magical or ritualistic significance attached to *retablos* illustrates the way in which Catholic beliefs became assimilated with the indigenous belief in the powers of nature.

It was not until the 1940s that the first *retablo* reached Lima and attracted the notice of city-dwellers. At this period the art of making *retablos* had virtually ceased, but with outside interest a revival began. At the same time, the traditional elements of the saints with their animals began to be varied, including scenes such as fiestas, markets and craftworkers. The magical or ritualistic value of the *retablo* was also lost at this stage, as it became reborn as a manifestation of Peruvian folk art. The artist Joaquin Lopez and his family, especially, created the early *retablos*, but today they are made in many different workshops and represent one of the most traditional of Peruvian handicrafts.

The figures are made of a mixture of plaster and mashed potato. They are modelled or made in moulds, sealed with glue, and then painted and positioned inside the brightly painted wooden box. Nativity scenes have become popular, although artists also portray the troubles of the civil war which for many years centred on the Ayacucho area. Today *retablos* are made in countless different forms and sizes. Some miniature versions are made in *chiclet* or chewing-gum boxes, others in egg shells. Others still are made with as many as five floors, all with different scenes, full of activity and colour and requiring months of work to complete.

Bread dough figures

The main street of Calderón on the outskirts of Quito, Ecuador, is lined with shops selling the colourful and imaginative bread dough figures or *figuras de masapan* that have gained immense popularity in recent years. Flour and water are the raw materials, coloured with vibrant dyes according to the imagination of the women who make them.

The origins of this art can be traced back to small dolls made of bread for the annual celebrations of All Souls' Day. The original edible figures, made in wooden moulds in the village bakery, were decorated with a simple cross over the chest in red, green and black, and were placed in cemeteries as offerings to the hungry souls of the dead.

Gradually, different types of figures appeared, and people started to give them as presents to children and friends. So began the evolutionary process that culminated in today's vast selection. Special pieces continue to be made for 2 November celebrations, such as donkeys and men and women in traditional costume, but production nowadays includes hundreds of different models including earrings, badges and hangings.

16 RIGHT *Ceramic figure of a woman decorated using the technique of 'negative painting' in which the piece is fired twice. Made by Gerásimo Sosa Alache, a master potter and artist from Chulucanas, northern Peru. H 21⅞"
(55 cm)*

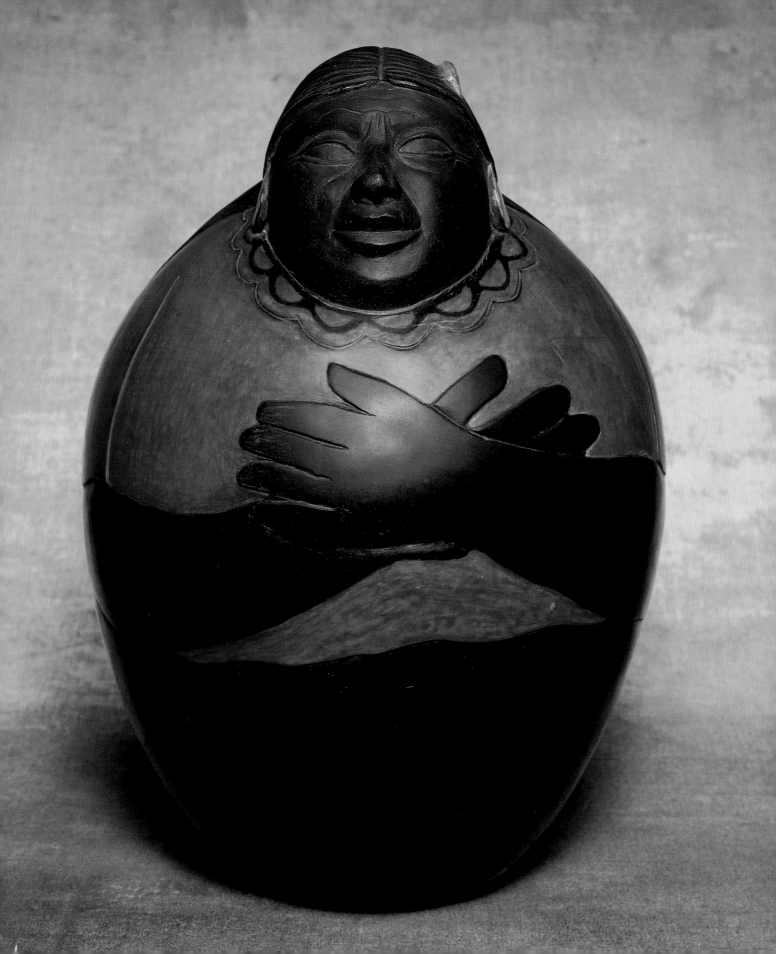

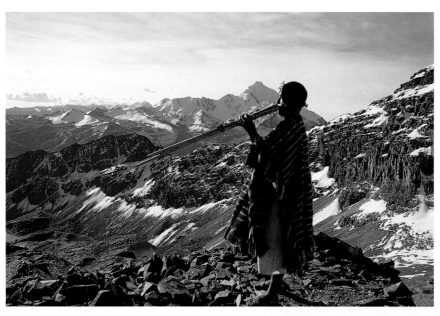

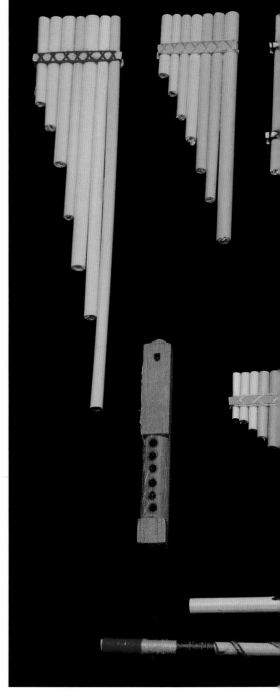

17 ABOVE *A Tarabuco Indian playing large*
toyos *(bamboo panpipes) in the snow of*
Chacaltaya mountain, La Paz, Bolivia

18 RIGHT *Señor Huatta from Taquile Island,*
Lake Titicaca, Peru, playing toyos *in the annual*
fiesta of Illapa, god of thunder, in which groups
of dancers and musicians perform together in
the main square of the island

19 FAR RIGHT *Traditional Andean wind*
instruments and a bombo *(drum) made of a*
hollowed-out tree trunk and stretched animal-
skin. The horn with a long pipe (at foot) makes
a sound like a trumpet.
H min. $3\frac{7}{8}''$ (10 cm), max. 39'' (1 m)

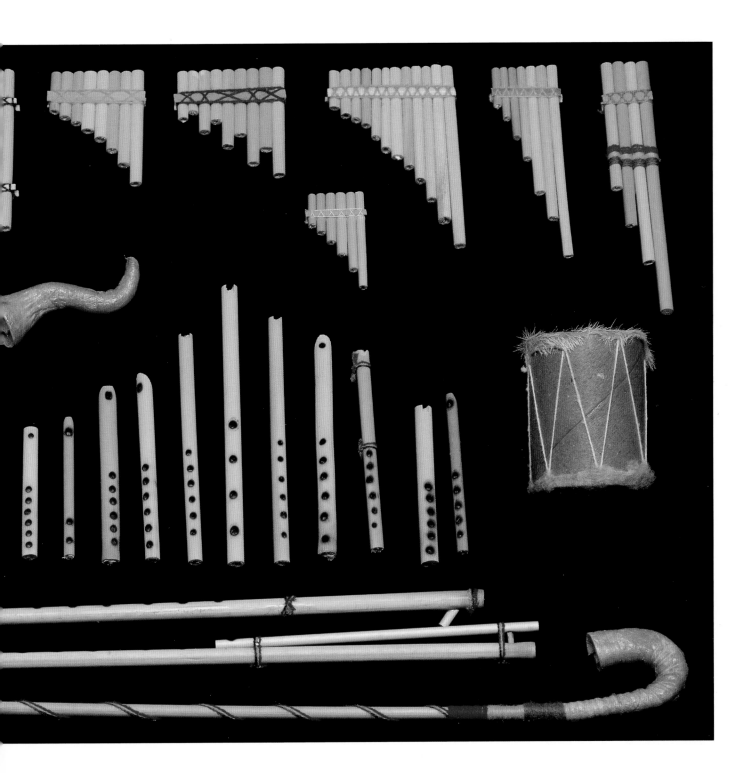

35

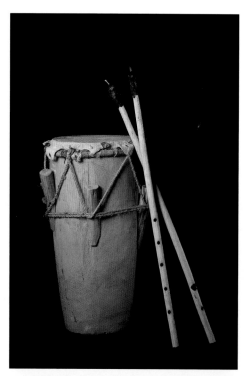

21 LEFT Gaita *flutes and drum made in San Jacinto, Bolivar, Colombia. The flute is a dried cactus stem with a quill positioned in beeswax forming the mouthpiece. L 31¼" (80 cm). The drum is carved from a hollowed-out tree trunk. L 24⅜ (62 cm)*

22 BELOW LEFT *Maracas made from the dried fruit of the* tutuma *tree, shaken like a rattle in tropical music (salsa, cumbia, merengue) in Colombia and throughout the Caribbean. D 3⅞" (10 cm)*

23 BELOW Charango, *a ten-stringed Andean instrument originally made from the shell of an armadillo, today more commonly carved from wood. La Paz, Bolivia. L 24⅜" (62 cm)*

20 *Members of the Lara family making* gaita *instruments in San Jacinto, Bolivar, Colombia*

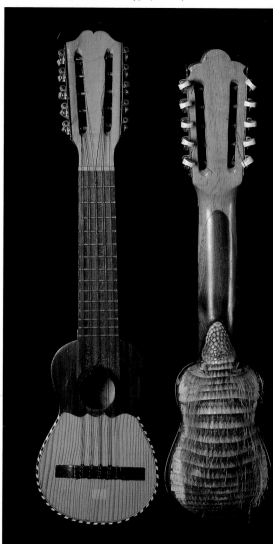

24 BELOW *Carving of an owl perched on a human skull, from the Cevallos workshop in San Antonio de Ibarra, the centre of woodcarving in Ecuador. H 20¾" (53 cm)*

27 RIGHT *Carving in walnut wood of a pregnant woman, from the workshop of Gabriel Cevallos in San Antonio de Ibarra, Ecuador. H 21⅝" (55 cm)*

25–6 BOTTOM *Pair of heads carved from hardwood representing indigenous faces (male and female). La Paz, Bolivia. H 7" (18 cm)*

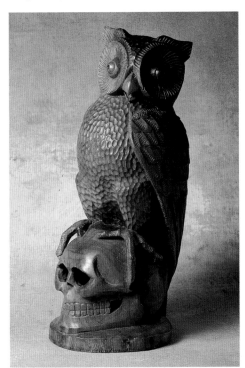

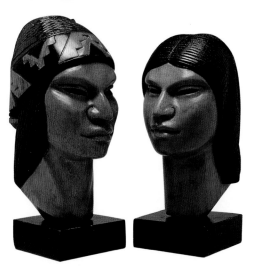

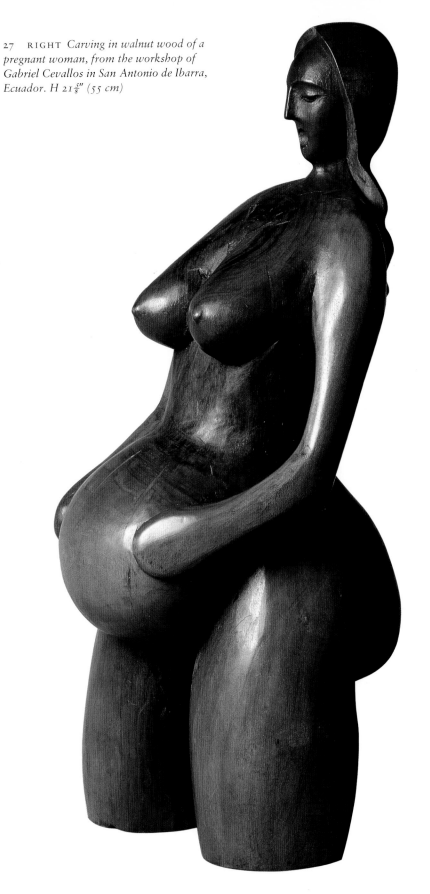

28 *Animal carved in hardwood in naive style by the Ava-Chiripa Indians of the Paraguayan Chaco. L 36¼" (92 cm)*

29 *Chair carved from a single piece of anis wood by Achuara Indians in the Ecuadorian Amazon. H 40⅞" (104 cm)*

30–33 *Wooden saints, carved and hand-painted in Tobati, Paraguay, in a tradition originating with the Jesuits in the seventeenth century.* FROM THE TOP LEFT, CLOCKWISE: *St Joseph, St Blas, St Mark, St Silvester*

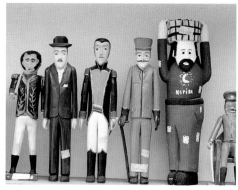

36 BELOW Ox-cart carved in the Paez workshop in Tobati, Paraguay. Each ox is carved from different wood, giving the animals distinctive colours and textures. L 25⅝" (65 cm)

37, 38 BELOW LEFT AND BOTTOM Woodpecker and duck carved from palo santo wood (Bulnesia Sarmiento) and decorated with cow-bone and other woods by the Mataco Indians of northern Argentine Chaco. L of base-wood 7½" (19 cm). L of duck 5⅞" (15 cm)

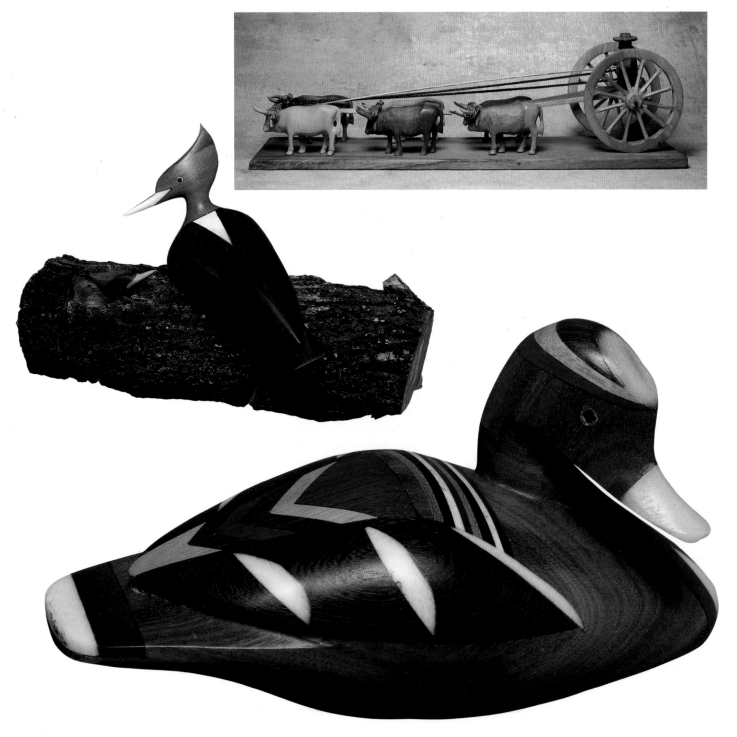

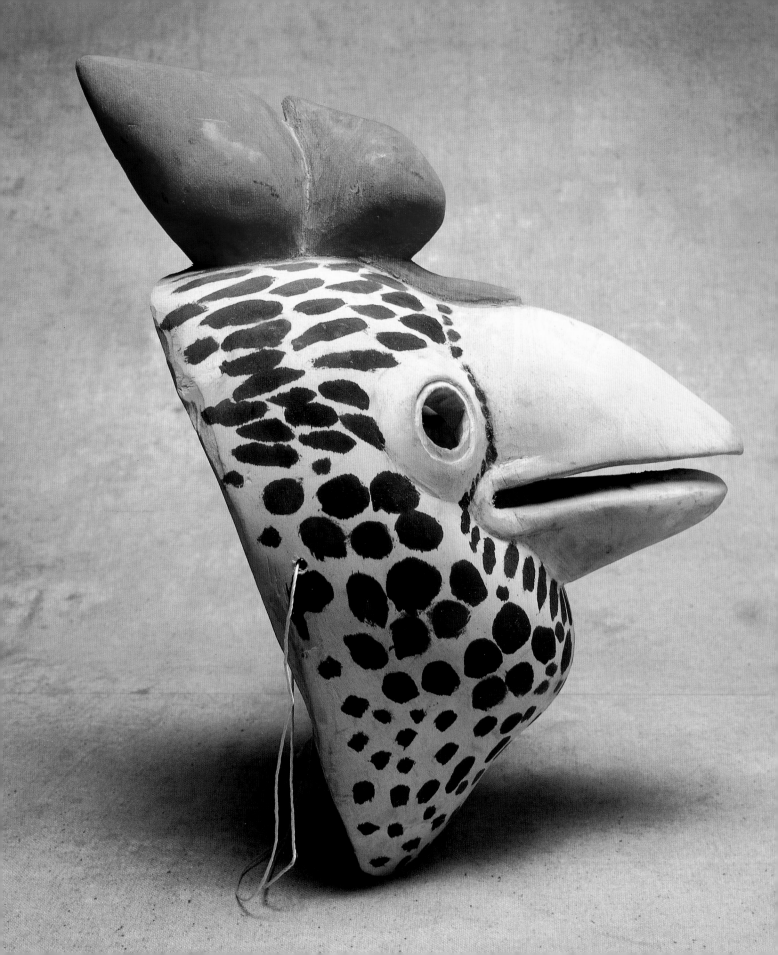

41 **BELOW** *Wooden rocking chair with seat and back of leather stamped with pre-Hispanic motifs, from Lima, Peru. H 33" (84 cm)*

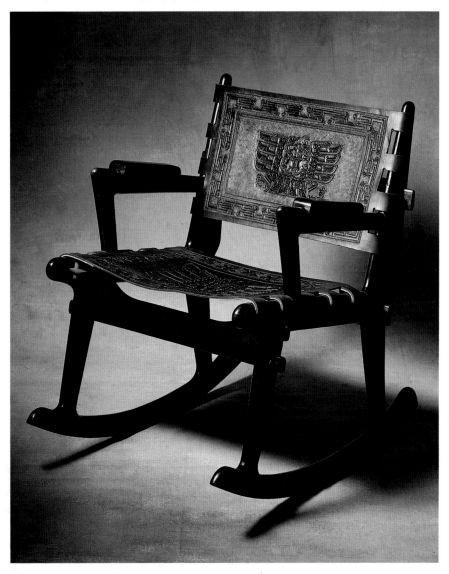

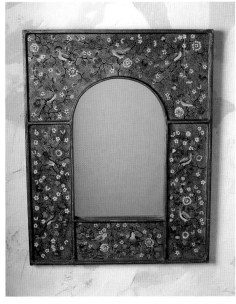

40 **ABOVE** *Andahuayliño-style mirror from Lima, Peru. Designs are applied by silkscreen and hand-painted with watercolour on the underside of the glass. Mirror by Krikor Alarcon. L 15¾" (40 cm)*

39 **LEFT** *Mask from Altos, Paraguay, traditionally worn in the fiesta of San Pedro and San Pablo to transform the wearer into a bird or an animal, according to the design, a ritual practice dating back to pre-Colombian times. W from beak to edge 7¾" (20 cm)*

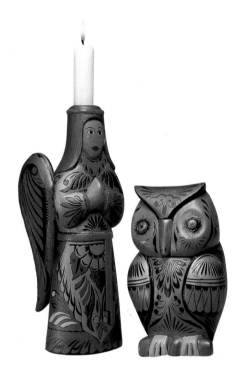

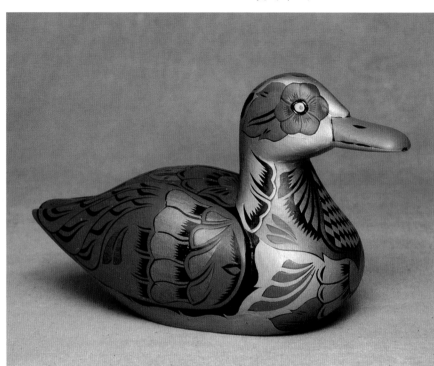

42–4 BELOW, LEFT TO RIGHT *Carved wooden figures decorated with* barniz – *thin sheets of dyed resin – from Pasto, southern Colombia. H of candlestick* $13\frac{3}{4}''$ *(35 cm). L of duck* $11''$ *(28 cm)*

45 BOTTOM *Fish carved from balsa wood in the Ecuadorian Amazon, and painted in vibrant colours. L* $9\frac{3}{8}''$ *(24 cm)*

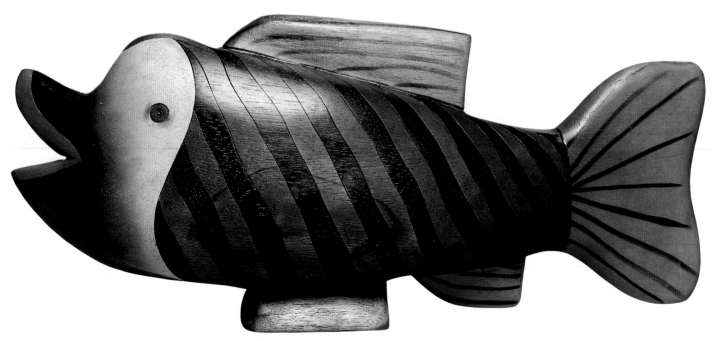

46 *Carved snakes and crocodiles, for which the wood is roughly shaped, cut from both sides and then halved lengthwise. Glueing the halves to a piece of leather through the centre gives the animal its realistic movement. Made in the workshop of Ruperto Monsalve, Villarica, southern Chile. L min. 15¾" (40 cm), max. 58⅛" (150 cm)*

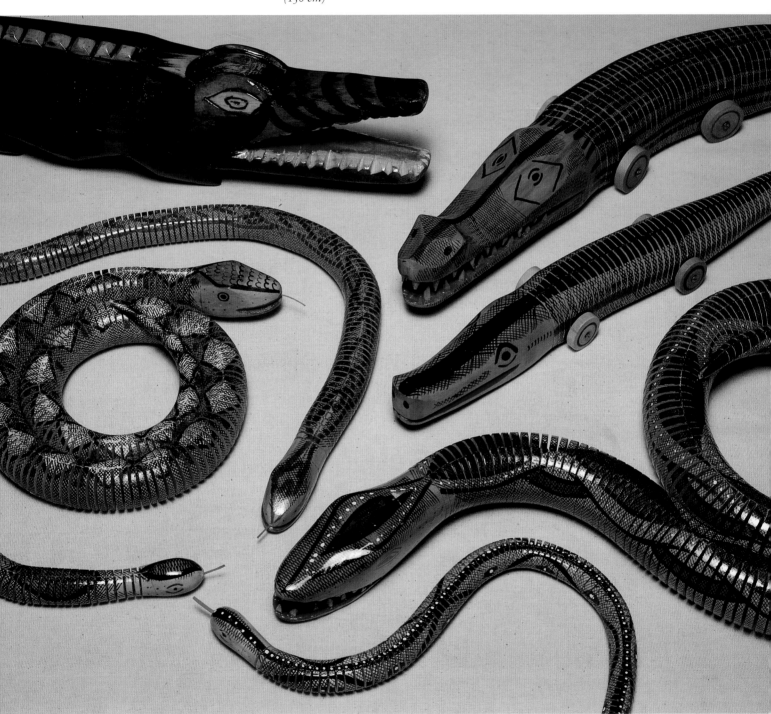

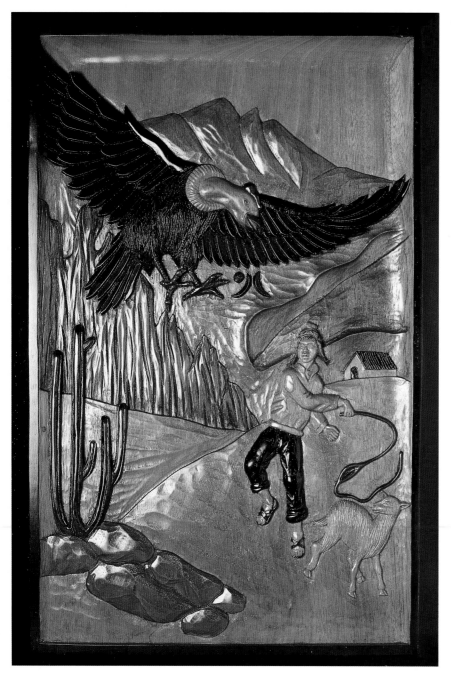

47 LEFT *Plaque carved of hardwood in La Paz, Bolivia, depicting a traditional Andean scene of a shepherd protecting his sheep from an attacking condor. H 59" (112 cm)*

48–9 BELOW Picarones: *humorous wooden figures from Villarica, southern Chile, carved so that on being picked up, their genitals are unexpectedly exposed. H max. 7" (18 cm)*

50 *Painting wooden candlesticks in Lima, Peru. Here furniture and other articles are painted, and a vast range of mirrors is produced with painted glass or wood frames*

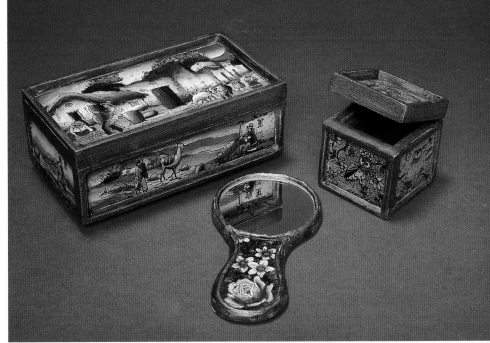

51 BELOW *Mirror and boxes decorated by painting on the underside of the glass. Lima, Peru. L of mirror $5\frac{1}{2}''$ (14 cm)*

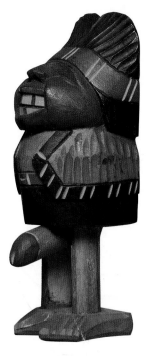

52 ABOVE *Cuzqueña mirror (mirror in Cuzco style) with the hand-carved wooden frame, plaster-covered and painted. Cut pieces of glass are set into carved niches in the frame. Lima, Peru. D $6\frac{1}{4}''$ (16 cm)*

47

53 Four-floor retablo or St Mark's box, with
figures of plaster mixed with mashed potato,
made in the López family workshop in Lima,
Peru. H of retablo 36¼" (92 cm)

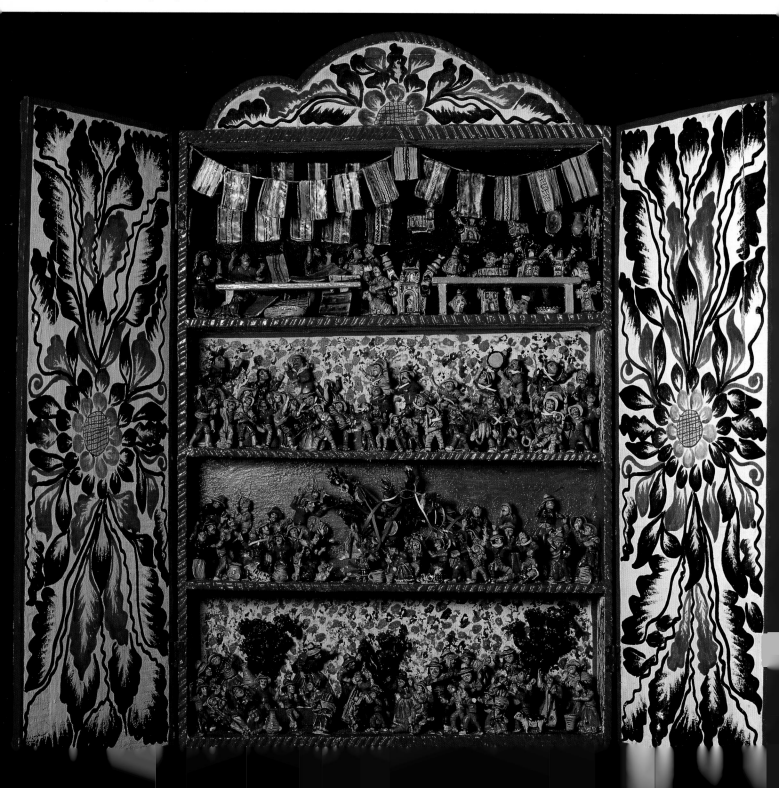

54 LEFT *Juan López in his workshop in Lima, Peru, making* retablos, *descendants of the portable altars introduced by the Spanish to South America in the sixteenth century. Traditionally the boxes held figures of Catholic saints or Nativity scenes, but contemporary* retablos *often depict fiestas, musicians and markets*

55 BELOW Retablo *depicting a Nativity scene on the top floor with musicians performing beneath. H of retablo 11" (28 cm)*

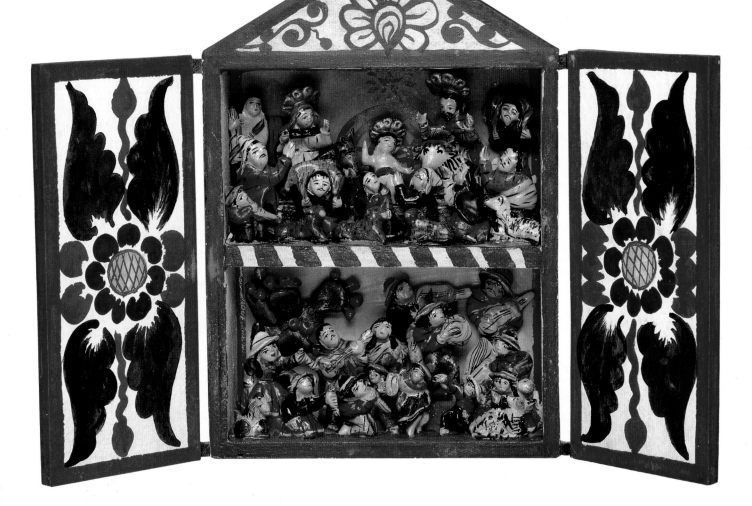

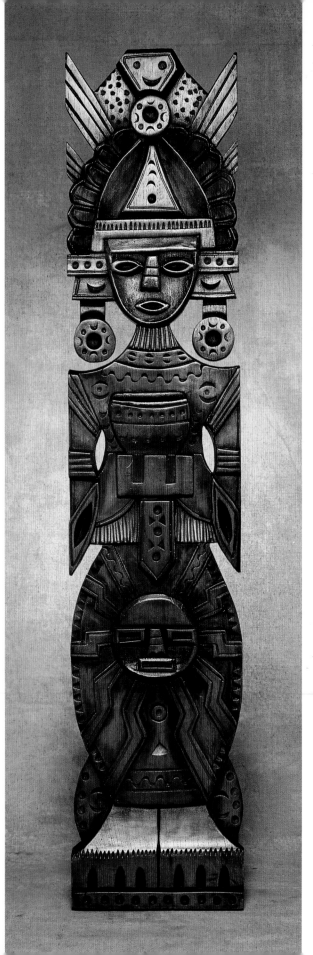

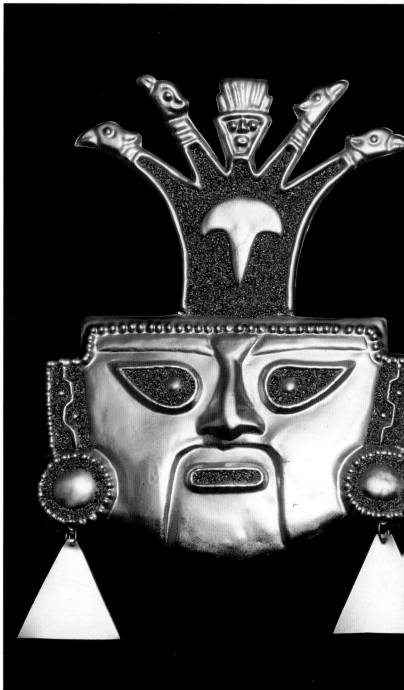

56 LEFT *Pre-Columbian dancer-god carved from* nogal *(American walnut), from San Antonio de Ibarra, Ecuador. Note the sun god* (Inti) *below the main figure. H 44″ (112 cm)*

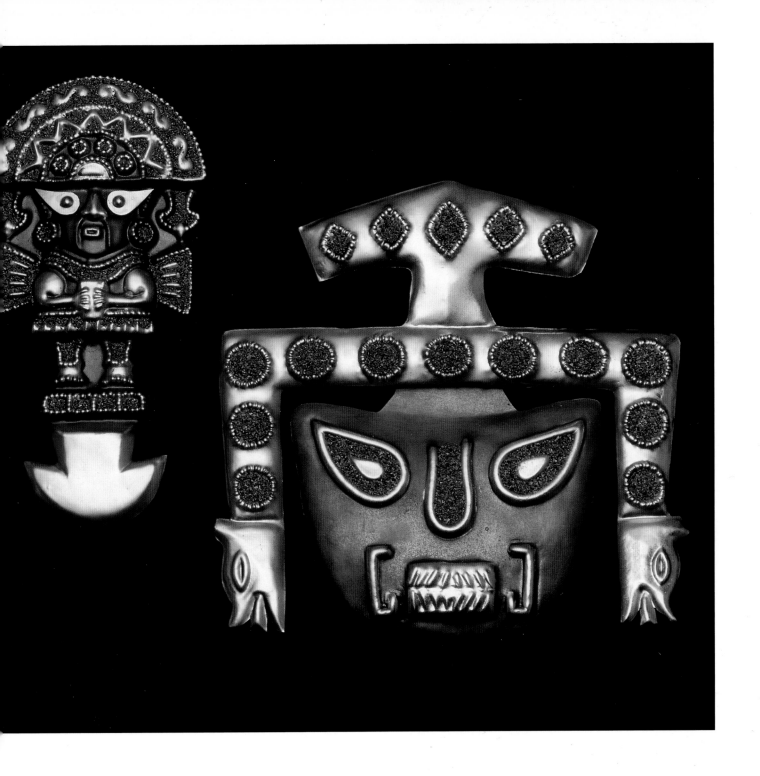

57 ABOVE *Tumi knife and replicas of masks of the Moche culture of northern Peru (AD 200–750). The material is copper, treated with acid to give a green tone. The* tumi *knife (centre) originated with the Moche culture and was associated with human sacrifice. L of knife based on pre-Hispanic designs 15¼" (39 cm)*

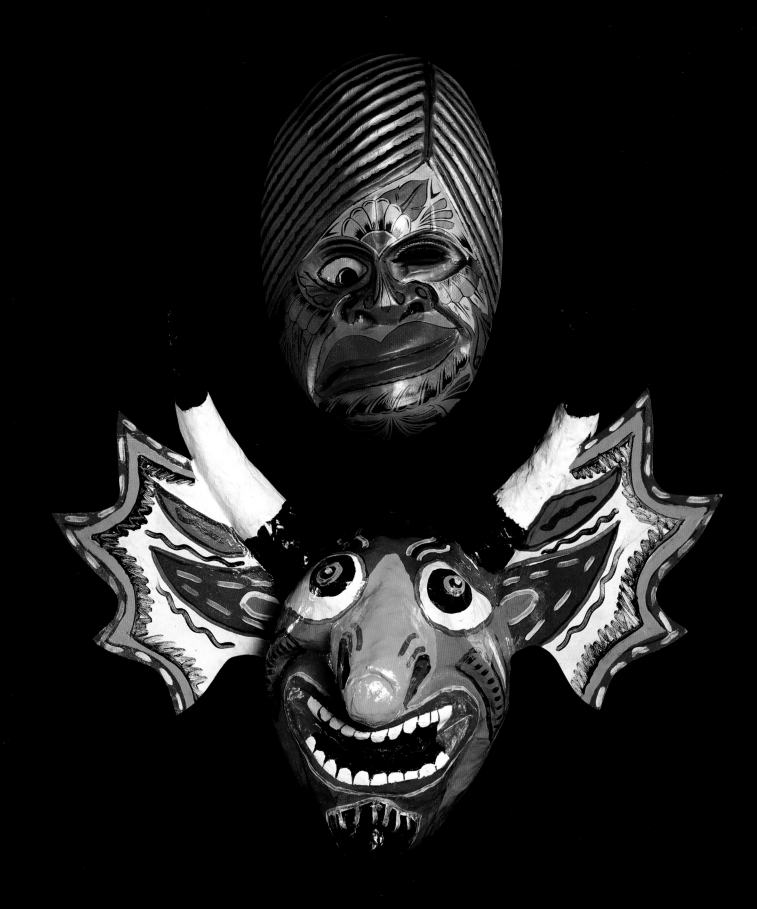

58 LEFT ABOVE *Wooden mask carved by the Indians of Sibundoy, near Pasto, southern Colombia, decorated with sheets of dyed resin in the technique known as* barniz de Pasto. *L 10¼" (26 cm)*

59 LEFT BELOW *Devil mask worn for the Corpus Christi celebrations in San Fransisco de Yare, Miranda, Venezuela. W 19⅝" (50 cm)*

60 RIGHT Figuras de masapan: *snowmen made of bread dough by the women of Calderón, near Quito, Ecuador. L 3¼" (8 cm)*

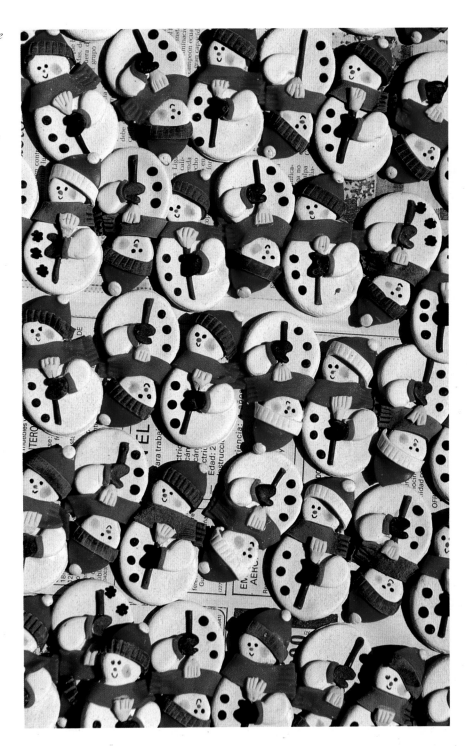

61 LEFT *Daria Laureano carving a gourd in Cochas, Peru. Whole families dedicate their lives to the art, many of them becoming talented carvers, producing intricately carved gourds that take months of painstaking work to complete*

62 BELOW *Finely carved gourd (máte burilado) from Cochas. The designs include traditional festivities and scenes of the daily lives of the carvers. D 18¼" (47 cm)*

63 RIGHT *Half-gourd painted with floral motifs, from Petare in the state of Miranda, Venezuela. L 12¼" (31 cm)*

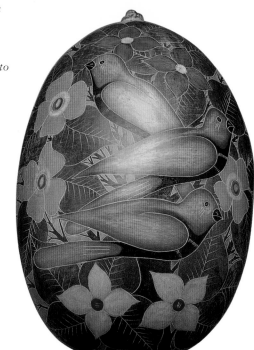

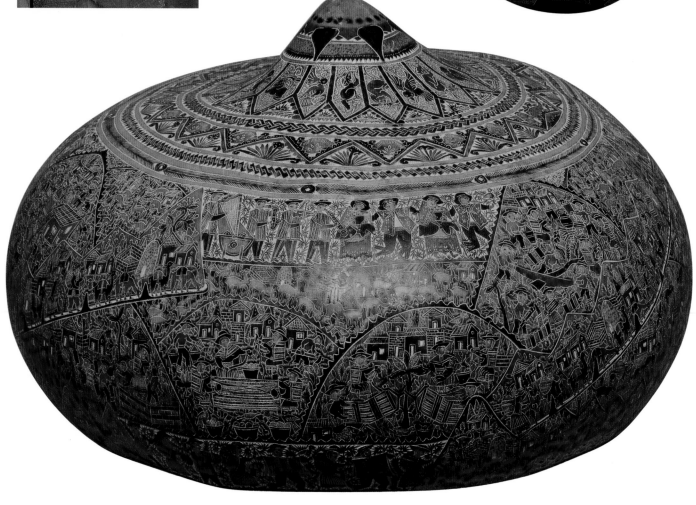

64 BELOW Máte *or dried gourd with a bombilla or metal straw, used for drinking máte,* a tea made from the leaves of the tree Ilex Paraguariensis, *in Uruguay, Argentina, Brazil and Paraguay. H of gourd* 4¼″ (11 cm)

65 RIGHT *Gourds decorated as women in traditional costume, from Cochas, Peru. H max.* 9¾″ (25 cm)

66 BELOW *Gourd decorated as a Gaucho from Uruguay, with leather poncho and hat. H* 9″ (23 cm)

67–9 *Dried gourds decorated as birds, from Cochas, Peru. H of left-hand gourd* 9″ (23 cm)

55

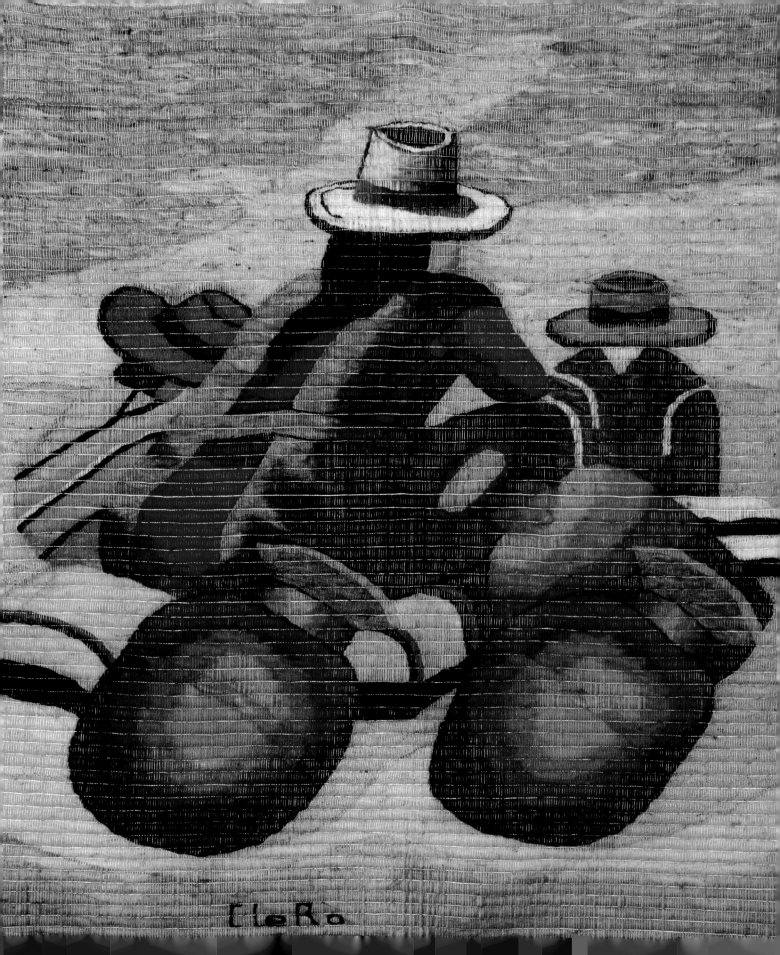

TEXTILES AND COSTUMES

THE WAYUU INDIANS of La Guajira in north-east Colombia have a saying, '*Ser mujer es saber tejer*' – 'To be a woman is to know how to weave.' Textiles have served many different functions for the Indians, and to understand the life of the region it is necessary to appreciate that they are not just a staple of the economy but have social and spiritual significance as well. Woven cloth was the most highly prized possession and sought after trading commodity in the Andes in pre-Columbian times, and it is not surprising to find that, despite the destruction of the indigenous social and economic order by the Conquest, many ancient weaving traditions have survived to the present day.

Prior to the period of Inca rule the Pacific coast of South America was the home of many cultures and traditions: the earliest evidence of garments was found on the coast in northern Chile, and dates from the Chinchorro culture (6000–2000 BC). During the ninth century BC cameloid fibres were introduced into the weaving of the southern coastal region of Peru, and the first cameloid-hair tapestry-weaves began to appear in an area where previously only human hair and plant fibres had been used. This innovation allowed the development of one of the most spectacular expressions of Andean culture, the textiles of Paracas (700 BC–AD 100). Paracas designs consist of intricate patterns of animalistic, supernatural and human forms embroidered on to dark backgrounds, producing an exquisite effect.

The valleys of Chancay in Peru, in the central coastal region, have yielded a great variety of sophisticated textiles. In the warmer lowland climate the Chancay culture (100 BC–AD 1200) cultivated cotton for white and beige-dyed patterned cloth, in preference to using cameloid fibres like the high-altitude Arica, Paracas and Nazca cultures.

The Incas who ruled the Andes for a century (AD 1430–1532) immediately before the coming of the Spaniards inherited three thousand years of weaving skills and traditions. They called their land *Tawantasuyo* (the Land of the Four Corners) and extended their power to Chile and Argentina in the south and as far as Colombia in the north, making Cuzco in Peru their capital. They captured the Aymara Indians, pre-Inca altiplano settlers from the Lake Titicaca basin, with Tihuanaco on Lake Titicaca as their centre, and forced them to work in their *mitas* or textile workshops. Today the ruins of some enormous *mitas* can still be seen at the temple of Raqchi to the south of Cuzco.

70 LEFT *Woollen wallhanging from San Pedro de Cajas, Peru. Naturally dyed unspun wool is introduced between the warp threads to give the effect of a painting. Woven by Claro. 47¼″ × 39¼″ (120 cm × 100 cm)*

Inca textiles are of high quality, varied in design, and very different from the coastal textiles, being warp-faced, closely woven and without embroidery. During Inca times large quantities of the finest textiles were woven specifically to be burned as ritual offerings – a tradition which survives to the present day. The Spanish *Conquistadores* were astonished by the vast stores of cloth they found in warehouses throughout the Inca kingdom, and set about exploiting this wealth and skill by using the *mitas* as their own workshops and exporting cloth to Europe. The upheaval in Andean life brought by the Spanish invasion was followed by the devastation of disease, and by the mid-eighteenth century the workforce of the *mitas* had dwindled to one third of its former size.

Costume and rituals

During the post-Conquest period native dress was modified to satisfy Spanish ideas of propriety. Spanish policy concerning dress, contained in the *Reopilacion de Leyes de Los Reynes de las Indias*, demanded that the Indian population should be fully and properly dressed at all hours, and that each individual must be dressed according to his or her class. Spanish dress was restricted to the upper-class Indian.

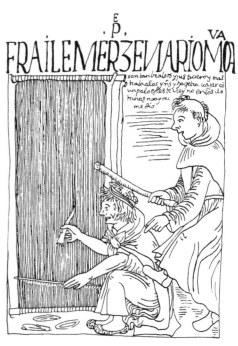

The last century of the Colonial period was disturbed by numerous Indian uprisings. The Spanish government believed that by restricting the Indians' clothing it could diminish their identification with their ancestors, and that thereby discontent would be reduced. The native male costume became pants, jacket, vest and poncho. Prior to the period of Inca rule, Aymara men of the Peruvian Andes had worn a tunic (*llahua*) and a mantle (*llacata*), and carried a bag for coca leaves (*huallquepo*), while their women wore a wrapped dress (*urku*), a mantle (*iscayo*) and a belt (*huaka*). Their coca-leaf bag was called an *istalla*, and several other woven cloths were used for foodstuffs. Probably in imitation of the clothes of the Aymara, the Inca men had tunics (*unkus*) and a bag for coca leaves called a *ch'uspa*. The women wore a blouse (*huguna*), skirts (*aksu*), and belts (*chumpis*), and carried their foodstuffs in large rectangular cloths (*llicllas*).

Textiles and costumes still play a vitally important role in Indian social, political and religious life. There are textiles specifically for ritual ceremonies, and some are held to have magical powers. One of the most extraordinary textile traditions found in the Andes today is that of the predominantly Aymara cultures of the various islands of Lake Titicaca, such as that of Taquile. On this very small island, some four by two kilometres and with a population of some fifteen hundred people, colourful costumes have survived the passage of time well, and pre-Columbian festivities are still celebrated. Each family possesses at least four different

TOP *Paracas woollen embroidery from Peru (700 BC–AD 100). The design is a personaje or supernatural being who figures prominently on cloths wrapping Paracas mummies.* ABOVE *Spanish overseer and an indigenous weaver, from a sixteenth-century Chronicle*

58

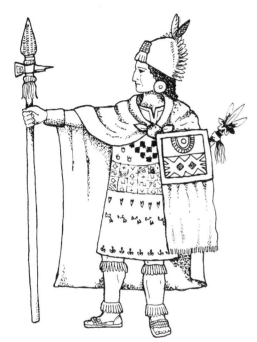

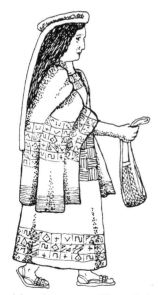

*Inca male and female costume. The male Inca, a ruler, wears a tunic (*unku*) and cloak (*manta or llaccolla); the woman has an* aksu *or skirt and a* lliclla *or cloak, and a* ch'uspa *or bag for carrying coca leaves*

types of costume: for work, leisure, weddings and festivals. For wedding ceremonies, which all take place on the same date, the third of May, when the planet Venus (*Hatun Chaska*) is visible, the bridegroom wears a red poncho provided by the best man. As a single man he wore a half red, half white cap, and now for the first time he wears the *pinta-chullo*, a long red cap that signifies his married status, and a wide red wedding belt or *chumpi*. His *ch'uspa* or coca-leaf bag is filled. The bride sits elegantly in her wide red hat (*montera*), her hands covered with a ritual cloth (*katana-oncoma*). A *quincha*, a small white cloth symbolizing purity, is hidden in her skirt. With her red wedding-blouse or *gonna* she wears a gathered skirt or *pollera* made of some twenty different layers of brightly coloured cloth. She too wears a belt (*faja*), and a black cloak known as a *chukoo* completes her costume.

In isolated Andean villages and communities women still wear the traditional *aksu*, a skirt of two pieces of cloth overlapping at the sides and held up by a belt. The women of Tarabuco and Potolo near Sucre in Bolivia, for example, commonly wear *aksus*, while Tarabuco men wear red and orange striped ponchos and hats similar to crash helmets, possibly inspired by the helmets of the Spanish army. Tarabuco women's hats are small white *monteras* decorated with sequins.

The women of the Sacred Valley of the Incas, near Cuzco in Peru, however, have long replaced their *aksus* with a layered, gathered *pollera* skirt. They wear the Spanish-introduced type of *montera*, a large round red hat, while the small round hats of their neighbouring communities, the Indians of Chachin and Choquecancha, are made in a variety of colours.

The men from Salasaca and the Saraguro Indians of Ecuador have wide felt hats and very thin black woollen ponchos, said to commemorate the death of the last Inca ruler, Atahualpa. The women too wear felt hats, and black *mantas* (shoulder-cloths) secured with a *tupu* (a silver pin). Their silver earrings are often shaped like flowers or birds. The men of Otavalo, Ecuador, on the other hand, wear very thick blue ponchos, with white trousers and cotton-and-hemp *alpargatas* (sandals). Their plaited hair and sombreros are a reminder of Spanish peasant costumes. The women's plain woollen two-piece skirts are similar to the *aksu*, and are worn with white blouses with colourful embroidery and long necklaces and bracelets of coral.

In southern Colombia, Guambiano Indian men wear a piece of cloth which reaches their knees like a kilt, with a small poncho and a hat. Women's *anacos* or layers of loose skirts of grey-black wool are decorated with horizontal coloured bands, and over their blouses they wrap dark-blue and grey woollen scarves with magenta-and-black decoration. In northern Colombia, the Arhuacos and Kogis of the Sierra Nevada de Santa Marta

weave thin ponchos of undyed wool-and-cotton mixture. Both sexes wear long white cotton overalls, and carry several handwoven *mochilas* or bags for their belongings.

The descendants of the pre-Columbian Kuna or Tule (meaning 'sons of god') are today crowded into the north-east of Colombia and the San Blas Islands. Little is known of their pre-Columbian textiles, although Fernandes de Oviedo y Valdes, an official in the party of Pedro Davila who came to Darién in 1514, described the Kuna women as 'very well clothed from the breasts down, in figured cotton *mola*', *mola* being the Kuna word for cloth. The traditional Kuna female dress consists of a cotton skirt and cotton blouse with a yoke and two panels known as a *mola*. In the early 1960s, tourists who began to visit the area bought the decorative panels separately rather than whole blouses, and the name *mola* became attached to these also.

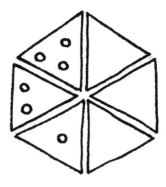

To make a *mola* numerous layers of coloured fabrics are first sewn on top of one another, then cut away to expose some of the fabric of each layer, according to the design. Traditionally *molas* were simple, with a few colours repeated, but then Kuna women started to record events, favourite birds, animals and motifs. Many of the designs relate to the old picture-writing. Sometimes *molas* are finished with fine embroidery stitches.

Though this particular type of appliqué work and embroidery is unique to the Kuna Indians, appliqué or patchwork is becoming increasingly widespread. For example in the village of Santa Rosa near Bogotá, Villa Salvador in Lima and Santiago in Chile, women apply simple patches to a background to make beautiful and bright contemporary designs. The Aymara Uru Indians who live on the islands of Lake Titicaca also make patchwork with pre-Columbian motifs dyed in bright colours sewn on to a cream or white *bayeta* or woollen-cloth background to create interesting wall-hangings and cushion covers.

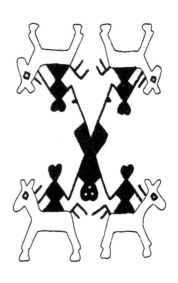

In each case the designs and motifs of the community reflect the vision of their culture and the nature of the place in which they live. So while the Uru Indians continue to use the pre-Columbian motifs of gods, birds and *totora* (reed) boats, the Kuna Indians represent their mythology and beliefs with the Tree of Life, the Mother Earth womb, representations of ceremonies connected with marriage, death, the coming to maturity of young girls (the puberty ceremony) and the witch doctor, as well as abstract designs and depictions of birds and animals.

Women of the nomad Wayuu tribe of the Guajira Peninsula wear simple *wayuusheein* or *manta guajira*, long, full cotton dresses, and the men are traditionally clothed in a *wayuwaite* (wide belt) and a *guayuco* (loin cloth) but are otherwise naked, although they are increasingly deserting their

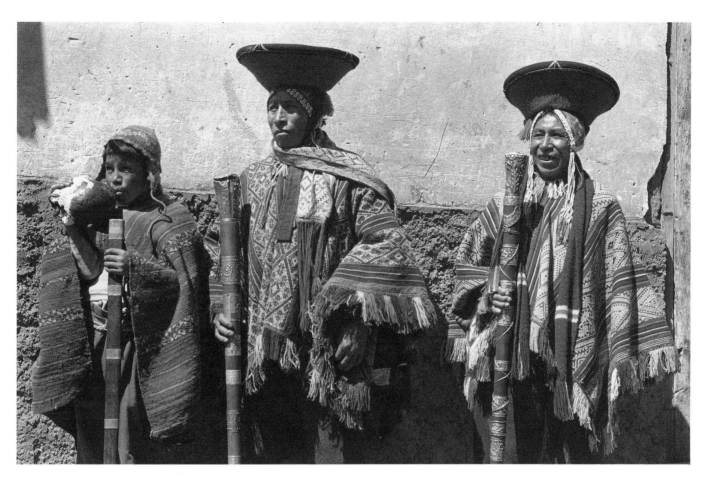

traditional costume for Western clothing. The women's leather-soled wool sandals have tassels which vary in size according to the social standing of the wearer. Donkeys and mules are adorned with the most exquisite and colourful woollen trappings, woven by the women on vertical looms.

The Atlantic coast of Venezuela, The Guianas, Brazil, Uruguay and Argentina yield little evidence of pre-Colombian textiles, while in the Amazon basin with its numerous indigenous tribes, clothing has played a small role, and was often made of short-lived vegetable fibres.

The history and tropical climate of Brazil have limited development of traditional costumes to areas in the north-east of the country, where African influences are strong, and ancestral African rituals and beliefs are still maintained. On the night of 31 December, for example, people head in groups for the shore to make offerings to Iemanjá, the water goddess. The women dress in Bahían costume, wearing long white dresses to signify the purity of the goddess of water, reflecting an African rite of worship of river deities. In the *Candomblé* ritual, women wear traditional long cotton skirts and white embroidered blouses, white headdresses and colourful bead necklaces.

An item of costume which plays a particularly important role in the lives of the indigenous population throughout the continent is the belt. The Mapuche Indians of Chile believe *Ngenchen* (god himself) sends them the knowledge of how to weave their traditional belts. The Guaraní of

Paraguay occupy much of their time with weaving long woollen belts for ceremonial wear, adorned with pre-Columbian symbols. Aymara settlers of Bolivia and the Lake Titicaca region similarly devote much of their lives to making belts for different occasions. Above all, the Incas of Peru developed a range of *chumpis* (belts) of ritual and spiritual significance which are still being used today, and these are responsible, probably more than any other article of clothing, for the preservation of ancient motifs. *Chumpis* are thought to have protective and purifying qualities, and are used as a medium of communication with the gods. To this day, some communities in the Cuzco area place *chumpis* on sacred mountain tops, or *Apus*, each *chumpi* carrying a particular ideogramic message. Traditionally, women give birth lying on a *chumpi*, and the baby is wrapped in a soft *chumpi*, known as a *walt'ana*, which ensures that he or she will grow properly.

From adolescence onwards, women wear a *chumpi* under the skirt, sometimes with an amulet attached to encourage a lover or deter an undesired suitor. *Huatana*, small narrow belts, are plaited into the hair to show married status. It is common for the bridegroom to lasso his bride with a *chumpi*; and on the wedding night the matrimonial godparents traditionally cross the bridal bed with two *chumpis*.

In pre-Columbian times the dead were buried with the family *chumpi*, and this ritual is still sometimes observed. In the village of Paccaritambo of the Cuzco province in Peru, we came upon an old woman weeping beside her husband's grave, holding the *chumpi* he had worn. On Taquile Island, Lake Titicaca, where we were the godparents in a ceremony in which the child's hair is cut for the first time, the hair was placed in a *chuspa* (bag) and fastened with the *chumpi* of babyhood. The godfather and godmother are given *chumpis* which are to be carefully preserved in accordance with their great spiritual value.

Textile materials

South America offers an enormous spectrum of vegetation and wildlife, and hence a wide variety of raw materials and techniques, used to make a great range of cloth, clothing, woven furnishings and decorative items. Fibre from trees, plants and shrubs, bird feathers, human hair and cotton were all used during the pre-Columbian period, and archaeological sites along the Pacific coast reveal the use of llama, alpaca and vicuña wool some three thousand years ago.

The Andean people principally use alpaca and llama wool. Because alpaca fibres are long and relatively scale-free, they can be spun into fine, shining yarn, and when woven have a lustre approaching that of silk. For making the most important textiles, the weaver used the finest wool, such as

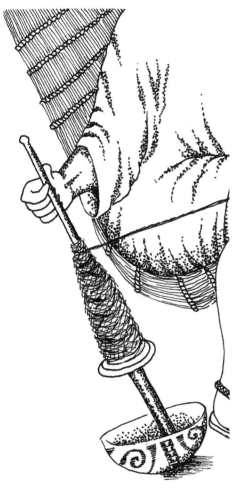

Wayuu Indian spinning wool while seated in a hammock. The spindle-end rotates freely in a half gourd placed in the sand

that from under the chin where the softest hairs grow. Vicuña was used sparingly as the animal was undomesticated and relatively scarce. After the arrival of the Spanish, sheep's wool became widely used, although it was less popular than alpaca.

Cotton has already been mentioned as cultivated and woven since pre-Columbian times in coastal areas although it was and still is little used in the Andes. We have seen that the Chancay culture (100 BC–AD 1200) in northern Peru used cotton for cloth stamped with designs of sea-birds and mystical figures. Sixteenth-century chroniclers describe printed cotton garments produced by the Chibcha people of Colombia.

Hemp or *pita* fibre is employed widely for rope, shoulder bags, rope-soled sandals, hammocks, and donkey and horse saddles. This native American plant which tolerates practically all climates is seen everywhere. The usual method of preparation is to pull apart the leaves to make long strips of fibre which are then stretched and twisted to give the essential yarn. In the Andes, the long leaves are placed on tarmac roads to be crushed by cars before being converted into fibre.

The important raw material in the Gaucho land of Argentina, Uruguay and Brazil is hide, which the Gauchos cut into strips of various widths and use to plait the most exquisite pieces of clothing, saddlery and stirrups.

Spinning and dyeing

The ancient settlers of South America twisted yarn by hand without the aid of any kind of spindle. Even today, the Indians of Salasaca in the high Andes of central Ecuador still use this simple method. The wool is wrapped around a thick stick held in one hand and is pulled and twisted with the other. Because tension is constant, the spun yarn has a fine, even surface.

When spinning with a spindle, a stick is weighted with a wooden wheel, and the raw material is fed through one hand (usually the left). A sudden twist and drop in the spindle spins the yarn. The thickness and twist of the yarn is controlled by the speed at which the spindle is fed, and spinning by drop spindle is a very sensitive art. The Indians of Peru and Bolivia often use the common drop spindle while they are herding their animals, walking slowly or standing in one place for a time. On the other hand the Wayuu Indians of the Guajira Peninsula of north-east Colombia, who watch their goats while lying in their hammocks, use a half gourd, feeding the wool to the top of the spindle with the left hand, while the right twists and rotates it in the gourd.

Spinning wheels, introduced by the Europeans, are increasingly used to meet the demand for modern textiles to furnish and decorate Western houses. In Ayacucho and San Pedro de Cajas in Peru, centres of the cottage

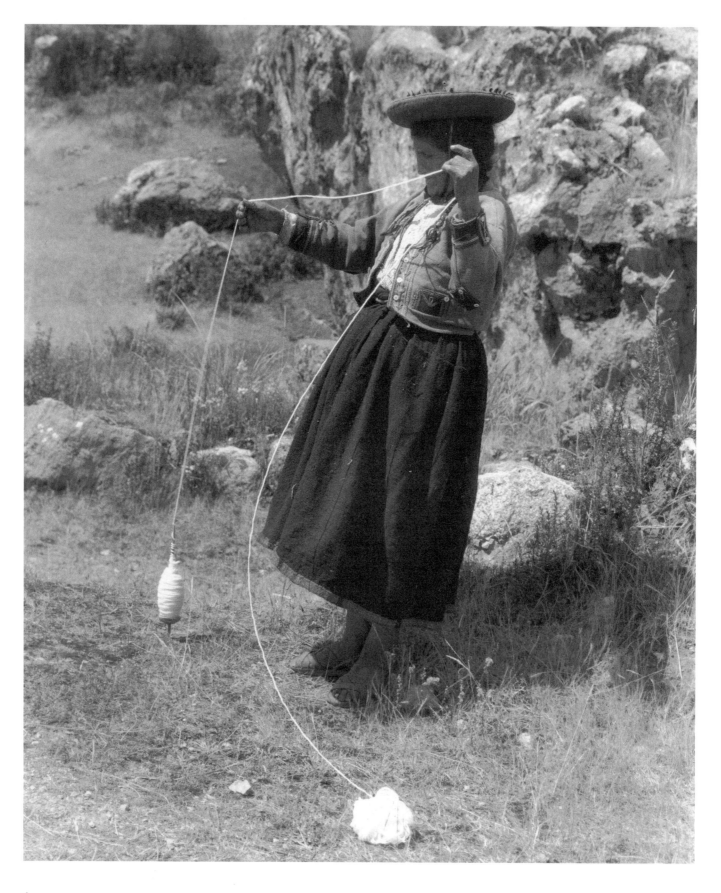

ABOVE *Cochineal (coccus cacti) insects living on a cactus leaf. The parasites were highly valued by the pre-Columbian weavers for the dyes they yield, ranging in colour from red through purple to black*

textile industry, the wheel is the most common form of spinning, as it is at Santa María de Catamarca in northern Argentina where a revival of rug and furnishing weaving has taken place. In Otavalo in Ecuador there is hardly a house which does not have a spinning wheel. It is usually women who spin, but there is no universal rule. On Taquile Island on Lake Titicaca, for example, men spin as well as knit the wool for their *chullos* (hats), and in Otavalo in Ecuador, both men and women are seen at the spinning wheel.

The earliest weavings discovered in the Atacama desert of the Pacific coast show the extensive range of colours known to the ancient Peruvians. In the Andean world, our knowledge begins with the time of the Aymara and Inca cultures. The Incas were able to produce colours in many shades, both bright and subdued, which neither bled nor faded.

Although the arrival of the Spanish altered much in weaving traditions, the skills of dyeing were still practised virtually unchanged. The colours of most nineteenth-century pieces found today remain brilliant and clear, a testimony to the exceptional abilities of the Andean dyers.

Nowadays the word *makhnu* refers to any natural dye, but originally it was the name for cochineal (coccus cacti), an insect which lives on the leaves of the *nopal* cactus. Cochineal dyes were used widely by the pre-Colombian weavers, from the Maya of Mexico to the Incas of Peru, and right through the Inca empire down to the Calchaqui valley in the north of Argentina. Today, however, the biggest centre of production in South America is in the valleys around Ayacucho, in the centre of the Peruvian high Andes. The colours obtained from cochineal range from red through purple to black. Although the high price of the insect for use in food colouring has discouraged its use for textiles, it is still widely combined with man-made analine dyes in the textile centres of Ayacucho and San Pedro de Cajas, in the high *sierra* of Peru, in the village of Villa Ribera near Cochabamba in Bolivia, and to a lesser extent around Lake Titicaca.

Vegetable dyes are made from the leaves, fruit and seeds of shrubs and flowers, and from lichen, tree-bark and roots. Traditional mordants are still employed to fix the colours: alum, human urine, salt, ash and lime juice. The choice of dyes and mordants depends partly on the availability of materials and partly on local tradition. Some mordants are also valued for their colouring properties: in San Pedro de Cajas human urine provides a soft yellow. Most plants will render some colours. Potatoes, corn, eucalyptus leaves, onion skin and holly berries are among the most common.

The Shipibo Indians of the Amazon basin of Pucallpa in Peru use mud from the banks of local rivers to dye their ceramics and textiles. Geometric lines are painted on white cotton fabrics woven on backstrap looms. When the mud dries and the fabric is washed, the design remains.

LEFT *Woman spinning in the fields while herding her animals, using the drop spindle, at Chinchero, near Cuzco, Peru*

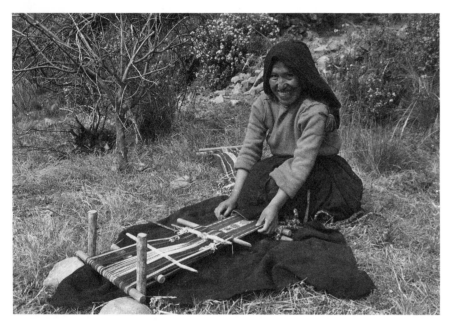

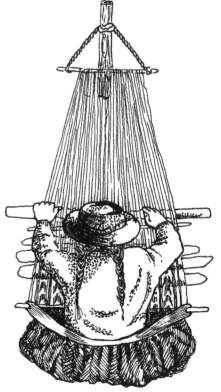

Señora Flores Huatta weaving a wide ceremonial belt on a horizontal loom, on Taquile Island, Lake Titicaca, Peru. BELOW *A pre-Columbian type of loom still in use today – the portable backstrap loom of the Andes*

Achiote seeds provide the red used by the Sibundoy Indians of southern Colombia. Dried and pounded, they colour textiles as well as the vegetable fibres used for hat- and basket-weaving.

The Mapuche of southern Chile use black earth (*aniltun*), yellow earth (*chodwekur*) and a yellow stone (*porkura*) to dye wool a soft yellow, while the people of Chiloe, an island off southern Chile, use a wide range of vegetable dyes to colour their rugs and sweaters, the most common being *nogal* (American walnut shell).

Today some communities are reviving the more traditional methods of dyeing, but more are turning from their heritage to weave with chemically dyed fibres.

Looms and weaving techniques

Pre-Columbian weavers produced a great variety of fabrics, from plain weaves to intricately varied textiles, including warp and weft yarns, double width cloth, open weaves, gauzes and tapestry weaves. Plain cloth was decorated with printed and painted patterns, or tie-dyed before weaving. After the Spanish invasion the weaving consisted chiefly of warp-faced textiles, for which two or more yarns of different colours are pulled forward and the remaining yarns fall behind, so creating a double-faced cloth with the colours reversed on each side. Most of the larger cloths consist of two uncut pieces joined along one edge. The smaller pieces, uncut, make bags,

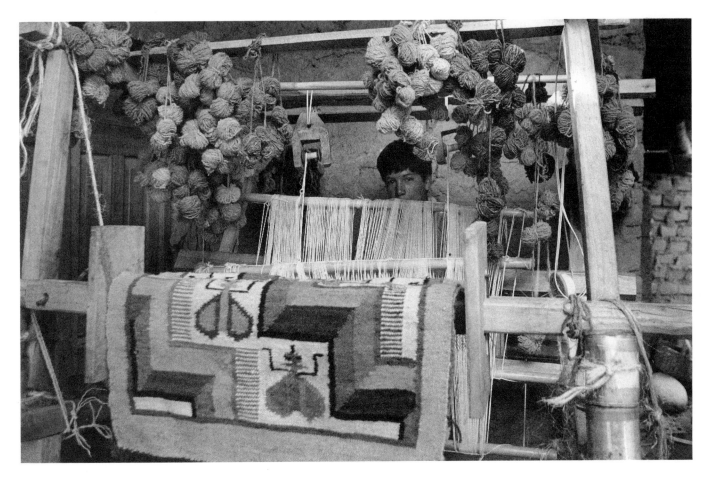

Weaving on the treadle or upright loom, Santa Ana, Ayacucho, Peru. Treadle looms were introduced by the Spanish and the weavers are usually men

belts and carrying cloths, usually woven with a detailed decorative border or ornamented with a fringe.

Pre-Columbian looms were often portable, and looms in use today are generally built on the same principle, though they vary in shape and size. A woman will herd her animals while making a piece of costume, often for herself or her immediate family. The backstrap loom, also known as the waist loom, cannot be used in the bare, treeless plateau of Bolivia or around Lake Titicaca, because although the weaver controls the tension on one side with her waist, the other side must be tied to an upright, such as a tree. The Aymara people of this region use four sticks set in the ground to hold the warp beams. Sometimes a weaver will own two looms, one a backstrap loom, tied to the side of her adobe hut, the other a loom for use while herding animals. For narrow belts the weaver may simply wrap the warp round her toe or knee.

The pre-Columbian methods of weaving are generally used for pieces intended as personal costume, while the treadle loom is used by men for more commercial pieces. Rugs, wallhangings, hammocks and other items of woven furnishing are made in several important centres, especially at Tintorero in Venezuela, La Guajira and San Jacinto in Colombia, Otavalo and Salasaca in Ecuador, Ayacucho and San Pedro de Cajas in Peru, Villa Ribera in Bolivia, Santa María de Catamarca in Argentina and Timbauba in the north of Brazil. In all these villages the treadle loom has replaced the

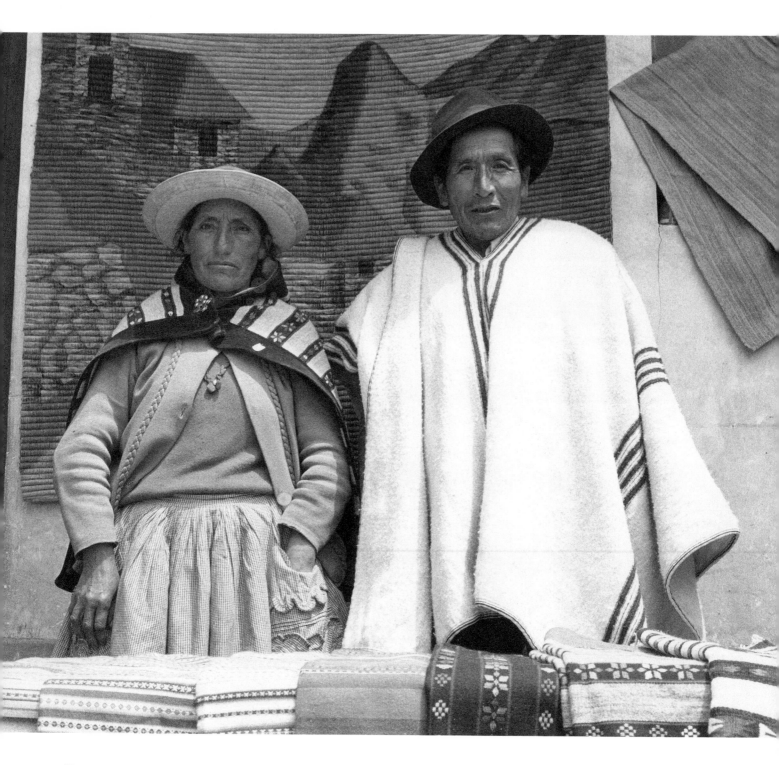

Señor and Señora Palomino, weavers of San Pedro de Cajas, Peru, an important weaving-community where the technique of 'wadding' is used to create wallhangings resembling paintings

Ayacucho wallhanging. Weavers thread yarn on a row of nails set 1 cm apart at top and bottom of a frame to make the warp for a simple open-weave picture

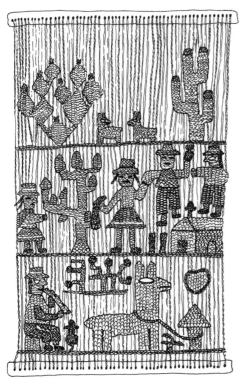

more traditional type of loom, providing greater efficiency and flexibility, and almost all their products, less intricately woven, are designed for sale in Europe or North America. Only the village of Villa Ribera in Bolivia, and among the Wayuu in Colombia, is another type of pre-Columbian loom used: the vertical loom, similar to the looms commonly used in the East for carpet weaving. The basic technique is like that of the treadle loom, but because the warp is separated from the weft by pulling the heddle rope by hand, the process is much slower. The advantages of the vertical loom are that the weaver can work either sitting or standing, and the width of the rug is not limited by the maximum reach of the arms.

In San Pedro de Cajas a new technique of weaving has emerged. This is known as 'wadding', and involves introducing naturally dyed unspun wool between the warp threads. The finished product appears more like a painting than a weaving, and the artist produces images of local scenery combined with abstract motifs. Quite contrary to the traditional practice, in which all the members of a community share a common language of symbols, here, like a contemporary artist, each weaver expresses his or her own individuality and creative talent.

Today, there is increasing pressure on indigenous people to desert their homes and join the white and *mestizo* people of the ever-growing cities. Even in Guatemala, Ecuador, Bolivia and Peru where they were formerly the dominant sector of the population, Indians in native costumes are often looked down upon and considered uncivilized. Unless positive action is taken during the next decade to reverse the trend, the traditionally woven textiles of the high Andes will become museum pieces rather than articles of daily use and wear.

In some areas foreign aid and the leadership of experts is proving effective. In Sucre in Bolivia, for example, a group of anthropologists has successfully brought about the revival of traditional village weaving. In and around the villages of Otavalo in the north of Ecuador, on the other hand, Indians are returning to semi-traditional treadle looms but also responding to increased demand by switching to electrically operated textile looms.

While the extremely cold climate of the Andes has led to the production of some of the most splendid textiles, the mild and tropical climate of the Amazon basin and Pacific, Caribbean and Atlantic coastal regions has also given rise to particular techniques and woven products. Hammocks, for example, are more widespread in South America than anywhere else on earth. The Wayuu nomad tribe of the Guajira Peninsula of north-east Colombia use their hammocks for sitting in as well as for sleeping. An important item of furniture, they are woven on vertical looms in exquisite designs and colours. In some villages and towns, such as Timbauba in the

north of Brazil and San Jacinto in Colombia, virtually every member of the community is engaged in making hammocks.

Knitting

The origins of knitting in Latin America are unknown. No evidence exists of knitted fabric in the pre-Columbian burial sites of Peruvian coastal settlements, and it seems likely the skill was introduced to South America by the *Conquistadores*. Even after the Conquest the costumes of Indians were mostly woven, rather than knitted.

In the Andes knitting has a relatively short history, though it has been used intensively in certain areas. The Taquile islanders of Lake Titicaca were knitting their conical hats during the latter part of the nineteenth century. Today on Taquile, only the men learn how to knit. By the age of ten a boy is able to knit his own round hat, known as a *chullo Santa María*, which is white-tipped to indicate single status. When a man marries or lives with a woman he adopts the traditionally patterned red-tipped *chullo*. This type of cap is exclusive to the islanders, but a more common type of *chullo*, with ear flaps, is worn elsewhere in Peru and also in Bolivia.

Member of a knitting cooperative outside Otavalo, Ecuador

Fibres commonly knitted are alpaca, llama and sheep's wool. Alpaca wool, which is the softest fibre, is restricted to the north of Argentina, large areas of Bolivia and in and around the Lake Titicaca basin in Peru, while much of northern Peru, Ecuador, Colombia and highland Venezuela use only sheep's wool. Sadly, during the last two decades much of the alpaca and llama wool produced has been bought by larger companies for export to Europe, America and Japan, and there has been a tendency to restrict breeding to white llamas and alpaca, excluding brown or black. Vicuña has become rare, although the Peruvian Government has been trying to breed the animal in several areas, one of which is Pampa Galera in the Central Peruvian Andes.

Today, much of the wool for knitting is bought ready-spun from factories, rather than hand spun, especially in Arequipa in southern Peru, La Paz in Bolivia, Cuenca in southern Ecuador, and Mira in north Ecuador. Cotton yarn is becoming popular for knitting in Chile, Peru and Colombia.

While the colours used in knitting are still most frequently the natural shades of white, grey, brown and black, during the last decade the knowledge of how to dye wool using natural and analine dyes has become more and more common at cottage industry level.

Outside the towns the majority of the knitting is still done by hand. Only a decade ago, Peruvian knitwear was knitted with old push-bike spokes for needles, but today metal and plastic needles are universal. Traditionally many of the *chullos* of Taquile Island are round-knitted with four small

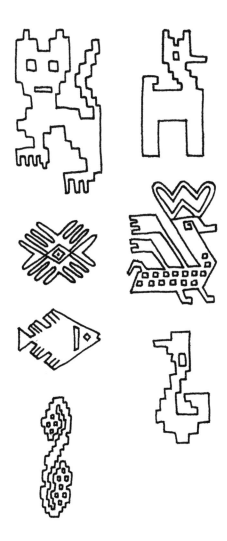

Pre-Columbian symbols woven into Andean textiles: the puma, god of the altiplano; *the llama, who accompanies the dead to the next world; the planet Venus, the Morning Star;* Taruka *the mountain deer deity; the fish symbol of the creator-deity* Wiracocha; Nunuma, *the duck symbol of Mother Earth; the twin-headed snake symbol of the deity* Amare

hooked needles. Hooked needles are also traditional in Bolivia and Peru.

In large cities such as Santiago in Chile and Lima in Peru, where knitting has become a major export industry, knitting machines have contributed towards the decline in hand knitting. In Otavalo, Ecuador, weaving sweaters on a treadle loom is becoming as popular as knitting them.

A revival of hand knitting and dyeing wool with vegetable dyes is not uncommon. Chiloe, an island off southern Chile, has become famous for hand-knitted, vegetable-dyed sweaters and brightly coloured knitted patch dolls.

In the Peruvian and Bolivian Andes the more traditional pieces still have patterns with llamas, mountains, and other scenic and geometric designs. Typically, black provides the background for brightly coloured patterns, creating a very rich effect, similar to that of the weaving in the area. Sweaters with appliqué patchwork dolls and three-dimensional scenes are becoming increasingly popular in the less rural areas.

In Uruguay, the work of Manos Del Uruguay, a company formed in 1968, has provided female weavers and knitters in scattered rural communities with an organizational framework and a market for their goods. Eight hundred women have formed eighteen cooperatives, in which quality control, teaching of techniques and research take place alongside the production of knitted and woven work for company shops in Uruguay. The company also exports approximately forty per cent of its products.

Symbolism

To study the patterns of textiles is to open a window on to another world – a world of owls, monkeys, dogs, cats, lions, horses, stars, dragons and strange, nameless figures floating upside down or acrobatically swinging against a pitch-black background. Where do these figures come from? Are they symbols inherited from pre-Columbian times, or conjured up by the vivid imagination of the individual weaver?

Traditionally every piece of textile of a particular community carried identical symbols and colours which were a source of pride and identity for the group. Each piece also carried its specific symbols, and each symbol told a story. In the Andean world, for example, the planet Venus (*Chaska*) played an important role in mythology and in the agricultural pattern. Its appearance was used to forecast the coming year's rainfall, vital for sowing and harvest time. This symbol and that of the sun (*Inti*) predominated in textile decoration, and were universal to *ayllus*, the self-sufficient and self-governing Inca communities.

On Taquile Island, Lake Titicaca, the islanders use the *Inti* and *Chaska* symbols as well as motifs such as fish and birds, unique to the islands, and

many strange characters. These symbols are woven into the important wide belt or *chumpi* described earlier. Another symbol appearing on the *chumpi* is the *suyos*, a circle divided into six segments, three shown dotted and three left plain. Traditionally the island has been owned by six *ayllus*, and each *ayllu* holds a piece of land in common. The dots symbolize crops, and their position changes according to the crops' rotation. Every year half the land is left uncultivated, hence half the circle is shown blank.

The Jalq'a people of Sucre, Bolivia, weave bizarre animal motifs on their *aksus* or overskirts. These symbols perhaps represent *chulpas*, creatures that inhabited the earth before the birth of the sun.

The pre-Columbian archaeological site of San Agustín in southern Colombia is rich with mystical symbols of the jaguar, and similar animal-figures dominate the motifs of the Chavín culture of northern Peru and are commonly depicted in the textiles of Paracas (from *c.* 700 BC). When the Otavalan Indians of northern Ecuador moved to their present town it is believed they brought with them their ancestral jaguar symbol from the Cara culture (AD 900), who traced their origin to the union of a jaguar and a woman. The cult of the jaguar is reflected in textile designs today.

Specimens of cotton and wool embroidery found in Paracas graves (700 BC–AD 100) often have as a central motif a puma, which some scholars associate with the cult of a 'trophy-head deity': a figure holding two severed heads. Today this and other pre-Columbian motifs are found on many herbal-dyed rugs and wallhangings of the Ayacucho region of Peru, and even as far north as Ecuador.

The Wayuu of La Guajira display totally different types of pre-Columbian symbols in their weavings. Each Wayuu is represented by a particular clan motif but some motifs are common to all, for instance *Januleky*, the double-headed fly, *Iwouya*, the bright star which announces the arrival of the rains, *Jalianaya*, the mystical 'mother of all motifs' and *Kalepsu*, the shape of natural hooks for hanging bags.

The arrival of the Spanish in the sixteenth century initiated a new era of symbolism, as old and new elements appeared side by side. Symbols such as *Inti* (the sun) may be found together with a horse-figure introduced after the Conquest. The execution of Tupac Amaru, the ruler who led the last Inca revolt against the Spanish, is commonly represented on cloaks in the Sacred Valley of the Incas, near Cuzco in Peru, by a figure being torn limb-from-limb by four horses.

Sometimes the meanings of motifs have multiplied or been superseded. The cross is an obvious example. In pre-Hispanic times a cross signified the constellation of *Cruz del Sur*, the Southern Cross, or *Cruz de la Siembra*, guardian of the fields. Both have been eclipsed by the Christian symbol.

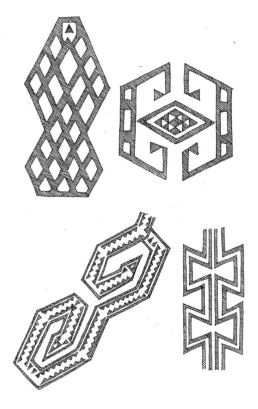

The Wayuu Indians excel in the art of weaving symbolic motifs on their vertical looms. Top: Iwouya, *the bright star;* Januleky, *the double-headed fly;* below: Kalepsu, *natural hooks;* Jalianaya, *the mystical source of all motifs*

71 *Detail of an aksu (overskirt) from the Jalq'a area north of Sucre, Bolivia. The strange animals in free fall may be* chulpas, *creatures that according to Andean mythology, lived before the dawn of time and before the sun rose over* Pachamama *(mother earth). The* aksu *(or* urku) *was the pre-Columbian Andean woman's dress, gradually converted into a smaller and more decorative garment. Textile woven on a vertical loom by Emiliana Nuñez of Karawiri community. L of warp 44¾" (114 cm), weft 28¼" (72 cm)*

72 BELOW *Guambiano Indians of La Campana, near Silvia, southern Colombia, who weave their own typical blue-and-fuchsia costumes. The design of the Indian costume is often ill-suited to modern means of transport such as the motorbike*

76 RIGHT *Wool squares woven with birds and human figures by the Salasaca Indians of Ecuador. The strange-looking creatures are thought to have orginated in the mythology of the pre-Columbian Cara Indians of northern Ecuador, who believed the first man was born of the union of a jaguar with a woman, and combined animal and human traits. Woven on pedal- or Spanish looms. $9\frac{3}{4}'' \times 9\frac{3}{4}''$ (25 × 25 cm)*

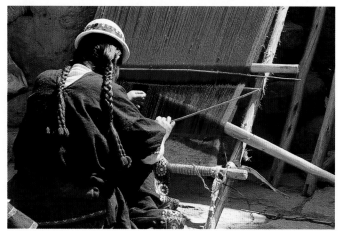

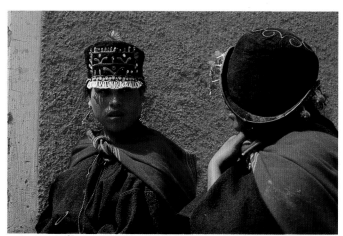

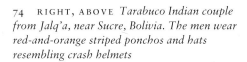

73 ABOVE *Saturnina Bonifac Villca of Potolo, near Sucre, Bolivia, demonstrating the pre-Columbian vertical loom which is used to weave* aksus *(overskirts)*

74 RIGHT, ABOVE *Tarabuco Indian couple from Jalq'a, near Sucre, Bolivia. The men wear red-and-orange striped ponchos and hats resembling crash helmets*

75 RIGHT *Young girls attending the Sunday Pisac market near Cuzco, Peru, wearing their best costumes, including* monteras *(hats)*

74

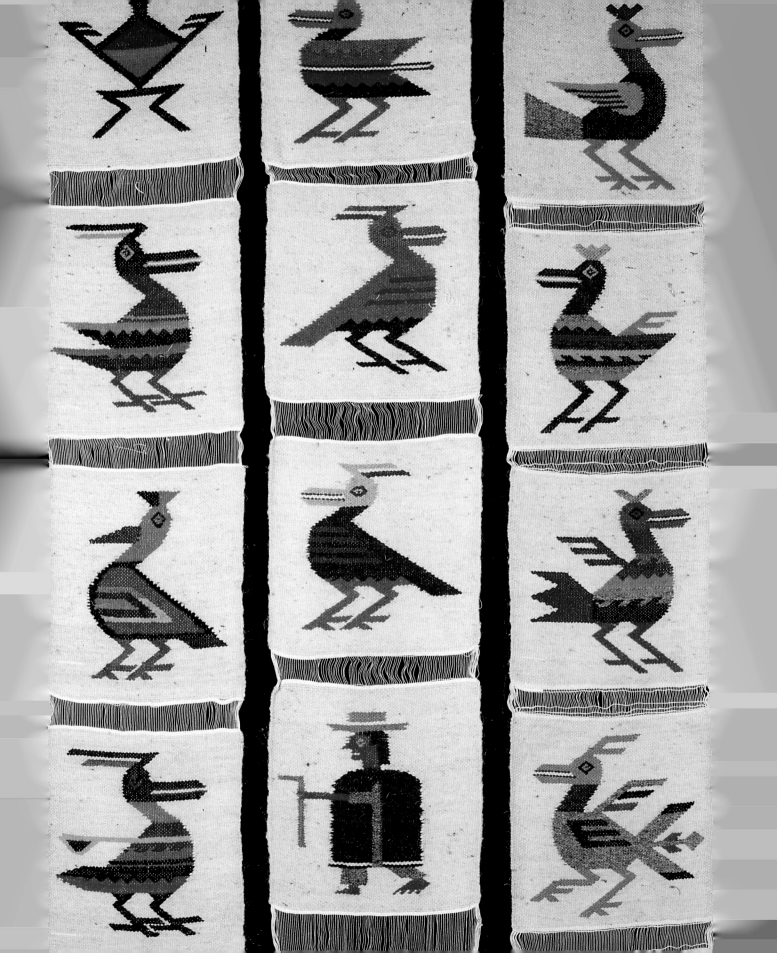

77 BELOW *Traditional weavings of Taquile Island, Lake Titicaca, Peru. Right: Wide ceremonial belt or* chumpi *with agricultural motifs. L 34⅝" (88 cm). Below: Matching* ch'uspa *or woven bag to hold coca leaves. Left: Narrow soft* chumpi *or* takapo, *wrapped around a child to help it to grow properly. L 63" (160 cm)*

78 CENTRE, BELOW *Half-finished* chumpi *of Taquile Island, woven on a horizontal loom held by four sticks driven into the ground. During the weaving the required colour of yarn is pulled forward and the remaining yarns fall to the back, creating a double-faced cloth with the colours reversed on each side*

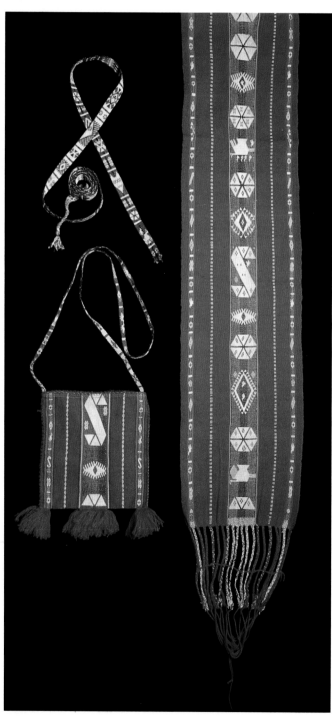

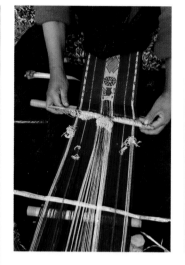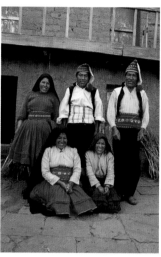

79 ABOVE RIGHT *The Flores Huatta family of Taquile Island, Lake Titicaca, Peru. The costumes of the islanders are very colourful, and each of the numerous articles of clothing has its own particular significance*

80 RIGHT Chumpis, ch'uspas *and an* unkuña *– Quechua names for ceremonial belts, coca bags and small ritual cloths. The belts (above and right) are thought to have protective and purifying qualities, and have been used as a means of communication with the gods. Top: pre-Columbian tapestry-weave belt (100 BC–AD 1200) from the coast of Peru, with bird motifs. Above and far right: belts of the Aymara and Quechua cultures of Peru and Bolivia. Centre below: natural-coloured belt woven by Toba Indians of northern Paraguay, which, unlike the rest of the belts shown, are worn by men exclusively, not by both sexes. L of belts min. 31¼ (80 cm), max. 98½ (250 cm). The* unkuña *(detail at left) is a warp-faced tapestry ritual cloth, used for coca leaves, from the Sacred Valley of the Incas, near Cuzco. 15¾" × 15¾" (40 × 40 cm). The coca bags are small, warp-faced cloths folded in half, made in Bolivia. The red bag is from the Lake Titicaca region, the blue bag from the Tarabuco community. L min. 6" (15 cm)*

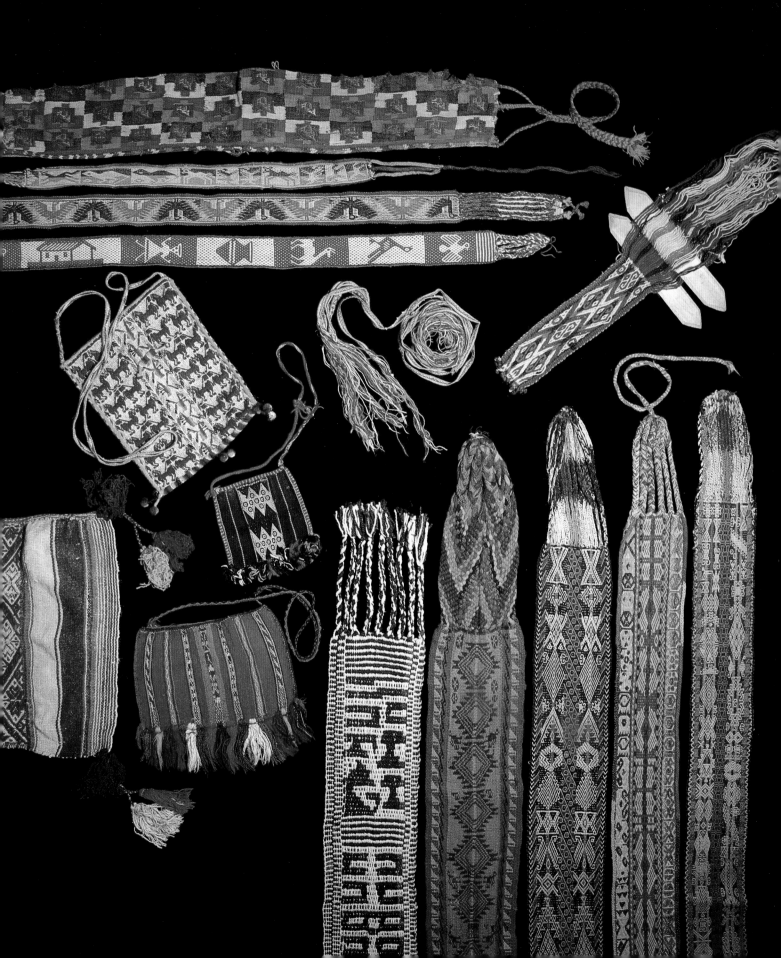

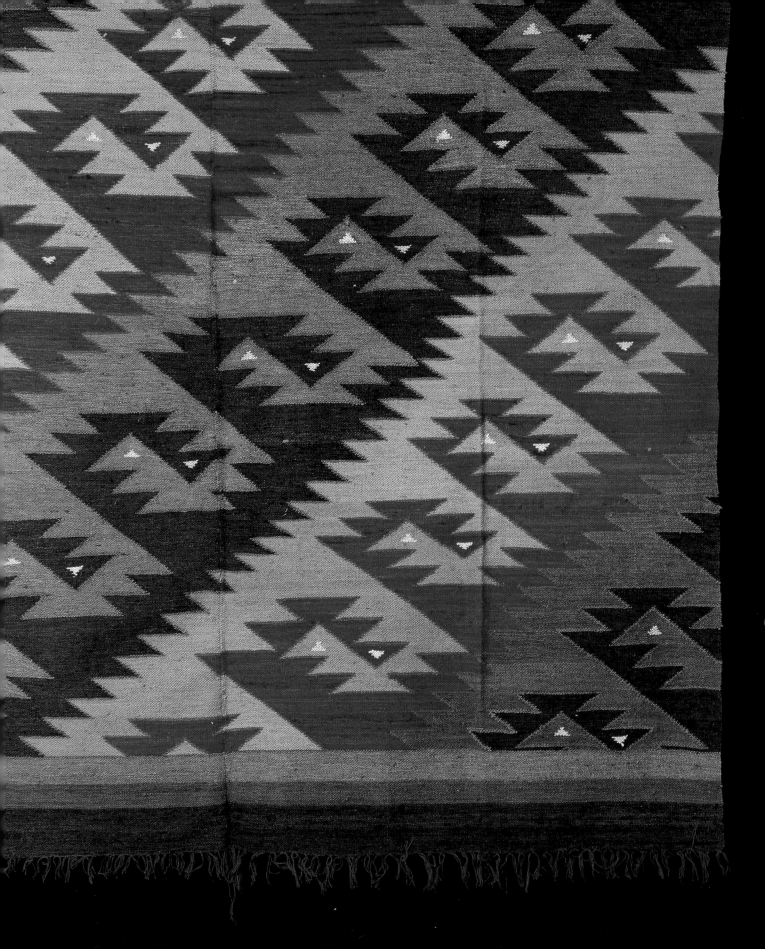

81 LEFT *Detail of naturally dyed rug from Ayacucho, Peru, traditionally the home of great weavers and potters. The last decade has seen the revival of natural dyes, especially the insect dye, cochineal. The rug is woven in two pieces. Whole 63″ × 47″ (160 × 120 cm)*

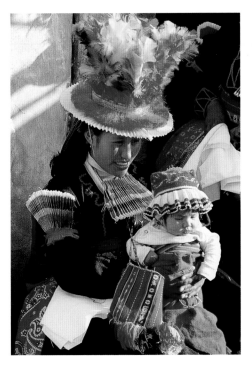

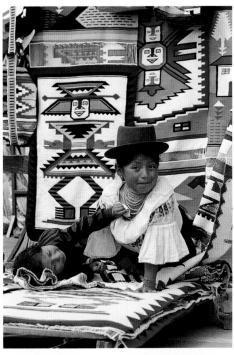

82 ABOVE *Woman and child in their dance costumes during Illapa Fiesta, the Festival of Thunder, on Taquile Island, Lake Titicaca, Peru*

83 ABOVE RIGHT *Otavalo Saturday market, Ecuador. This market sells handicrafts from all over Ecuador, as well as from other Latin American countries. The Otavalan Indians sell their own weavings and those of the Salasaca Indians*

84 RIGHT *Favio Guillém and his rug with a bird-design from Villa Ribera, near Cochabamba, Bolivia. Bright, artificially dyed sheep's wool is being woven on a vertical loom – a type seldom seen in South America*

85 FAR RIGHT *Wayuu woman weaver. The Wayuu nomad tribe of La Guajira of northern Colombia and Venezuela weave their hammocks on vertical looms. The exquisite designs are woven loosely into the warp*

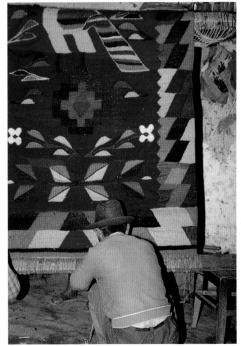

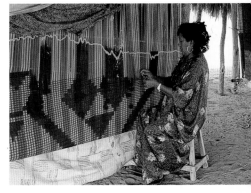

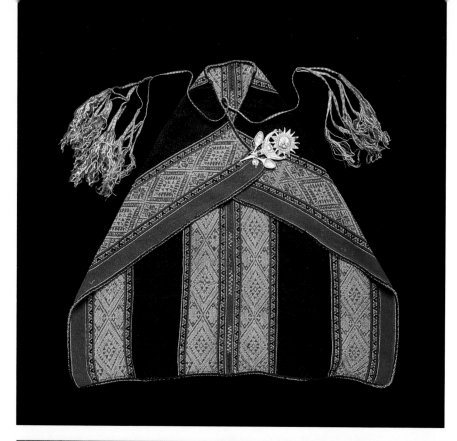

86 Lliclla or manta *(shoulder-cloth) held in place by a* tupu *or silver pin. The* lliclla *and* tupu *are pre-Hispanic in origin, and still widely worn among the indigenous communities of the Andes.* $31\frac{1}{2}'' \times 31\frac{1}{2}''$ *(80 × 80 cm)*

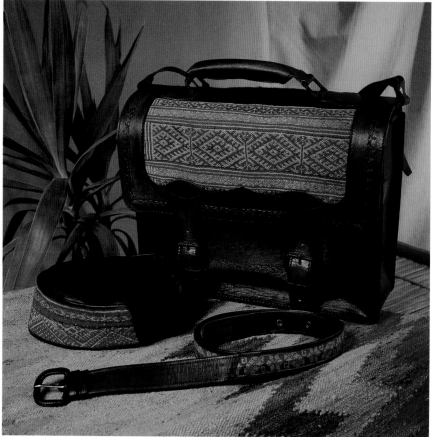

87 *Leather shoulder-bag with textile panels. During recent years the application of old textiles to leather objects has become a new popular craft in Bolivia. Bag made by Gonzalo Realuna, La Paz*

88 *San Pedro de Cajas wallhanging in the*
'wadding' technique, made by the well-known
weaver Julio Montes. $70\frac{3}{4}'' \times 47\frac{1}{2}''$ *(180 × 120 cm)*

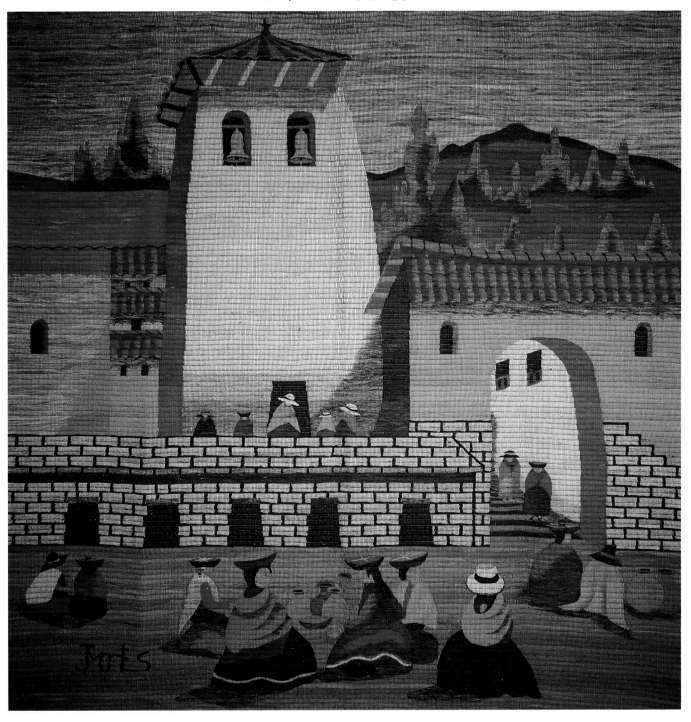

89 *Women's patchwork session in Villa Salvador, on the outskirts of Lima, Peru*

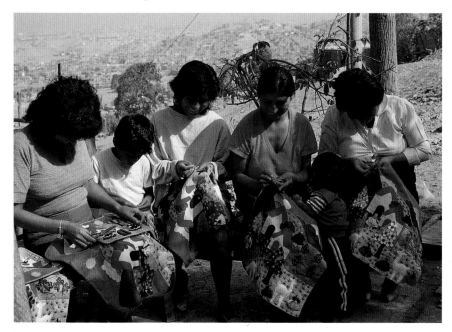

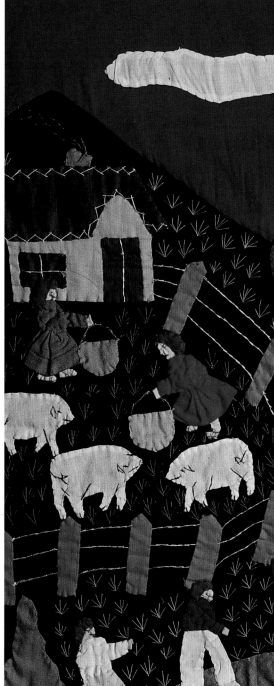

90 *Detail of a large patchwork from Santa Rosa, near Bogotá, Colombia. Designs may be either complex and sophisticated, or colourful and simple like this rural scene with a large butterfly. 47$\frac{1}{2}$″ × 39$\frac{1}{4}$″ (120 × 100 cm)*

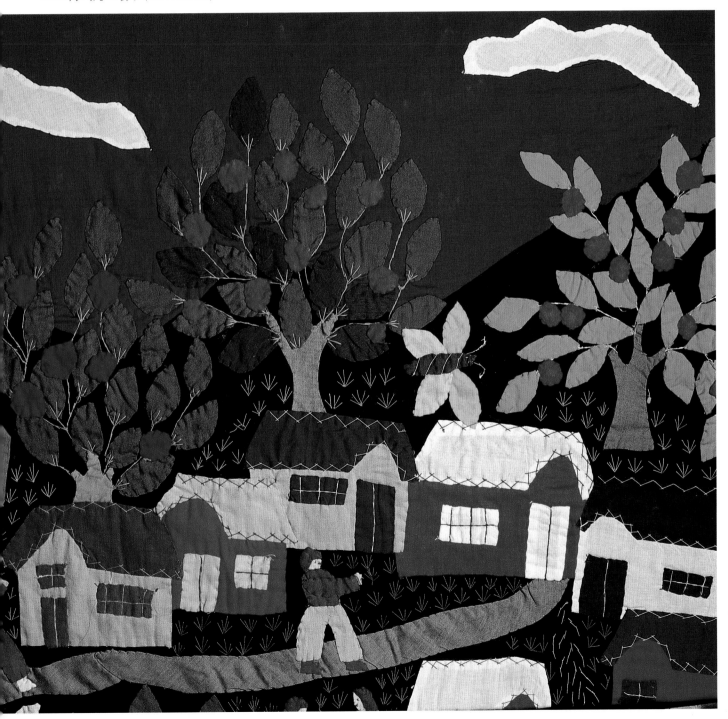

91 *Woven sweater from Otavalo, Ecuador. Contrary to the conventional method of producing sweaters, in Otavalo woven cloth is cut and sewn*

92 BELOW *Knitted and crochet woollen patch dolls from Chiloe Island, southern Chile*

93 BOTTOM *Knitters from a women's cooperative in the outskirts of Otavalo, Ecuador*

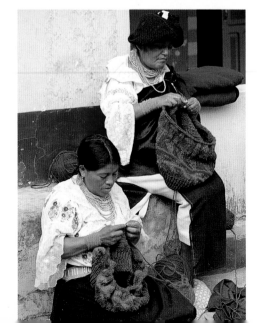

94 *Molas of the Kuna Indians of the San Blas Islands of Panama and northern Colombia. Traditionally* molas *formed the panels of Kuna cotton blouses, but today they are made as simple, colourful pieces for decoration. Layers of different coloured fabrics are sewn together and cut away to form the design. Approx.* $19\frac{5}{8}'' \times 15\frac{3}{4}''$ (50×40 *cm*)

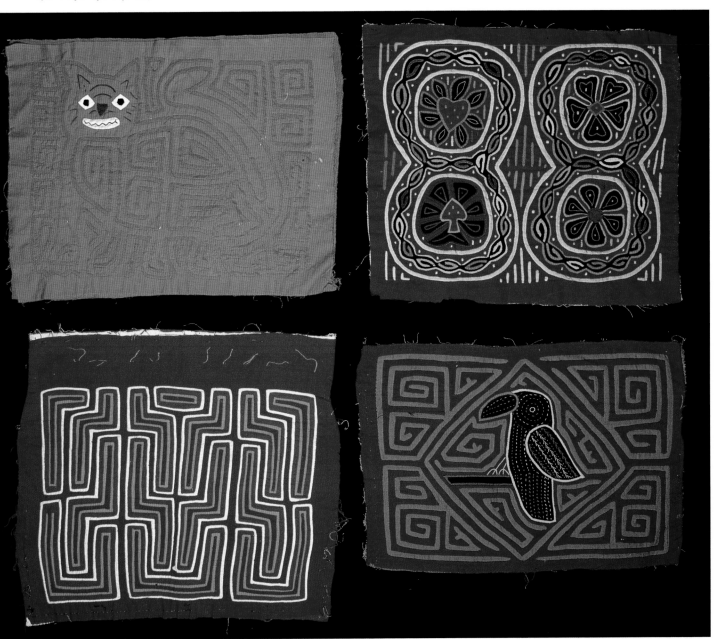

95 BELOW *Carded alpaca wool sweater with llama design from La Paz, Bolivia*

96 BELOW LEFT *Group of llamas being herded in the foothills of the Peruvian Andes*

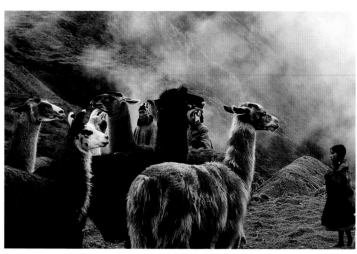

97 LEFT *Man from Calca wearing a chullo, a one-piece, round-knitted hat of traditional pattern. Sacred Valley of the Incas, Cuzco, Peru*

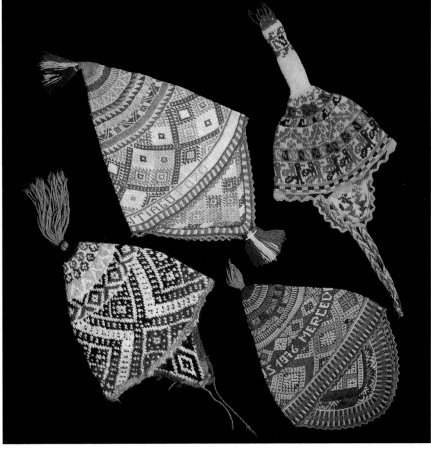

98 ABOVE Chullos *with earflaps. The natural-coloured* chullo *is knitted of alpaca wool, the others of sheep's wool. The shapes and patterns belong to four different communities in and around Cuzco. Each design is unique to a particular* ayllu – *a family or tribe*

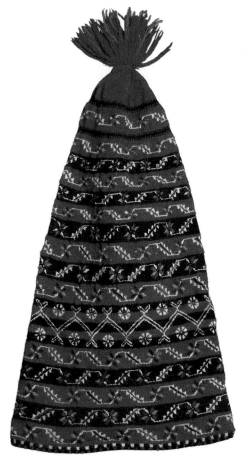

99 LEFT Chullo *knitted by Alejandro Flores Huatta on Taquile Island, Lake Titicaca, Peru. By tradition the men and boys of Taquile knit their own* chullos

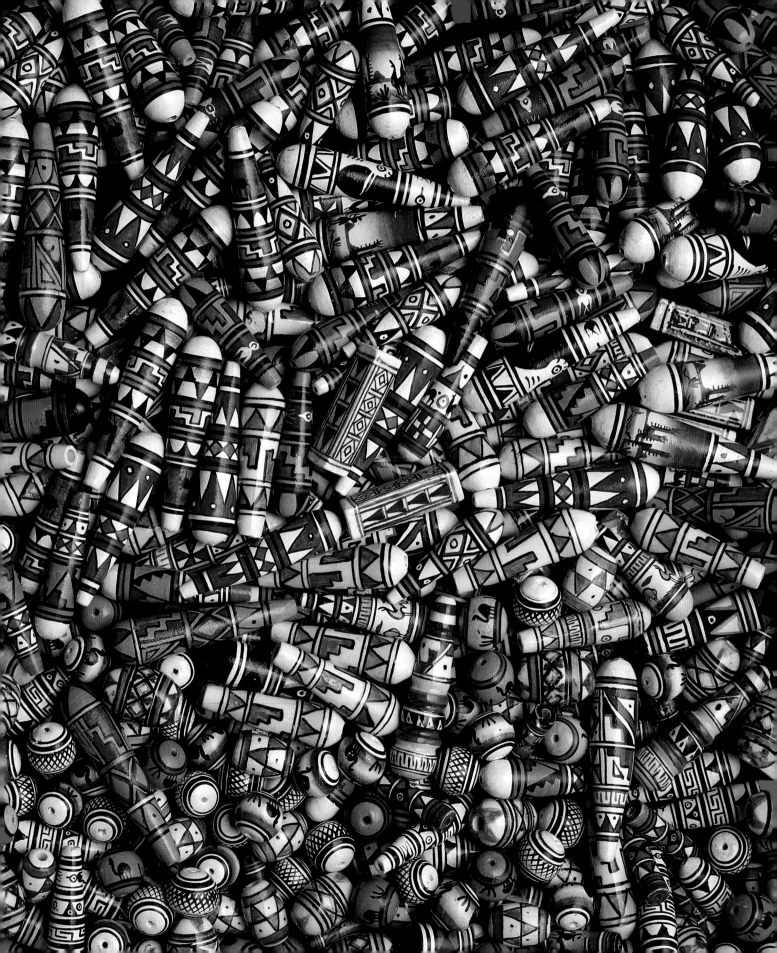

JEWELRY AND METALWORK

WHILE THE SPANISH INVADERS WERE DAZZLED by the Incas' use of gold, it was the pre-Inca cultures who mastered the art of working with metal. Some of the earliest goldwork discovered in Latin America originates from the Chavin culture of Peru (800 BC onwards), from where the art spread northwards to present-day Colombia and southwards into Argentina. One of the most striking pre-Hispanic pieces is a gold *tumi* knife found in Lambayeque on Peru's northern coast. *Tumi* knives with their tapering handles and semi-circular blades first appeared in Peru in the Moche culture (AD 200–750), when they were associated with human sacrifice. Five centuries later the Inca were using them for surgical operations such as trepanning the skull. Today they are a common motif in jewelry and the other decorative arts.

The discovery of the Sipán tomb in 1987 in the north of Peru, near Lambayeque, was a find of great interest and importance, for it had remained undiscovered by the *huaqueros* or tomb robbers, and contained many treasures in their original positions. It was the burial of an important nobleman or possibly a priest of the Moche culture. The dead man held a sacrificial knife in each hand. On his wrists he wore bracelets of gold, shell and turquoise, and on his feet copper sandals, while a sheet of gold cradled his head. All around him lay intricately worked pieces of jewelry: miniature human heads modelled in gold, strings of peanut-shaped gold and silver beads, feather ornaments, earrings of silver, gold and turquoise in the shape of duck, deer and human figures.

No less remarkable was the goldwork of the early cultures of Colombia. The Museo de Oro in the capital, Bogotá, displays the immense skills of these metalworkers, from the third century BC to the arrival of the Spanish. The Quimbaya culture (AD 200–1600), for example, produced 24 carat gold containers to holding the lime chewed with coca leaves, and gold helmets and pendants, as well as pieces in *tumbaga*, a gold-and-copper alloy. The Tolima culture of the Magdalena valley also made pure gold artefacts, and one Tolima figure, a stylized human form with outstretched arms and legs, is often incorporated in modern jewelry designs.

As in Peru, so in Colombia, early cultures panned for gold in the rivers of the foothills of the Andes, rich in gold deposits. Some also diverted rivers by building or digging out small canals in order to flush out the gold more systematically from their sandy banks, a technique later adopted by the

100 LEFT *'Inca beads' made in Pisac, near Cuzco, Peru. Although the Incas were highly talented potters and decorated their ware with detailed geometric motifs, they are not known to have made ceramic beads. The modern beads are fired in earth kilns and individually hand-painted*

Spanish. Some deep shaft mines have also been discovered in western Colombia, though goldmining was not commonly practised. Copper was mined, and the gold-copper alloy *tumbaga* was common throughout Colombia. Copper, being harder to mine than gold, was greatly valued by these early civilizations. Platinum, too, has been found mixed with grains of gold in the Pacific coastal region. It is important, however, to understand that these cultures held metals to be precious only when they had been fashioned into jewelry or objects for ritual use.

While metals made hatchets, fish hooks, needles, tweezers and many other tools, their primary use was for votive pieces of a spiritual and ritual significance. Many carefully worked figures were offered as sacrifices to the gods. The special receptacles for narcotic drugs and the *poporos*, containers for the lime used while chewing coca leaves, had ceremonial significance and were forged of gold.

A study of the Muisca culture of Colombia has shown that the metal-workers were divided into two distinct groups. One group was responsible for the making of body ornaments or jewelry, such as earplugs, nose-rings and bracelets, while the other, which lived apart from the rest of society, was dedicated exclusively to creating objects to be used for sacrifices to the gods. Both groups were highly respected; and indeed, to be a skilled goldsmith requires not only individual talent but also a long and studious apprenticeship supported economically by society.

The pre-Hispanic culture known as La Tolita in Ecuador (500 BC–AD 500) is thought to be unique in having utilized platinum. Their goldwork was impressive: pieces were often articulated; for instance human figures have moving limbs. A particularly striking object is a model of the sun with a human face, encircled by moving golden rays. Masks have separate ear- and nose-rings that are finely worked pieces in their own right.

Various techniques of metalworking were employed in pre-Columbian times, the simplest being to beat the metal into thin sheets and then emboss it with designs, sometimes using wooden patterns. Copper alloy becomes harder as it is hammered, and was therefore heated while it was beaten to keep it malleable. Many pieces were produced with the more refined technique of casting by the lost wax method. Figures were modelled in wax and then covered with clay. On firing, the wax melted and drained from a hole in the clay shell, which was then filled with molten metal. Breaking open the clay shell after cooling revealed the gold figure within. Hundreds of identical copies could be made in this way, and this was the practice of the Muisca and Tairona cultures of Colombia.

Pre-Hispanic metalsmiths learned to produce alloys of copper and gold by covering the pieces in a clay-and-salt mixture and heating them to very

ABOVE *One of the best-known of the gold figures found in Colombia, from the Tolima culture (after* AD 900*).* ABOVE RIGHT *Nose-ring of the Tairona culture (1000 BC–AD 1600), found in northern Colombia, and made of copper and gold alloy (tumbaga). Nose-rings were relatively common in pre-Columbian cultures, and denoted high social standing.* BELOW RIGHT *Gold figure known as the* Venus de Tacarigua *from the Valencia Lake region of Venezuela, dated around* AD 200

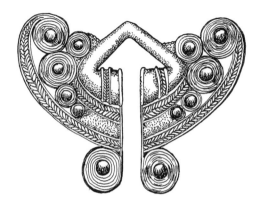

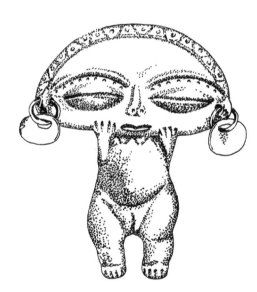

high temperatures. The smelting ovens of clay were limited in their ability to conserve the temperatures necessary for the process, but were fanned with ceramic blow-pipes, and in Peru the ovens were placed on mountain-tops to take advantage of the strong winds.

The rumour of a kingdom with streets and palaces made of pure gold, ruled by a king whose body was covered in gold-dust, must have spread like wildfire among the Spanish *Conquistadores* when they arrived in the New World in the sixteenth century. The origin of the myth of *El Dorado* ('the Gilded One') is not certain. Some believe it was a confused report of the Inca empire and its use of gold; others, that it arose from a Muisca ceremony performed upon the accession of a new ruler. In this ceremony, which took place on Lake Guatavita, north of Bogotá, Colombia, the future ruler was stripped naked, covered with clay and then with gold-dust. He boarded a raft, heaped with offerings of gold and precious stones, and accompanied by chieftains wearing gold jewelry, set out for the middle of the lake where the precious offerings were consigned to the waters.

Gold was associated with the sun by the Incas, as it had been by their predecessors. Early chronicles state that the Inca regarded gold as 'the sweat of the Sun', and silver as 'the tears of the Moon'.

Although they never discovered the fabled city of El Dorado, the Spanish were not slow to plunder the gold of the Inca empire. The *Conquistadores* could scarcely believe the evidence of their eyes when they saw the treasures surrounding the Inca ruler, Atahualpa, whom they ambushed and captured in Cajamarca in northern Peru in 1532.

Atahualpa took note of the Spanish passion for gold, and offered a roomful of gold in exchange for his freedom. He sent out orders for gold and silver to be brought to him from all the corners of his kingdom. Gradually it arrived in Cajamarca in the form of jewelry, goblets and many other treasures. It was not enough, and Atahualpa gave orders for the Sun Temple of Coricancha in Cuzco to be stripped of its gold. Atahualpa was never freed, although he had kept his side of the bargain. He was later executed by the Spanish, who continued to amass gold and silver objects, all tragically melted down. The resulting blocks of metal were distributed among the *Conquistadores*, with the Spanish King receiving the 'Royal Fifth'. Consequently there remain to us today precious few examples of Inca goldwork, and the artistry of a culture has been lost forever.

The Spanish next set about extracting the precious metals of the New World. The surviving Indians were forced to work in barbaric conditions in gold and silver mines. The death toll was horrifically high, and black slaves were sent to replace the dwindling Indian workforce. The silver mines of Potosí in Bolivia, at an altitude of 4,070 metres above sea level in a freezing

wasteland devoid of grass or wood, were particularly cruel and terrible.

As the New World society began to take shape artisans emerged as important agents in the mutual assimilation of indigenous and European styles and techniques. Metalworkers came from Spain and Italy in order to develop the industry. Gold and silver pieces were no longer made as votive offerings, or as objects to accompany the dead on their afterlife journey, but to furnish the altars of Catholic churches and the houses of the new élite.

Ironwork, introduced to the New World at the Conquest in the form of the weapons and armour of the Spanish, was also developed during the Colonial period. Besides weapons, iron made furniture, gates, bells, locks, hinges and countless other utilitarian items. Copper was used for cooking pots, stirrups, and other useful objects, as well as for decorative work.

The Spanish preferred silver to goldwork, and strongly influenced the evolution of silverwork during the Colonial period, although Moorish stylistic influence also entered with Spanish and other European tastes. A style known as Andean Baroque developed around Cuzco, Peru, embracing both indigenous and European elements. Silver bowls in the style, known as *cochas*, with engraved or embossed decoration, are still used in Andean ceremonies today.

Silverwork has become strongly associated with the Gauchos of Uruguay and parts of Argentina and Brazil. The Spanish took a long time to settle Uruguay, the smallest Hispanic country in South America, and in the early years of colonization the land was only inhabited by groups of nomadic Gauchos with their cattle. Uruguay had no pre-Hispanic metallurgy traditions, and European silversmiths settled to produce pieces for Catholic use. However religious fervour proved to be limited, and the artisans adapted their skills to provide household items and riding equipment. The tradition of the Gaucho developed into a powerful cultural identity, and today Gaucho silver and leatherwork form two of the strongest artistic and cultural elements of the country.

All the trappings of riding – stirrups, bits, rings, halters and spurs – as well as costume accessories such as engraved buttons and belts, and the long knives treasured by the Gauchos, were forged from the silver produced in abundance by the Potosí silver mines. As cattle-rearing developed into a prosperous industry, so the silverwork became more ornate, until entire reins were made of silver mesh. Stirrups became ornate and oversized, and gold decoration was added to silver pieces.

The name *máte* is applied both to a tea drunk originally by the native Guaraní and to the vessel from which it is drunk. The Jesuits who established missions cultivated plantations of the tree (*Ilex Paraguariensis*) whose leaves provided the infusion. Silver vessels imitating natural gourd-

ABOVE *Saraguro woman of Ecuador wearing a traditional silver* tupu *to fasten her* manta *across her shoulders.* RIGHT *Gold* tumi *knife from the Sicán culture of the Lambayeque valley of northern Peru. The head, heavily incrusted with turquoise, is thought to represent the legendary being* Naymlap, *founder of a kingdom in the twelfth century* AD. L *of knife* $16\frac{7}{8}''$ *(43 cm)*

shapes were made in Colonial periods for *máte*-drinking, and gourds themselves were sometimes inlaid with silver.

False filigree, as it is termed, was an art practised by some of the pre-Hispanic cultures. The effect of filigree was obtained with the use of tiny droplets or beads of gold. True filigree-work developed in the Colonial period, and today there are a number of centres of filigree-production in Latin America. Initially it was used as decorative detail, but gradually earned sufficient popularity to warrant the making of entire objects. Metal wire, sometimes no thicker than a strand of hair, is fashioned by twisting, plaiting and soldering into intricate designs. Besides delicate earrings, brooches and pendants, larger decorative figures of birds, animals and horsemen are sometimes made, demanding immense patience and many hours of work. Originally popular in Ayacucho, Peru, this tradition continues in the small community of San Jerónimo de Tunan, near Huancayo. Here silversmiths produce intricate filigree earrings, spoons, jewelry-boxes, and numerous imaginative miniature models. The town of Catacaos near Piura in the north of Peru also maintains its long tradition of filigree-work in both silver and gold, while the Colonial town of Mompós, on the Magdalena river in Colombia, is noted for fine gold filigree-work.

Part of Inca female everyday costume was a large silver pin with a decorative head, the *tupu*, worn at the neck of the cloak or *lliclla* to hold it in place. Today, it continues to be made and used by the majority of Quechua-speaking Indians in Peru and Bolivia, though its form has changed over the centuries. In Inca times the decorative head was usually disc- or fan-shaped – the shape is thought to be derived from the *tumi* knife. During Colonial times Western emblems superseded the Inca forms. When in the nineteenth century uprisings caused native costume to be strictly regulated by the authorities, the *tupu* developed an oval, spoon-shaped head, sometimes incised, and had decorative charms suspended on silver chains. *Tupus* remain part of the traditional dress of the Saraguro women of Ecuador.

Among indigenous groups who maintain elements of their traditional costume and jewelry are the Mapuche of southern Chile, who gained fame by their long stand against the Spanish during the sixteenth century. Indeed, they had maintained their territory against the Incas, who invaded a century before the Spanish, and who built an armed frontier by the Biobio river to protect themselves from their indigenous opponents. Gradually, however, the Mapuche territory shrank during the nineteenth century, as European immigrants settled in the south, and today there are estimated to be a mere twenty thousand Mapuche living around Temuco.

It was with the circulation of silver coins in the eighteenth century that Mapuche metalwork gained momentum. The silver was hammered or

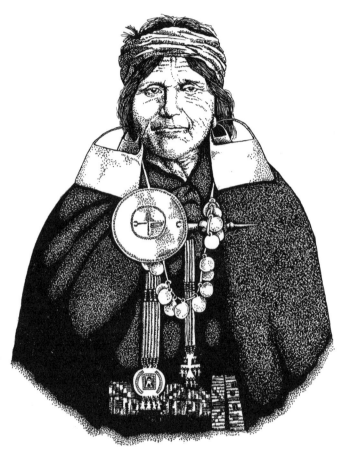

Traditional silver jewelry worn by a Mapuche woman of southern Chile, denoting her high social rank. Behind her large earrings, or chawai, *she wears a smaller pair. A* tupu *with a large incised head fastens her* manta, *and she has two types of brooch, each made from silver tubing, one ending with an incised disc, the other, known as a* trapelakucha, *with a decorated cross. Around her neck she wears a* kikai *or string of silver discs on a cord*

melted down to make the necklaces and other jewelry worn by important Mapuche women, who often kept their own metalsmiths to make articles exclusively for them. The majority of pieces date from the nineteenth century, when the Mapuche remained a powerful and relatively prosperous group. Photographs show Mapuche women wearing very large earrings, sometimes touching their shoulders. Today production of the large, distinctive pieces of jewelry is limited, although there are Mapuche jewellers who continue to make the traditional designs. Earrings are the most common form, made in various simple shapes – oval, oblong, trapezoidal, often with no decoration. They are secured on the ear by pinching them on the earlobe. Other traditional pieces included various brooches, decorated silver chains worn to connect two plaits of hair, and *tupus*.

The jewelry of the Wayuu woman of northern Colombia and Venezuela has a significance far greater than that of mere bodily adornment, for it is the first part of the payment agreed between her parents and those of her future

husband when she decides to marry. Although much of the jewelry is not made by the Wayuu, they do make long strings of beads from coconut shells, so carefully cut out that the half-shell with holes can be used as a colander afterwards. The beads are rubbed with vegetable oil to darken them and polished with sand before stringing. Sometimes they are covered with gold.

Seeds, flowers and feathers continue to be used as adornment by many of the Amazon and other jungle Indians. Pre-Hispanic cultures also favoured particular natural materials which were fashioned into jewelry. The sea shell *spondylus*, for example, was highly revered by ancient Peruvian peoples such as the Chavín and Moche cultures. The shell was found only along part of the Ecuadorian coast, and so must have been acquired by trade. It has also been found in Central America and Chile.

The Western fashion for natural or ethnic jewelry has encouraged production in centres such as Lima in Peru. Large, often brash earrings were created with combinations of brightly coloured feathers, cow-horn, fish-bone, seeds, even sometimes animal teeth. All these elements were brought together using alpaca wire (an alloy containing a small percentage of silver). More ambitious pieces were produced by talented jewellers, using silver wire. Natural materials used to produce jewelry include bread dough as at Calderón, a village on the outskirts of Quito, Ecuador, where women form hundreds of pairs of tiny, brightly dyed earrings and badges using their own secret recipe. Anything from corn on the cob to pairs of laughing clowns is adapted by these ingenious craftswomen.

In Rari, Chile, the women use horsehair to weave bangles and extremely delicate butterfly-brooches. In Cuzco, Peru, craftsmen make a great variety of fun and innovative jewelry: miniature musical instruments or brooches, or tiny figures of men and women in traditional costume as earrings. In Cochas, near Huancayo, Peru, gourd-carvers make necklaces and earrings which they decorate with imaginative designs.

The rich imagery of the Moche culture continues to attract today's artisans, who make replicas of Moche pots and copies of their ancient masks. Masks were frequently produced by pre-Hispanic metalworkers, not only in Peru, but also Colombia and Ecuador. They were often placed in tombs, some covering the faces of the dead. The copper replicas made today in workshops in Lima are treated with an acid solution to turn areas of the metal green, forming a strong contrast with the natural metal-colour. Replicas of *tumi* knives, sometimes with turquoise inlay, commemorate the original Lambayeque *tumi* knife.

Necklaces of onyx, quartz, turquoise, jade and many other precious and semi-precious stones have been found in pre-Hispanic tombs, and it would seem were a part of everyday dress in the various cultures. Intricate and

finely worked figurines were carved as decorative detail on larger pieces such as ritual headdresses. Today the jewellers of Santiago de Chile work with lapis lazuli which is mined from the Chilean Ovalle Cordillera, setting it into silver to make delicate drop-earrings and necklaces. The emeralds of Colombia are famous throughout the world, and are often set in gold. Brazil, however offers the greatest variety of stones, from mines concentrated in the south of the country, in the states of Santa Catarina, Rio Grande Do Sul and Minas Gerais. Stones from Brazil are exported to other Latin American countries, such as Peru, where they are used to make earrings. Polished, semi-precious Brazilian stones and Peruvian stones such as quartz, obsidian, onyx and turquoise are set in twisted and shaped alpaca wire in many workshops in Cuzco, Peru. This style of jewelry has grown popular in the West during the last couple of decades.

Chile has been the world's largest producer of copper since 1982. Artisans work copper into mobiles, small boxes with enamelled lids, and earrings, sometimes inlaid with tiny cabuchons of lapis lazuli.

Stones and shell beads from pre-Hispanic tombs sometimes appear in modern jewelry, but in Cuzco, the ceramic beads commonly referred to as 'Inca clay beads' have a surprisingly short history. Relatively large beads made in Cuzco in the 1970s were used for leather thonging and also strung as necklaces. However, it was not until potters experimented with smaller beads decorated with the same Inca-derived motifs that they met with the success they enjoy today. The cylindrical beads were rolled individually in the palm of the hand, a very time-consuming means of production, until recently a machine similar to a manual mincing-machine was adapted to produce the beads in quantity. They are then hand-painted, and glazed.

Today clay beads are produced with simple machinery by countless, often family-run workshops in Cuzco and nearby Pisac in the Sacred Valley of the Incas. Some are made into earrings, necklaces and bracelets, but many thousands are sold loose to allow people to create their own designs and combinations.

Many modern jewellers continue to be inspired by the designs of their pre-Hispanic predecessors – the famous Nazca lines, for example, intriguing images including a hummingbird, spider and monkey, which have somehow been etched into the surface of the desert, but on so vast a scale that they are only decipherable from the window of an aeroplane. How these lines were made, and for what purpose, remains a mystery. Maria Reiche, the archaeologist who has dedicated her life to their study and who connects them with the constellations, reminds us that 'the future is deeply rooted in the past, and the present is the conduit for this linkage'. The comment is apt for today's artisans, heirs to so many rich traditions.

102 RIGHT Tupu *or silver pin worn at the neck to hold the woven* manta *in place. The Inca* tupu *continues to be used by Quechua Indians in Peru, Bolivia and Ecuador.* L (excluding chain) 6¾" (17 cm)

101 RIGHT *Silver Mapuche jewellery from Temuco, southern Chile. The style of brooch (above centre) was adopted by Mapuche jewellers at the end of the last century and gradually replaced the Inca* tupu *as a fastening for the* manta *or shoulder-cloth. L 9" (23 cm). The* trarilonco *(beneath) was an ornament worn across the forehead, originally made of natural fibre with feathers and flowers. Silver coins were used as decoration in the eighteenth century and finally evolved into the silver discs seen here. L 14⅛" (36 cm). The earrings or* chawai *(above left and right) are made in various simple forms. L 2½" (6.5 cm)*

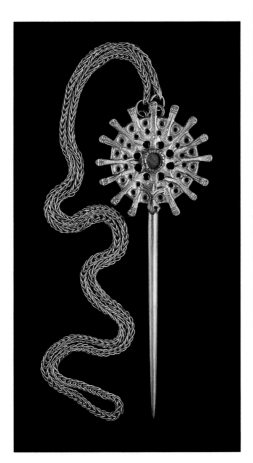

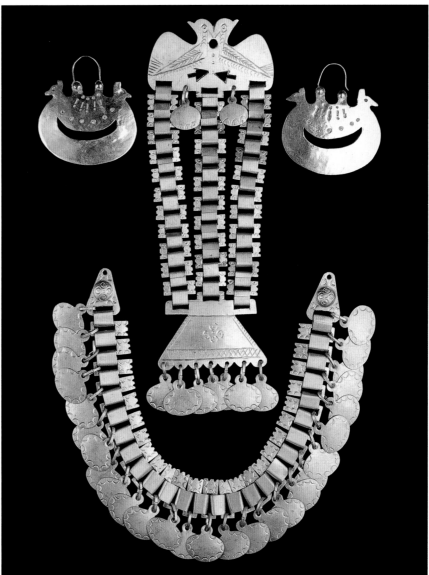

103 BELOW *Ceramic hand-painted bead bracelets, necklaces and leather thonging from Cuzco, Peru, with a pair of ceramic tumi-head earrings. W of tumi heads 1¾" (4.5 cm)*

104 BELOW *Necklaces of terracotta beads made in Pisac, Peru. L 18⅛" (46 cm)*

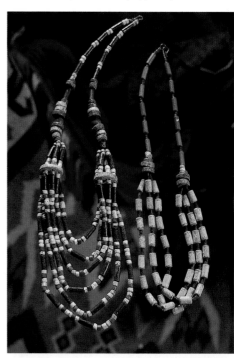

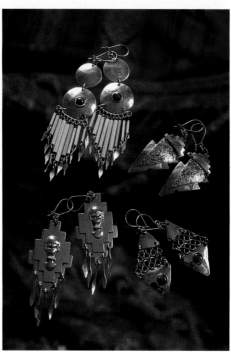

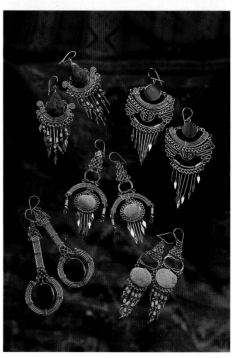

106 RIGHT *Earrings of alpaca (silver alloy) and brass with small lapis lazuli stones and bamboo decoration, from workshops in Santiago, Chile*

105, 108 FAR LEFT AND BELOW *Earrings and necklace made from a combination of natural materials collected from forests, seashores and rivers in Peru. They include bamboo, cowhorn, coconut shell, seed-pods and feathers, together with alpaca (silver alloy) and semi-precious stones. This style of ethnic jewellery is made in workshops in Lima, Peru. L of feather earrings 2$\frac{7}{8}$" (7.5 cm)*

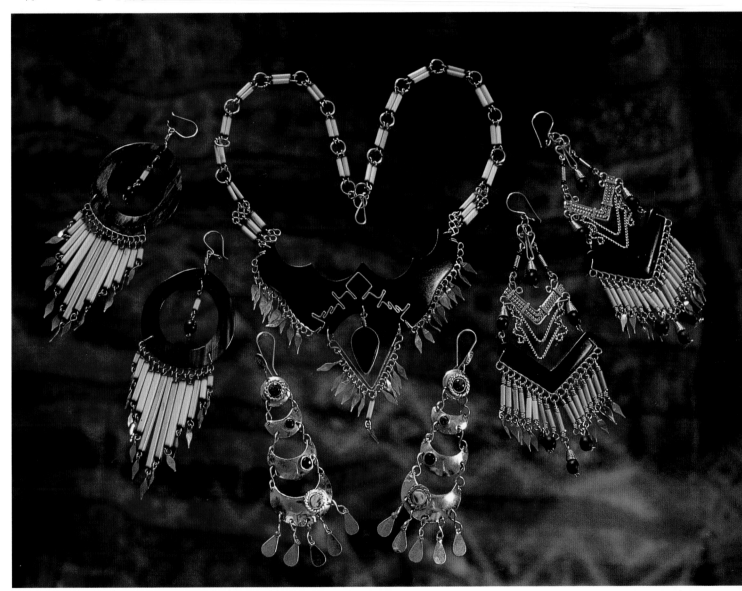

107 LEFT *Earrings of alpaca wire, twisted, plaited and bent into intricate designs, with semi-precious stones including malachite, agate and rose quartz, from Cuzco, Peru. L of centre earrings 3$\frac{1}{4}$" (8.5 cm)*

109 BELOW *Necklace with natural materials: monkey's teeth, beads of shell, coral and semi-precious stones, set in sterling silver, made in Lima, Peru. L 18¼" (46 cm)*

110 BELOW *Turquoise-inset silver filigree earrings made in Catacaos, near Piura, northern Peru. L 1⅞" (5 cm)*

111 BOTTOM *Silver necklace and earrings set with lapis lazuli, from Santiago, Chile. L of earrings 1¾" (4.5 cm)*

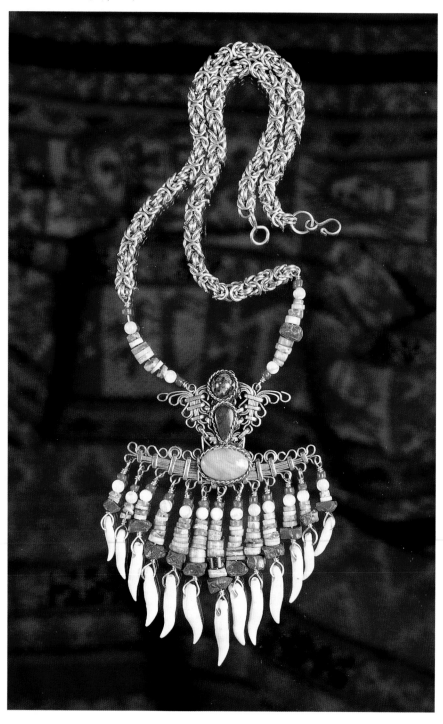

112 BELOW *Pre-Columbian necklace composed of handcarved malachite, amythyst, turquoise and sodalite beads, highlighted with gold cylindrical beads, probably of the Huari culture of central Peru (AD 500–900). L 22¾" (58 cm)*

113 BELOW *The Sipán tomb of northern Peru (Moche culture AD 200–750). The tomb is in situ, although the original treasures of highly worked gold, silver, copper and precious stones are preserved in nearby Lambayeque, and have been replaced by replicas*

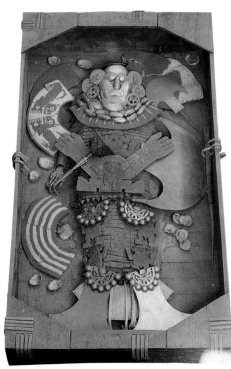

114 *Gold-plated reproduction (scale 1:1.2) of one of the gold and turquoise earrings found in the Sipán tomb (above). It is believed to represent the dead man with a warrior at either side. W 2⅞" (7.5 cm)*

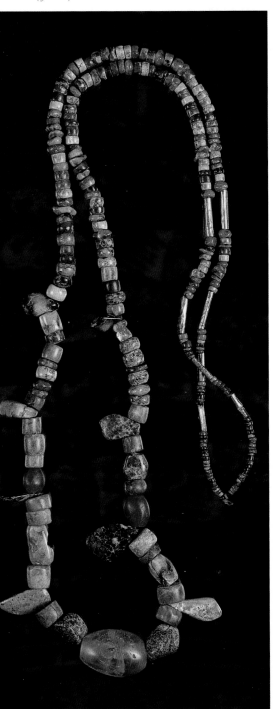

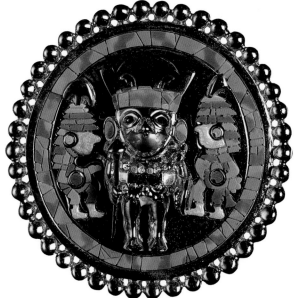

121 RIGHT *Necklaces and beads of quartz, tiger's eye, agate and sodalite, and a large amythyst crystal from the mines of Minas Gerais*

115 LEFT *Silver earrings based on an ancient Peruvian motif and inset with semi-precious stones, made in Cuzco, Peru. L 4¾" (12 cm)*

116 BELOW LEFT *Horsehair bracelets and butterfly brooches, woven by Gabriela Parada in Rari, Chile. W of brooch (max.) 1⅞" (5 cm)*

117 BELOW *Miniature drum, panpipes and* quena *(Andean flute) made as badges, from Cuzco, Peru. L of panpipes 1¾" (4.5 cm)*

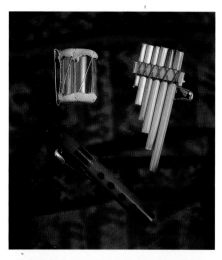

120 ABOVE *Carved gourd combined with bamboo and alpaca wire for a necklace and earrings made in Cochas, near Huancayo, the centre of gourd-carving in Peru. L of earring 2¾" (7 cm)*

118 FAR LEFT *Figuras de masapan – dyed bread dough figures designed as earrings, from Calderón, near Quito, Ecuador. H 1¼" (3 cm)*

119 LEFT *Silver earrings representing the monkey motif of the ancient Nazca lines of southern Peru. L 1⅞" (5 cm)*

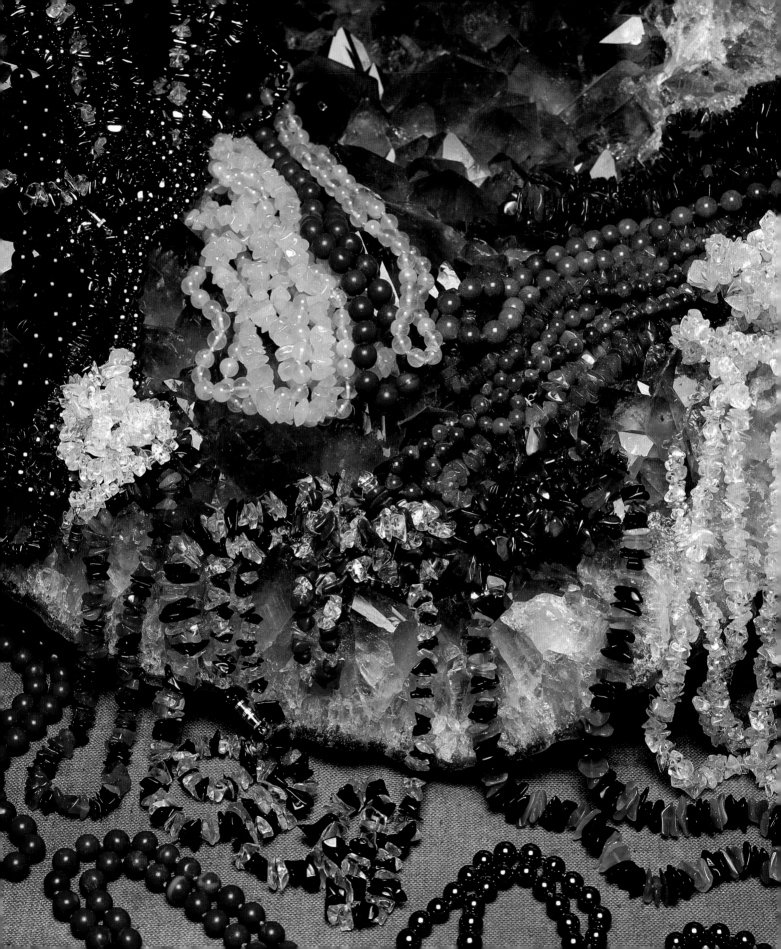

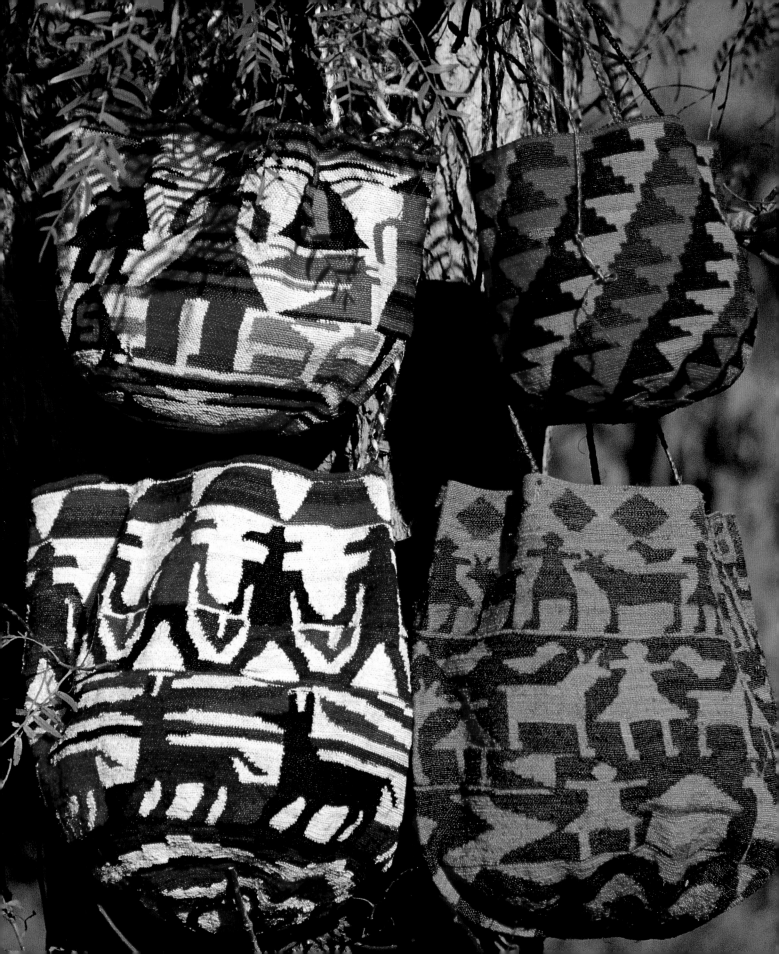

BASKETRY, HATS AND BAGS

THE WEAVING OF PLANT FIBRES is a skill found in virtually all primitive societies, and in the Americas the greatest variety of forms can be found among the numerous tribal communities of the Amazon, a vast though sparsely populated region where raw material is abundant and modern products have not generally taken the place of traditionally made pieces. However such weaving is still commonly practised in countless towns, scattered villages and communities right across South America. A woven basket or bag is as common in Latin America as a plastic bag in the West, and mats, hats, fans and boxes are only some of the variety of objects made and sold in local markets.

Few pre-Hispanic pieces have survived owing to the rapid decomposition of plant fibre, but examples have been found in Muisca settlements in the north of Colombia, in areas where basketry remains a thriving craft today. Spanish chroniclers reported the indigenous basket-makers as weaving items to adorn their temples and decorate the houses of the Muisca élite.

In the Peruvian coastal Paracas culture (700 BC–AD 100) the dead were buried in woven baskets. In coastal villages such as Huanchaco in the north of Peru, fishermen still make the famous reed boats or *caballitos* (literally, little horses) using locally grown reeds. Similar narrow boats with upturned prows appear in the decoration of pots and textiles from the pre-Hispanic Nazca and Paracas cultures.

Reed (*totora*) boats are also made on Lake Titicaca, in Peru and Bolivia, where the reeds grow freely. It takes the Aymara who live around the lake about a month of continuous work to complete a *totora* boat which will then last for at most one year. Here too are the 'floating islands' of reeds on which the Uru Indians continue to build their reed houses and fish from *totora* boats.

Plant fibres continue to be used in the more rural communities for the construction of roofs and walls. The Wayuu Indians of La Guajira in northeast Colombia and Venezuela use them for open-weave walls that are ideally suited to the hot semi-desert region in which they live, and which reflect the finer weaves of their hammocks. Plant fibre is a primary construction material throughout Latin America and serves for both hot and cooler climates. In the highlands of Peru and Bolivia straw is woven for thatch, and mixed with mud for adobe walls.

122 LEFT *Finely sewn* shigras *bags made from hemp fibre obtained from the inner leaves of the* maguey *(American agave). The designs from Salcedo, Ecuador, combine ancient and modern motifs. The bags were originally used to carry water as well as to store dry foodstuffs*

In Ecuador, around San Pablo lake near Otavalo, where reeds grow readily, large *totora* mats are woven for floor and wall coverings. Demand for these mats is great throughout Ecuador, and the *totora* reeds are becoming increasingly scarce.

Hats

Hats were an important element of much pre-Hispanic costume, worn to denote rank as well as to protect the wearer from the elements. Some superb examples of pre-Hispanic hats and other headwear have been preserved in the exceedingly dry conditions of the Atacama desert of northern Chile and southern Peru. Caps made of plant fibre as well as wool, turbans, and ornate headdresses incorporating feathers and metal ornaments bear witness to the high level of artistry of these ancient cultures. A common style, particularly of the Inca period, was a fez type of cap, sometimes with feather decorations sprouting from the top. Over a hundred different types of hat have been recorded in Colombia alone.

The so-called panama hat or sombrero is only one of many styles of straw hat worn in Latin America today. It has its origins in Jipipapa, a small coastal town in Ecuador, and indeed the name 'Jipijapa' has been adopted by some production centres for both the fibre and the hat. From the early nineteenth century the art of sombrero-making spread within Ecuador and also to neighbouring Colombia, first to the southern state of Nariño and then to the north. With time, each area of production developed an individual style. The sombrero gained its more popular name – the panama hat – during the building of the Panama canal at the beginning of the twentieth century, when Ecuadorian and Colombian hat-merchants sold their hats to the passing Canal trade.

Sandona, in the state of Nariño, is an important centre for panama-hat making, although weavers also produce woven mats and other items. Hat production falls into two distinct phases: weaving, carried out by women in the home, and the finishing process – drying, shaping and moulding, which is always the work of shopkeepers and hat-manufacturers. It is a common sight in Sandona to see row upon row of shapeless sombreros lying out in the streets to dry.

The raw material, *iraca* palm, is harvested by nearby communities. Once the plant is mature, after three years' growth, it can be cut every month. The green inner leaves are split into strips with a special double-bladed knife, the distance between the two blades determining the width of the fibre. The fibres are hung to dry in the sun, and then boiled, to whiten them. Some are dyed, using natural dyes such as *achiote* which produces a rich shade of red, and *nogal* (American walnut) for various shades of brown, or analine dyes.

TOP *Cutting* iraca *palm to be used for weaving sombreros, at Sandona, Nariño, Colombia. The distance between the two blades can be varied to alter the thickness of the fibre.* ABOVE *The weaving of a sombrero commencing at the centre of the crown with an* estera *or cross. Here two* esteras *are being joined*

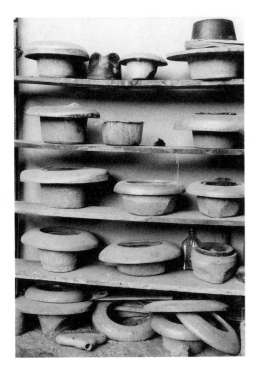

Wooden moulds and sombreros

Sombrero-weaving is commonly begun with a pair of fibres placed at right angles, known as an *estera*, round which further pairs are twisted. The finer the weave, the longer the weaving takes, and the more expensive the finished item. It has been said that the test of a really fine sombrero is whether it will pass through a wedding-ring. The weaver may introduce patterns of various kinds, either in the weaving or by incorporating coloured fibre. After washing and drying, and trimming off loose ends, comes shaping. Shaping of the hat is always done on a wooden mould, either with large automatic presses or the more old-fashioned method of hand-ironing with steam.

The Wayuu Indians of northern Colombia and Venezuela weave sombreros known as *womu*, or *kots* in their language, Arawak. These are worn by both the men and women. The fibre used grows only in a certain area of their homeland, La Guajira. Designs are normally geometric and including fibres dyed with both natural and chemical dyes.

An alternative method of hat-making is to sew braids of plaited fibres in concentric circles. This technique is used in Ecuador, Colombia and Mexico, and by the Maya Indians of Quiche in Guatemala. A sturdier and probably more durable, but less fine and flexible hat results.

Weavers of Sampués in Sucre, Colombia, make hats of the arrow cane which grows in the coastal areas of Colombia. The naturally white fibres are used undyed, but discoloured ones are dyed red by boiling them for several hours with the plant *limpia dientes*. If clay is added to the mixture, the fibres are dyed black. The entire dyeing and soaking process can take up to fifteen days. The white or dyed fibres are then woven into long braids. The number of fibres in a single braid is on average twenty-two, but as many as forty-two fibres may be included. Experienced weavers know the designs by heart, mixing the coloured fibres expertly to produce zigzags, squares and more complex motifs. Each design has its own name, such as *el peine* (the comb), or *granito de arroz* (grain of rice), and its particular significance to the weaver.

The braids are sewn together by machine, and beaten with a stone to help to shape the hat, beginning from the centre of the crown and working outwards. No moulds are necessary, for the shape is determined by the sewing. The hats, popular throughout Colombia, are known as *sombreros vueltiao*, '*vueltas*' being the rows of braid of which they are made. Although this art is traditional in Sampués, it was revived as recently as the 1980s. The hats are made by women, some working alone, others in cooperatives. Bags, mats and belts are made in the same technique.

Montecristi, not far from Jipijapa, on the Pacific coast of Ecuador, is an important centre for panama hats and all manner of baskets, some

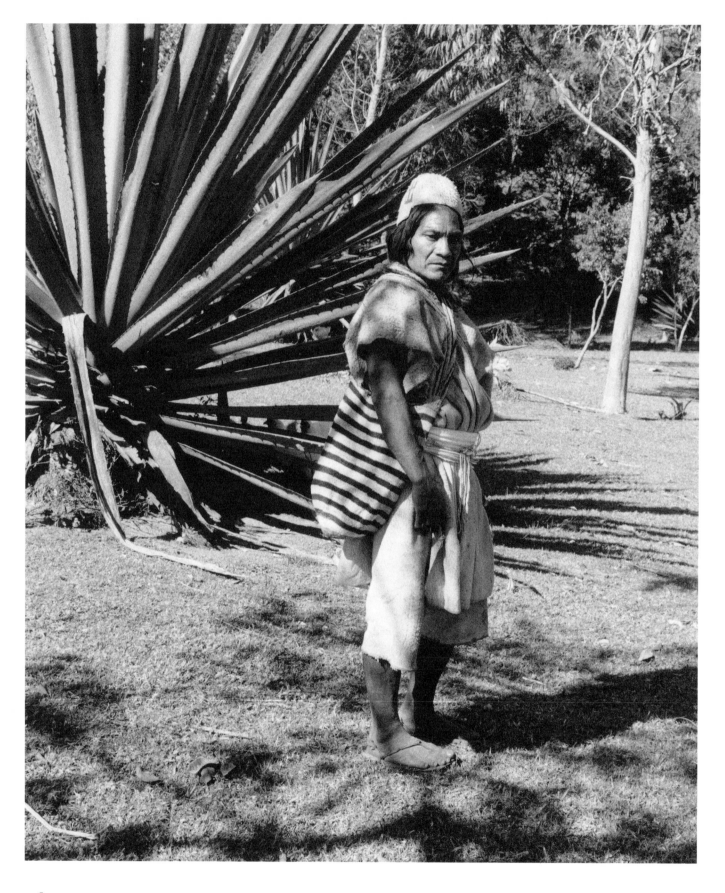

extremely finely woven and very small, in some instances only large enough to hold a single ring. Small figures of people and animals and other decorations are ingeniously woven. Analine dyes with the natural cream of the fibre produce eyecatching designs. Here, unusually, the men also weave.

The art of sombrero-weaving spread from Montecristi to the most important centre of panama-hat production in South America today: Cuenca. From small-scale, old-fashioned workshops and large factories emerges a multitude of woven hats. The many villages and rural communities surrounding the city provide the hand-weaving.

Horsehair weaving

Horsehair is occasionally woven in areas where other fibres are in short supply. One community in Chile, Rari, has gained fame with its unique woven horsehair products. Virtually all the women know how to weave horsehair into small figures and trinkets.

The horsehair is woven around a structure of more solid fibre, originally from the roots of a local tree but now, since the pieces' increase in popularity, from a vegetable fibre especially imported from Mexico. The horsehair comes mainly from Santiago. Analine dyes are used to give vivid colours but the natural hair colours are also used to good effect. Mothers hand on their skills to their daughters at an early age.

Basketry and bags

Tenza, in the Colombian state of Boyacá, is a typical thriving basketry community. The Muisca who inhabited this part of Colombia prior to Spanish settlement were noted for their skills in weaving plant fibre and the tradition continues today. In Tenza, a bamboo-like cane known as *chin* or *caña de castilla* (*Arundo donax*) is mostly used. It is more pliable and easier to weave than bamboo, although some weavers work with bamboo cane as well. The cane is slit into strips, the width depending on the particular piece to be made. Demand exceeds supply, and practically every family in the village makes baskets. Both men and women weave, and children can often be seen helping their parents.

Plant fibre is not only used for weaving but also sewn into a fabric for bags and other articles. *Mochilas* (Spanish for 'bags') are used throughout the continent as everyday holdalls. Some, like those used by the Arhuaco and Kogi Indians of the Sierra Nevada de Santa Marta region in northern Colombia, are of sewn fibre. The majority of these indigenous tribes still maintain their traditional costume of simple cream-coloured woven garments, and always carry at least one, but often two bags. The larger bag holds everyday items while the smaller is for the coca leaves which are

LEFT *Rafael Crespo of Sierra Nevada de Santa Marta, northern Colombia, in traditional costume, wearing* mochilas *or bags woven from the hemp fibre obtained from the agave plant, seen to his left. All Arhuaco men carry a small bag for coca leaves and a larger one for everyday articles.* ABOVE *Weaving a figure with horsehair in Rari, Chile. Virtually all the women of Rari are occupied with this type of hand-weaving*

chewed virtually all day. Even those who have set aside their traditional clothes still carry their *coca mochila*.

The bags are woven by sewing with a large, blunt needle, using *maguey* or hemp fibre (American agave) which is spun by hand, or sometimes sheep's wool. All are made exclusively by women, although only the men use the coca bags. Girls start to sew bags at the age of seven or eight. Designs are simple but varied. The *Momas*, or spiritual leaders of the communities, are the only people who use completely white *mochilas*, which immediately and visibly set them apart. Men generally wear a *mochila* over each shoulder, with the straps crossing at the front and back, while the women often carry very large *mochilas* with the strap across their foreheads to bear the weight of heavy loads. The use of natural dyes continues, although there is pressure from outside the communities to adopt strong analine dyes. Were the Indians to do so it would change the nature of the bags, and replace their spiritual value with a commercial one.

Shigras bags, made from hemp in the province of Cotopaxi in Ecuador, were originally used to store dry foodstuffs around the home. It is said that the very finely woven ones were even used to carry water from the wells, the fibres swelling when wet to make the bags impermeable. At one stage they virtually died out, killed by the arrival of plastic containers, until Western demand for these colourful and immensely strong bags ensured that the art continued.

The raw material for *shigras* is obtained from the inner part of the mature leaves of the *maguey* plant, torn into strips and soaked for up to fifteen days until the pulp disintegrates. The remaining fibres are left to dry in the sun, and then dyed. Analine dyes are commonly used, although a few artisans prefer natural dyes. The juice of the *maguey* plant itself provides a fixative, or alternatively salt and lemon may be used. The dyed fibres are hand-spun and twisted together, sometimes against the leg of the weaver, to make a fibre of half the original length. Designs are numerous, and reflect both ancient and contemporary influences.

Like the small backstrap looms and drop spindles of the Andes, the bags are portable, and can be sewn while women are herding animals in the fields. Today the women's production is often organized by suppliers, who provide dyed fibres for sewing and later buy the bags to sell. Here too, a large, blunt needle is used to sew the strong fibres, and the finished article is likely to last considerably longer than the user. The bags are sold at the Salcedo market and in the famous Otavalo craft market.

The most beautiful baskets by far are those made by the Cholo Indians of the Chocó in northern Colombia, along the Pacific coast. So densely are these woven that on first sight they could be mistaken for clay pots. The art

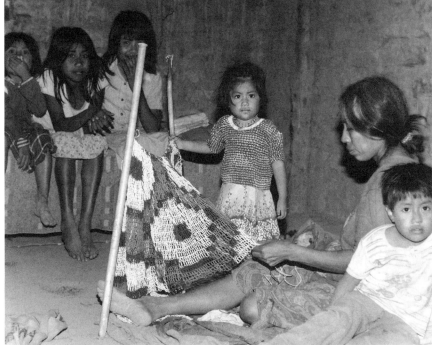

ABOVE Mochila *or bag woven from plant fibre in Paraguay, typical of bags found in many parts of the continent. The mesh is a basic sewing-weave.* ABOVE RIGHT *Weaving a* jika *or bag commonly used by the Mataca tribe, Mission Santa Maria, near Tartagal, northern Argentina*

stems from pre-Columbian times, and continues today virtually unchanged. Originally the Cholo Indians used the baskets to hold and carry water, but now they use commercially produced containers instead. The baskets are made from the *werregue* palm which grows in the Chocó. Although women make the baskets, the palm is traditionally collected by the men. Natural dyes including *achiote* are used to give a red-brown colour, or clay is added for black, which with the natural cream of the fibre gives the three elements the weavers mix to create their designs.

In making the baskets the women twist the fibres using their hands against their thighs, and then, starting at the centre of the base, sew concentric coils, using narrow strips of fibre as thread. Designs are produced with the threads as they bind the fibres, hence the woman is always having to stop and change to another colour of thread. The designs are innovative, some playing with geometric shapes, others incorporationg stylized images of human and animal figures, or including simple horizontal or vertical blocks of colour. Production is painstakingly slow, and a single *werregue* basket can take many months to complete.

The black settlers slightly further south on the Pacific coast make *cundu* baskets from a cane so flexible that the finished basket can be squashed to

almost any shape or size. Unlike the *werregue*, the *cundu* basket has a broad and open weave; because of the weave, decoration is not an important feature, and brown and black fibres are mixed indiscriminately. The population lives primarily by fishing, and the *cundu* baskets are used to carry fish and fruit. They trade with the Cholo Indians, and some of the women have learnt the Cholo art of making *werregue* baskets.

The Paraguayan Chaco is a vast but sparsely populated region, representing almost two-thirds of the entire land area of the country. It has been settled by German Mennonites, but still holds large numbers of the indigenous tribes of Paraguay. While few of these Indians continue to live their traditional life of hunting and gathering, due to invasion of their land and other outside influences, they still produce on a small scale the artefacts that used to be an integral part of their daily lives. Bags and hammocks are woven from the fibre of the *caraguata* (a variety of *Bromeliacea*). The fibres are dried in the sun and dyed using natural dye-elements from bark, fruit, resin, roots and seeds. Ash helps to fix the dyes, and the fibres are spun by twisting them against the thigh.

The Nivacle-Chulupi indigenous group of the Chaco are famous for their woven bags, while the Mby'a men of the Tupi Guaraní linguistic group weave palm-fibre baskets. Their mythology centres on the indentification of the basket with the different parts of the human body: the opening the mouth, the walls the trunk, and so on.

Margarita, an island off the Caribbean coast of Venezuela, is known for baskets, sombreros and fibre bags of various sizes known as *mapires*, used by women and as donkey saddlebags. Basketwork is common in the state of Sucre in Venezuela and in the villages around Mérida, and is notable for the wide variety of raw materials employed and the myriad needs fulfilled, from saddlebags and containers for collecting coffee beans to cradles for babies. Baskets of all shapes and sizes, but always incorporating brightly dyed fibre, are woven in Huacho, northern Peru. A rectangular shape with a fitted lid and woven fastening is common. Smaller versions make shoulder bags with woven straps.

Brazil's rich variety of basketry is found particularly in the north-east region, in the states of Bahía, Pernambuco and Paraíba, and in the Brazilian Amazon – a vast area comprising forty-five per cent of the national territory and holding only eight per cent of the population. Here raw material abounds, and baskets are woven to meet the immediate needs of the Indians. Baskets, hammocks, nets, slings for carrying babies, masks and body-adornments are only some of the artefacts woven from plant fibres. The list is endless, and reflects the degree to which these people live in harmony with their immediate environment.

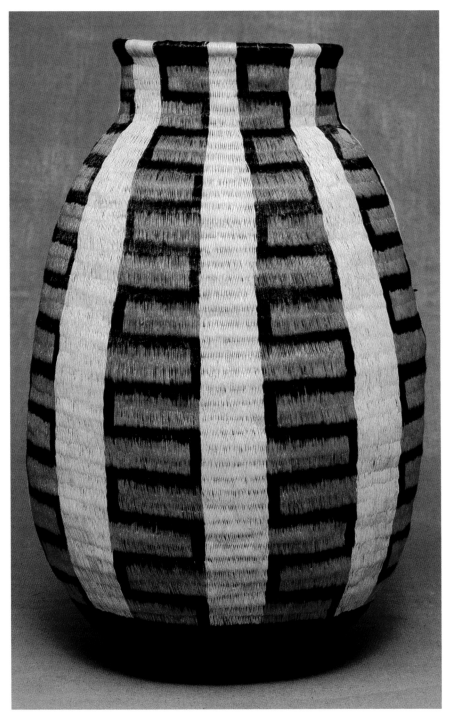

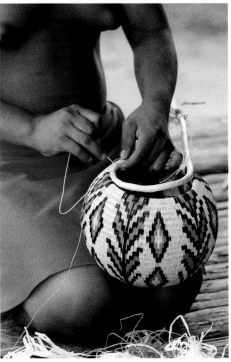

123 LEFT Werregue *palm basket sewn by the Cholo Indians of the Colombian Chocó.* H 20¾" *(53 cm)*

124 ABOVE *Cholo woman from the Colombian Chocó sewing a* werregue *basket. Coils of fibre are sewn tightly together and the designs are created by introducing different colours of palm-thread. A single basket can take months to finish*

125 *Horsehair hanging, a witch woven by*
Gabriela Parada of Rari in Chile. L 9″ (23 cm)

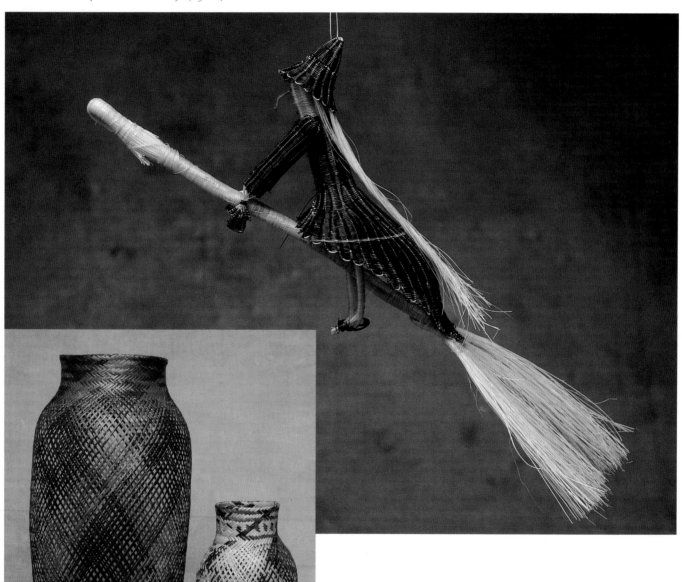

126 LEFT Cundu *baskets woven by the black*
coastal population of the Colombian Chocó.
These baskets are extremely flexible, enabling
them to accommodate objects of different
shapes and sizes. H of left-hand basket 20¾″
(53 cm)

127 *Handwoven sombrero and the balsa wood box in which it is carried, both made in Cuenca, Ecuador*

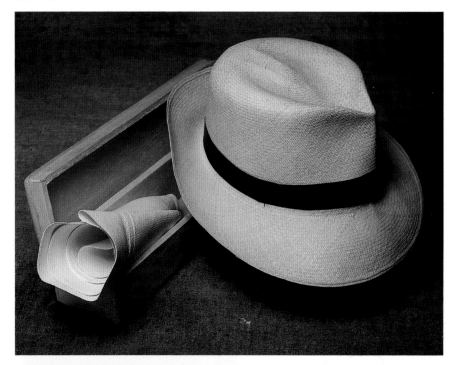

128 BELOW *Weaving a fine sombrero, traditionally women's work in Montecristi, Ecuador, not far from the town of Jipijapa which has been claimed as the birthplace of the panama hat*

129 BELOW RIGHT *Luz Alsida Riascos, aged thirteen, weaving a sombrero in Sandona in southern Colombia*

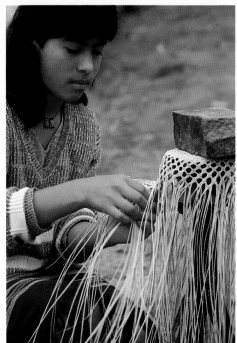

131 *Decorations and baskets woven in Montecristi in Ecuador. The most popular pieces are the finely woven circular baskets with tight-fitting lids, some of which are extraordinarily small. H of figure (left)* $3\frac{7}{8}''$ *(10 cm)*

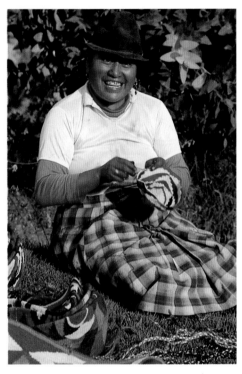

130 ABOVE *Rosa Elena Taipi sewing* shigras *bags using a large needle, in Salcedo, Ecuador*

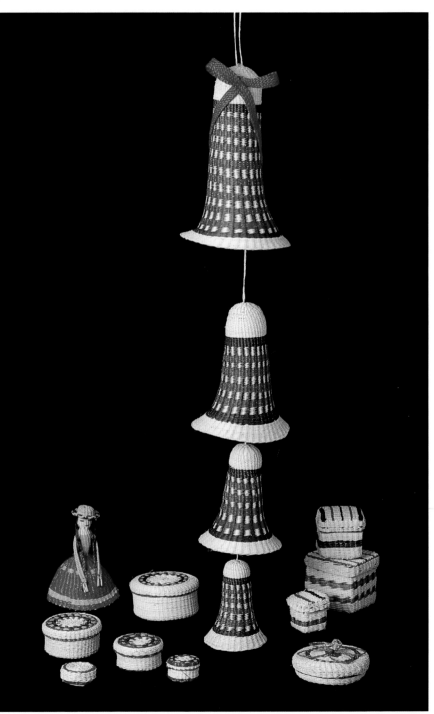

132 *Baskets woven in Huacho, an important basketry centre in northern Peru. H of lidded basket 12″ (30.5 cm)*

133 BELOW *Brightly coloured baskets from Riobamba, Ecuador, made in sets of six to fit inside one another. L (max.) 10¼″ (26 cm)*

134 *Seeds of the* achiote *tree, source of a bright-red dye for the plant fibre used in sombrero-weaving and basketry*

135 *Cutting* iraca *palm, a fibre used to weave sombreros, mats and baskets in Sandona, southern Colombia*

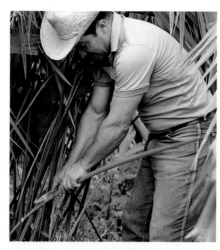

136 BELOW *Strands of* iraca *palm hung out to dry. Analine dyes are used to produce the bright colours*

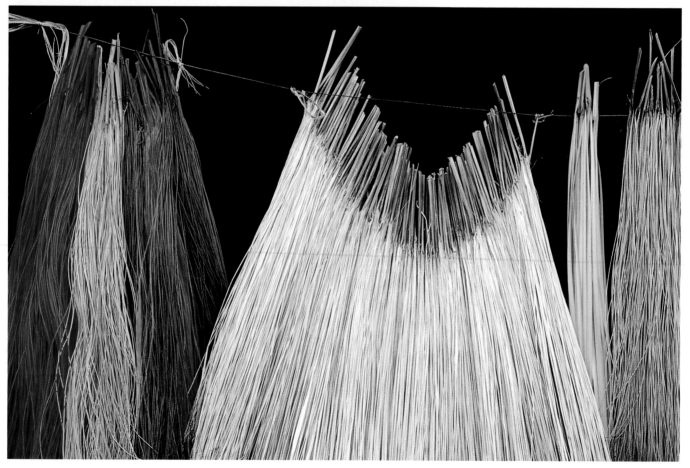

137 **BELOW** *Arhuaco woman and children carrying* mochilas *or bags sewn from hemp fibre, in Nabusimake, Sierra Nevada de Santa Marta, northern Colombia*

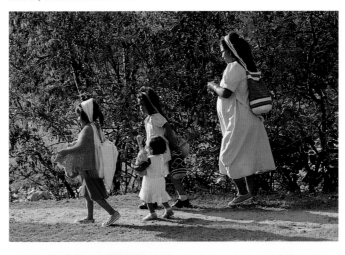

138 **BELOW** Mochila *crocheted with commercially spun and dyed cotton by a Wayuu woman of La Guarija, the area extending across northern Colombia and Venezuela. The designs are the Wayuu clan symbols, passed on over generations by matrilineal inheritance*

139 **BELOW RIGHT** *Sombrero* vueltiao *and bag woven from arrow cane in Sampues, Colombia. The type of sombrero is so named for the* vueltas *or 'rows' of woven fibre which are sewn together to form the hat*

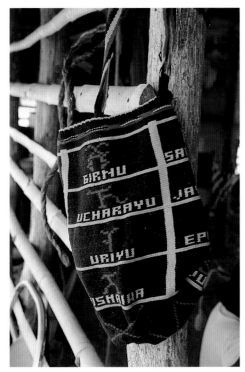

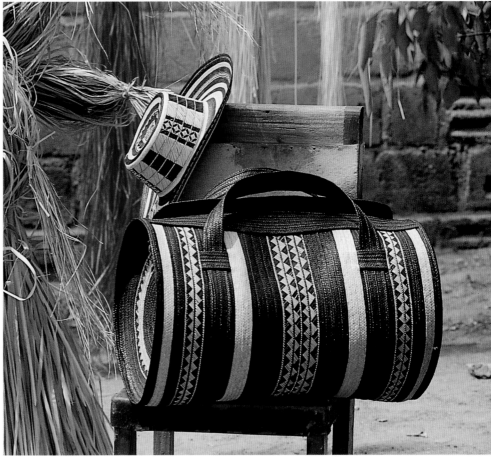

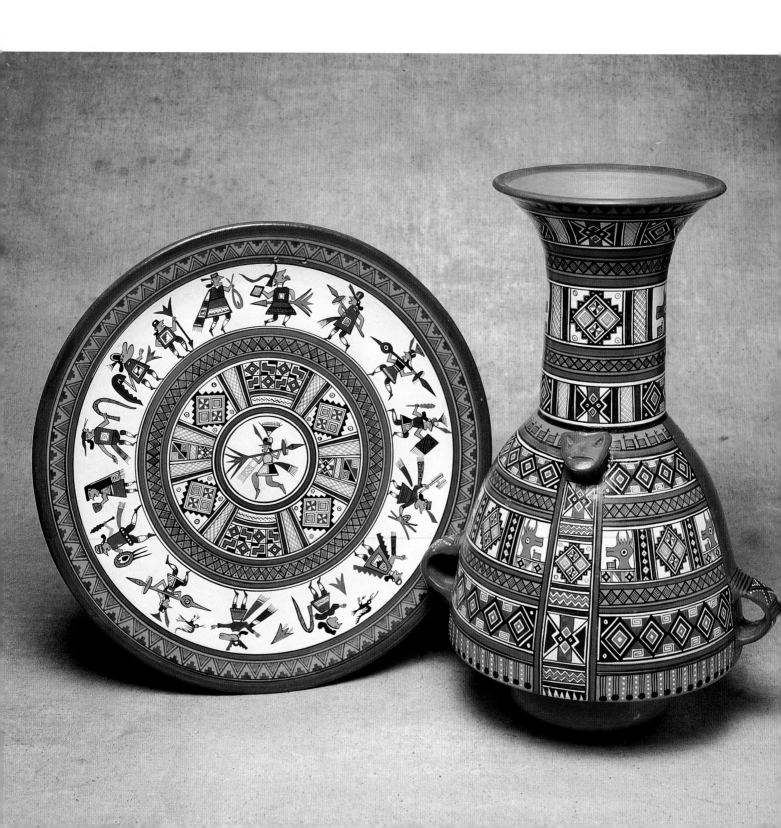

POTTERY

IN ALL THEIR VARIETY, the pre-Hispanic ceramics encountered in burial sites across the Americas have emphasized the extent to which the pre-Columbian potters imbued their work with religious or magical symbolism. The potter's skill was not merely required to produce utilitarian objects necessary for daily life but was evidently a specialized, sometimes sanctified art which required more than mere technical expertise from its creator. In Peru the word *huaco* (from the Quechua root *hua*, meaning sacred) has come to denote any ceramic artefact which has a votive or spiritual significance. Such votive pieces often carry detailed iconographic decoration which allows us to begin to decipher the religious beliefs of pre-Hispanic cultures.

The most spectacular archaeological finds have been made in modern-day Peru. The Nazca culture of the northern coastal region of Peru (100 BC–AD 900) excelled in polychrome painting of vessels with motifs of supernatural beings, often with a strong feline identity, as well as birds, fish and animals, usually outlined in black as well as coloured. Many of the Nazca ceramic motifs are similar to those found in the textiles of their predecessors, the Paracas, who were highly skilled weavers. Common Nazca ceramic forms included vessels with a bridged double spout.

Outstanding for their naturalistic detail and technical skill, the vessels of the Moche or Mochica culture of northern Peru (AD 200–750) combined modelling and painting to depict details of Moche daily life. Human faces are modelled on stirrup spout vessels with such precision that they suggest personal portraits. No less remarkable is the modelling of animals, fruit and plants. The Moche also excelled in intricate linear painting, often executed in brown on a cream base, which provides scholars with hints concerning their religious belief system. Erotic pottery figures representing all manner of scenes are believed to relate to fertility.

The Incas, originally a small mountain tribe, had expanded by 1500 to embrace the whole of modern-day Peru, Ecuador and Bolivia, as well as large areas of Chile and Argentina. Inca ceramic decoration consists chiefly of small-scale geometric and usually symmetrical designs. One distinctive form of vessel which continues to be made and used today is the *arybola*. This pot is designed to carry liquid, in particular *chicha*, fermented corn beer, and is secured with a rope on the bearer's back. It is thought that *arybolas* were used mainly by the governing Inca élite and so became important status symbols. Today pottery in the Inca style is extremely

140 LEFT Arybola *and plate decorated in the Inca style, from Cuzco, Peru. The* arybola *was the traditional Inca vessel, used to carry* chicha *or fermented corn beer. Designs hand-painted by Máximo Quinto. H of vessel* 11⅝" (29.5 cm)

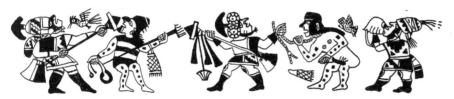

LEFT *War-scene depicted on a Moche vessel (AD 200–750).* BELOW *Vessel with bridged double spout of the Nazca culture of southern Peru (370 BC–AD 450).* BOTTOM *Moche stirrup pot with vivid naturalistic modelling*

popular in Cuzco (the Inca capital) and in the nearby village of Pisac in the Sacred Valley of the Incas. The sixteenth-century Spanish invasion changed the artisans' world irrevocably. Some indigenous communities were completely annihilated, and with them were lost their entire artistic traditions; other, more isolated communities remained relatively untouched, while others again combined Hispanic and indigenous traditions and techniques.

The Spanish brought with them not only Catholic subjects for ceramic representation – crucifixion scenes, saints and penitents – but also three important innovations: the potter's wheel which gave greater speed and uniformity to production, the knowledge of the enclosed kiln, and the technique of lead glazes. Before the invasion potters had fired their pots either in the open fire or in a pit in the ground. Temperatures were hard to control and pieces were not uniformly fired. The enclosed kiln made temperature regulation easier and also allowed higher temperatures to be maintained, producing stronger pieces. Pre-Hispanic societies had not used any type of glaze, although stones were used to burnish the surface.

Today many communities continue to apply the techniques of pre-Hispanic pottery production virtually unchanged while others use more modern processes. Both ancient and modern techniques are used in Ráquira in the state of Boyacá in Colombia. Mainly utilitarian pieces, especially large hand-modelled or moulded earthenware pots, are made exclusively in surrounding hamlets following the tradition of the pre-Hispanic Chibcha people, while in the town itself, mobiles, animals and Nativity scenes incorporate more European elements. Today a ceramic horse made only in Ráquira has come to symbolize Colombian pottery production. Outside Ráquira the clay is extracted locally, and for the large pots three types of clay are combined to give the right consistency. Pots are made by punching a fist into kneaded clay and using a rough plate, which can be turned with the free hand. When a pot is half dry the outside is beaten with a wooden pallet to obtain the desired shape.

Firing is done in clay kilns, using a mixture of wood and coal because firewood has become scarce, and may take anything up to ten hours. The majority of younger potters in the town, however, are now concentrating on more modern means of production, using moulds and large electric kilns. When functional ware is gradually being replaced by mass-produced china

BELOW *An Inca* arybola *designed to be carried on the back, and with a conical base to aid pouring.* BOTTOM *Motifs commonly found on Inca pottery, where geometric and symmetrical designs predominate*

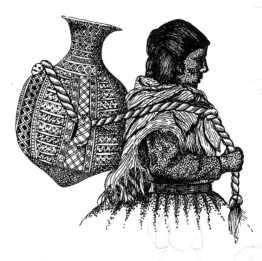

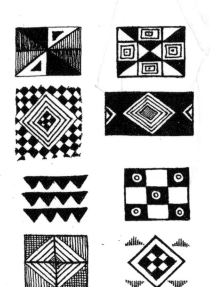

or plastic, a means of survival for the artisan potter may be concentration on decorative products which are valued in the Western world for their artistic uniqueness or the authenticity of their cultural expression.

Blackware represents another example of traditional rural pottery production. Although pre-Hispanic cultures never used closed kilns to fire their ware they did practise the art of firing by means of reduction – that is, without the presence of oxygen. Lack of oxygen causes the iron in the clay to change colour from red to black, turning the pot itself either black or dark grey. Remains of such pottery have been found in sites across the Americas, and it is still made in various scattered communities today. The quiet village of Quinchamalí, 27 kilometres west of Chillán in Chile, is famous for its black pottery pieces, and in particular for miniature models of the wood-burning stoves commonly used in the south of Chile. Some two thirds of the population of Quinchamalí works with clay, in a tradition dating back to pre-Hispanic times. Kilns are not used, instead the pieces are laid round the edge of a bonfire to warm until the flames have died down, then placed directly in the red-hot embers, covered with dung, and left for about thirty minutes. On removal they are covered with straw and left to oxidize.

A popular piece made in Quinchamalí is the *Guitarerra*, a woman playing a guitar. The legend behind this figure is of a woman who fell passionately in love with a singer who one day left her and never returned. She became so heartbroken, waiting, that she turned into clay. Today all manner of pieces are produced, many utilitarian but more decorative. Some are decorated by rubbing powdered white clay into incised lines.

Blackware is also very much alive in La Chamba, a small riverside village in the state of Tolima, Colombia, where the women devote their time to working with clay. The present production only began in the last century, but the techniques involved are pre-Hispanic. Locally extracted clay is dried and pulverized with a wooden pestle and mortar known as *el pilón*. The powder is sieved and mixed with water to form a dough ready for kneading. A thin pancake of clay is laid over an upturned pot that serves as a primitive mould. When it is dry, the pot is built up using the hands to form the finished *cántaro* or pitcher. Finally, pots are painted with a clay slip, burnished, and after firing immediately placed in sealed containers with red hot coals and left to smoke for ten minutes. The smoke impregnates the pieces, turning them black.

Although more famous for its blackware, La Chamba also produces pale brown and terracotta pots. The pale brown is the natural colour of the clay after firing. If pieces are painted with a slip containing iron-rich clay from the Magdalena river and then burnished with a river stone before firing, they emerge a rich terracotta.

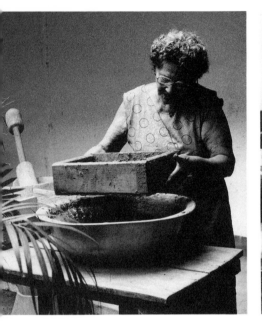
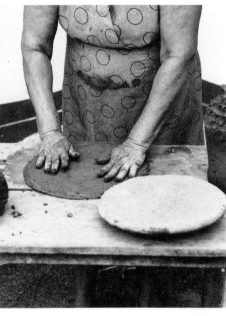
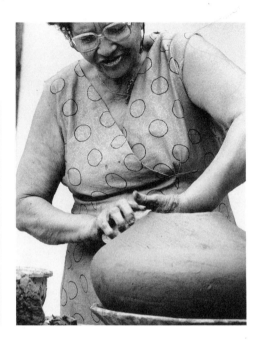

Since it is generally agreed that food tastes a lot better from clay pots, La Chamba has become a household name across Colombia, and its ware is fast becoming popular all over the world.

Pomaire, 83 kilometres west of Santiago in Chile, produces terracotta ware rather than the black. Women are chiefly the potters, producing vast numbers of casserole dishes, bowls, plates and jugs used in households throughout Chile, as well as miniature ornaments.

While many communities and artisans across Latin America can claim to be continuing pre-Hispanic techniques and art forms, there is a town in the north of Peru where an ancient technique has been discovered and revived in the last thirty years. The potters of Chulucanas, 40 kilometres north-west of Piura, formerly produced only large utilitarian terracotta pots, like their neighbours. In the 1960s, however, tomb robbers brought to light pottery of the second half of the first millennium BC from the Vicus and Tallane cultures, and led some of the potters to think again.

A group who called themselves *Sañoc Camayoc* (Quechua pottery specialists) researched and experimented with forms and techniques based on the pre-Hispanic finds, helped and supported by various outsiders, among them Gloria Joyce, an American Catholic missionary. In particular they experimented with the 'negative painting' technique used by the Vicus potters and others. In this process two firings are required, the first after painting with an oxide. The fired pot is painted in parts with a solution of

ABOVE *Pottery-making in La Chamba, Tolima, Colombia. Ana Cecilia Carbal sieves the pulverized clay, rolls it out and gives it rough shape by laying it over an old pot, then builds up the sides by hand and smooths the outside with* la tutuma – *a piece of gourd dipped in water.* ABOVE RIGHT *Pre-Hispanic ceramic figure from the Camay culture, found in the state of Lara, Venezuela. H 10ꜱ" (27 cm)*

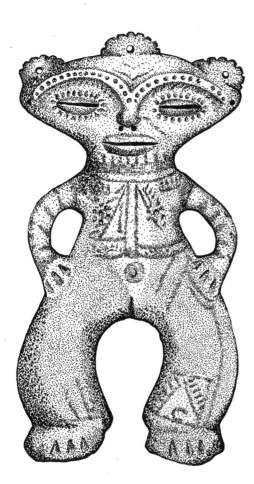

clay and water and fired a second time with mango leaves, to blacken it with smoke. The painted areas are finally wiped clear, exposing the oxide colour which contrasts with the black of the rest of the pot. This produces a very unusual and subtle effect. The same result can be achieved by painting with wax instead of the clay slip. The pots are made from local clay entirely by hand, beginning by punching the clay into shape and gradually building up the semi-hardened walls using a wooden pallet. The kilns are wood-burning, and sealed for the second firing.

At first the potters imitated the forms of the Vicus pieces, but gradually they developed a freer expression, using stylized figures from their own environment. The most popular form to emerge is the *chichera* – a fat lady who makes and sells *chicha*, fermented corn beer. Some of the potters in Chulucanas are artists rather than artisans, producing unique and highly prized pieces. Each piece is signed, and the majority are sold in galleries and shops in Lima and abroad.

While for many years the value of pre-Hispanic art forms and traditions was little regarded in Peru, the 'indigenist' school of thought of the 1960s resurrected many of the earlier styles by bringing folk ceramics to the attention of *mestizo* and white people in Lima – people as distant from the indigenous inhabitants of their country as someone living in Europe might be.

The folk art of the small and picturesque village of Quinua in Ayacucho, Peru, is an example. The settlement looks down upon the impressive ruins of the Huari culture (AD 600–900). Pottery has been produced in Quinua for centuries, but over the last decade conflict between the Peruvian military and the Shining Path guerrilla group has left Quinua almost deserted, as many of its artisans fled to the relative safety of the capital, Lima, where they had to adapt to different clay and working conditions. Today the area is more peaceful and it may be hoped they will return. Pieces made in the village range from model churches and Nativity figures to humorous groups of musicians and gossiping women. The rich red local clay is modelled mainly by hand and decorated with local mineral earth colours. Firing is brief, approximately an hour in small wood-burning kilns. Traditionally the churches are set on the roofs of newly occupied houses to ward off evil spirits. Virtually every roof in Quinua has a model church perched on it.

Pucara, in the province of Puno, produces pieces of a similar type but with far more detailed modelling – a style dubbed 'grotesque' because the figures' features are wildly exaggerated. They are usually left unpainted and unglazed, the earth-colour and rough surface playing a part in the overall effect. Among the great variety of figures produced in the surrounding area, the best known is that of the Pucara bull. While the llama was a votive

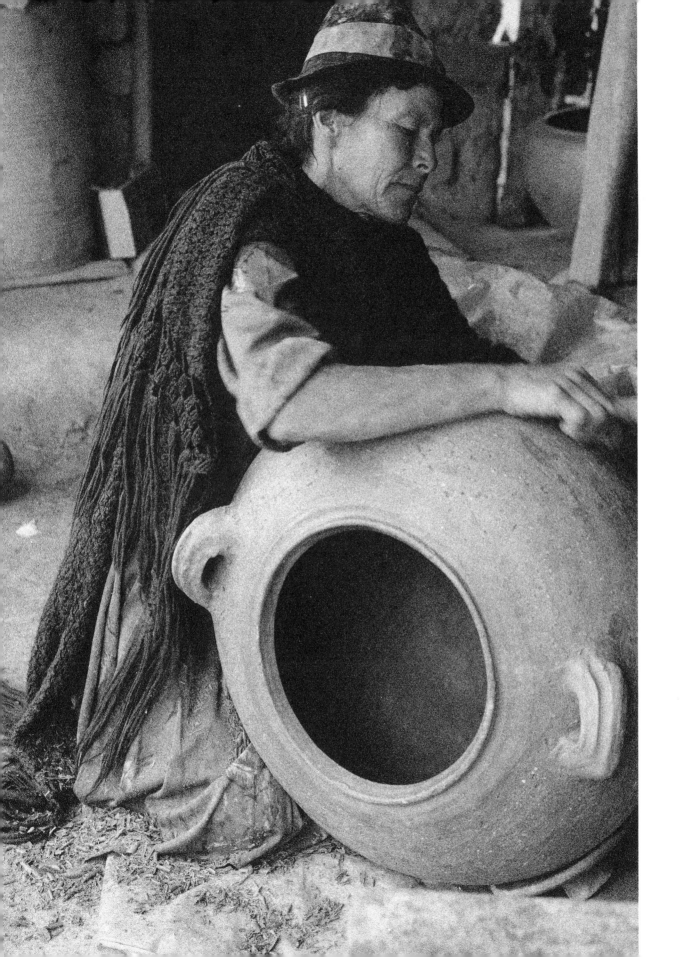

symbol for the Inca culture, often carved out of stone and used for burning incense and other sacred purposes, the bull, which was introduced by the Spanish to the Americas, has taken its place as a symbol of strength and virility. The popular Pucara bull gained fame with the coming of the Cuzco-Puno railway. The train stops frequently, and with little effort the bull could be sold to travellers and was carried for long distances across Peru. In some fiestas in the area bulls are cut on the neck and their blood is offered to the four winds and to *Pachamamma* – Mother Earth. Flowers are thrown at the animal, and coca leaves placed on its wounds to cure the pain. The coca leaves are usually painted on the ceramic bulls.

An innovative style of pottery has evolved in the town of Tobati, some 20 kilometres from Asunción in Paraguay. Tobati is famed for its ceramic tiles and woodcarving, but the women of the scattered dwellings outside the town model figures of local clay. What began as a decorative detail on jugs and money-boxes has developed into independent figures known as *Las gordas*, or fat women, which are made in various sizes.

The women work at home, often outside where the air is cooler, and use few instruments. The pieces are built up from coils of clay, in a tradition passed down from mother to daughter. A slip known in the Guaraní language as *tapyta* is applied to turn some of the pieces terracotta. Other artisans produce black pieces, although this is a relatively recent phenomenon.

Along the Ucayali river near the town of Pucallpa, on the edge of the Peruvian Amazon, the women of the Shipibo-Conibo tribe practise a distinctive ceramic art, unchanged, it is believed, for countless generations. Their pieces stand out from all others made in the Americas by virtue of their geometric decoration. No one knows the true significance of these designs. One theory is that the lines represent a primitive map of the waterways of the area; others believe they represent the constellations. The same designs are stamped on cloth, and were formerly painted on people's bodies during certain tribal rituals.

The Shipibo vessels are built up with coils of clay and burnished with river stones. Each vessel is made with a specific purpose in mind, and all are regarded as imbued with deep spiritual meaning. Today, however, the Shipibo are also aware of the commercial value of their products, and have organized themselves to market them, although the forms and techniques remain unchanged.

Ana Rosa Valero smoothing the outside of her pot with a stone. Using only the most basic of tools, the potters around Ráquira, Boyacá, Colombia, maintain traditions believed to be unbroken since pre-Columbian times

Indigenous pottery traditions have been revitalized in the north of Argentina in the beautiful town of Cafayate, set in the dramatic landscape of the Calchaqui valley. This is one of the main wine-growing regions, with impressive rock formations which attract many tourists to the area. Black

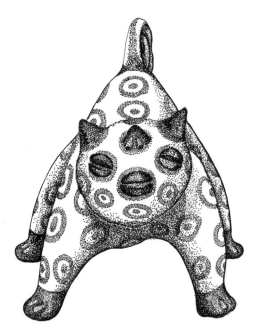

pottery is produced in workshops there by sealing the kiln with cow- or horse-dung in the final stage of firing. Both traditional forms – jugs, bowls and plates – and more individualistic sculpted ceramics are produced. One particular potter decorates pieces in a naive style, using natural pigments and simple imagery reminiscent of prehistoric cave painting. Sometimes he burnishes the surface with an electric light-bulb rather than a pebble, producing a good shine.

Just as pre-Hispanic ceramics sometimes tell us something of their makers' daily lives, so do the figures of Alto Do Moura and Pitalito. Alto Do Moura is a village of some five hundred houses in the north-east of Brazil, whose inhabitants spend their lives making miniature figures of clay.

Vitalino was the name of the potter who changed the history of this village. He began to model figures from scraps of clay as a child while the women around him were making their utilitarian pots. His hobby grew until he was selling pieces in the local market, and his figures evolved into scenes which offered a commentary on the social and political situation as it affected him. Among his most popular subjects were fiestas and weddings, but his work also reflected the problems of the area, such as high unemployment. Since he died in 1963 his pieces have become sought-after collectors' items. Today those who carry on his tradition paint the tiny figures with bright enamel paints, and they have made the name of this small rural community known throughout Brazil.

Vitalino made no figures on a religious theme, but there are countless communities in the north of Brazil which do produce religious figures of clay. The potters of Tracunhaem, for example, work the rich red clay of the area into lifesize unglazed figures of saints. In Goiana, detailed clay sculptures of angels are made by the famous potter Ze Do Carmo, as well as many others who follow in the same tradition.

Huila province in southern Colombia has an ancient tradition of outstanding sculpture, for the vast and impressive San Agustín archaeological site at the source of the Magdalena river has attracted numerous potters, stonecarvers and weavers to the area to live and work. Among the production of the many small villages and towns, however, the brightly painted, imaginative and often amusing ceramics of Pitalito stand out. Utilitarian pottery was once made here, but today the artisans direct their talents to scenes of everyday life, in particular with the *chivas*. These open-sided wooden buses are generally packed to overflowing with people, animals, fruit, vegetables, and anything else the potter cares to add. Other scenes depict special occasions, such as wedding parties, religious processions or funerals. Such pieces represent not just a form of popular art, but the record of a time and a culture.

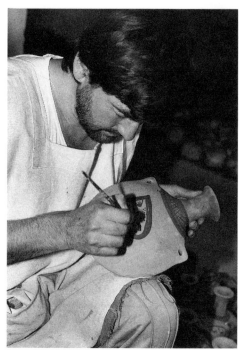

TOP *Pre-Hispanic pottery figure found in the state of Lara, Venezuela.* ABOVE *Manuel Cruz decorating a pot with his characteristic naive motifs at Cafayate, in northern Argentina*

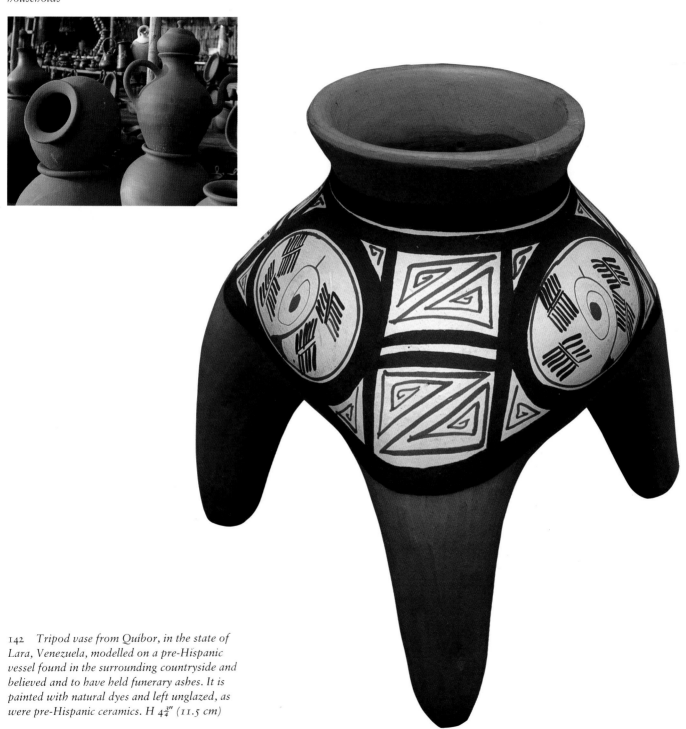

141 Pots from Pomaire, Chile, for sale at the roadside. Pomaire pottery is the most traditional of all Chilean earthenware, sold at every market and used by countless Chilean households

142 Tripod vase from Quíbor, in the state of Lara, Venezuela, modelled on a pre-Hispanic vessel found in the surrounding countryside and believed and to have held funerary ashes. It is painted with natural dyes and left unglazed, as were pre-Hispanic ceramics. H 4¾" (11.5 cm)

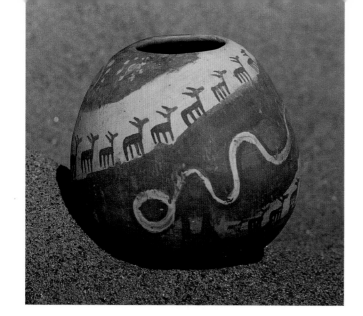

143 LEFT *Pot made by Manuel Cruz of Cafayate, northern Argentina, who employs naive designs for his pieces. The pots are left unglazed and fired in wood-burning kilns*

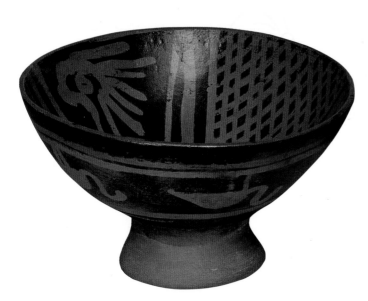

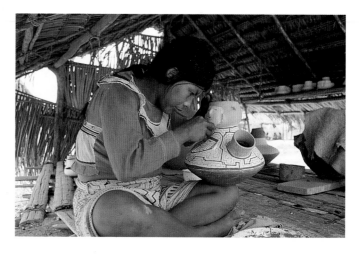

144–5 ABOVE *Bowls from northern Ecuador decorated with designs based on those of the Carchu culture (AD 1200–1500). The designs are applied with melted wax, and the bowls then dipped in a coloured slip. On firing, the wax melts and the design-areas are exposed. H of bowl $4\frac{3}{4}''$ (12 cm)*

146 RIGHT *Shipibo woman decorating a pot*

147 *Pot made by the Shipibo-Conibo Indians of the Peruvian Amazon. The linear designs are thought to represent the constellations, or possibly local river-patterns, and are applied using natural dyes present in local river mud. H 15¾" (40 cm)*

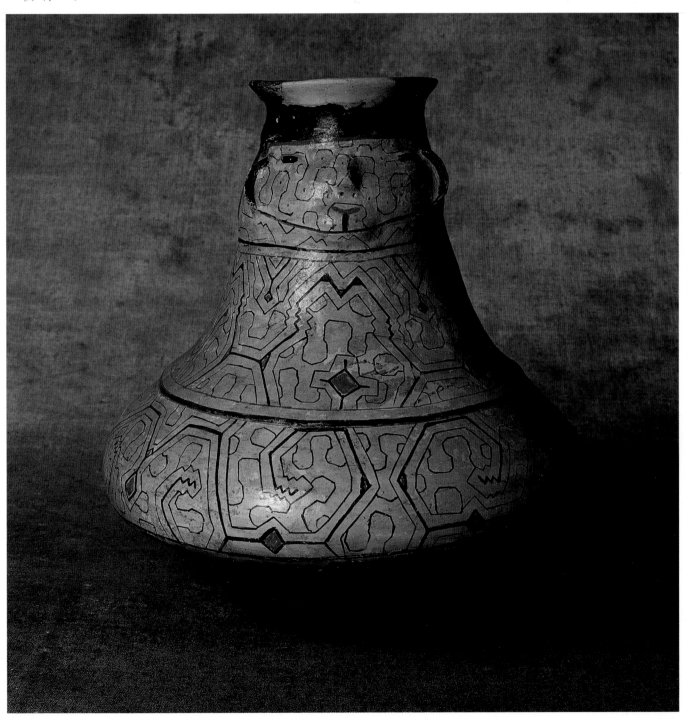

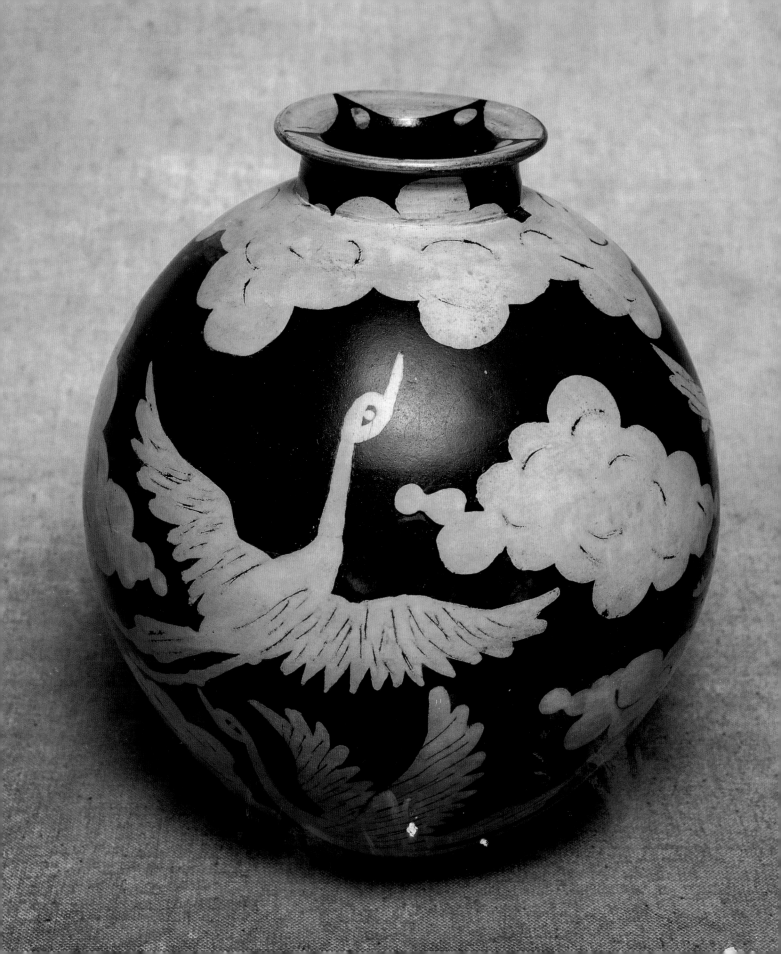

150 LEFT *Model of a Colonial house from Cuzco, Peru, a city famous for its Inca and Colonial architecture, as well as its present-day pottery production. H 7¾" (20 cm)*

151 BELOW *Clay church of the village of Quinua, near Ayacucho, Peru. The pieces are all modelled by hand and decorated with natural earth pigments, and are left unglazed. H 8⅝" (22 cm)*

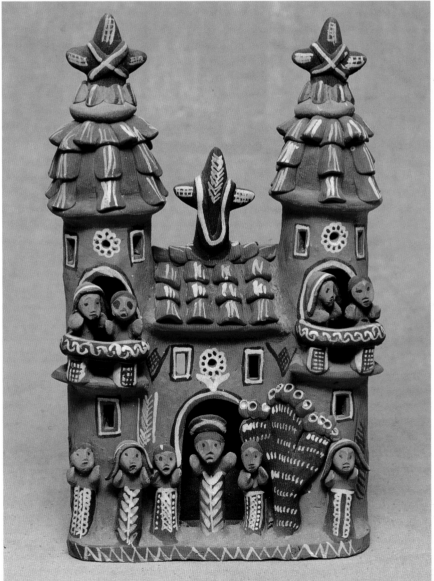

148 LEFT *Vase made by Santodio Paz from Chulucanas, northern Peru, decorated using the 'negative painting' technique in which the piece undergoes two separate firings. After dipping in a coloured slip and firing, the pot is painted with designs using clay and water, and fired for the second time in a reducing atmosphere, turning the surface black, apart from from design-areas, which are finally wiped clear to reveal the colour of the slip. H 6⅞" (17 cm)*

149 ABOVE *Pots drying in Chulucanas, ready for decoration by the 'negative painting' technique*

153 RIGHT *Pot from Ayacucho, an area of Peru rich in artistic tradition, known for pottery, textiles,* retablos, *and basketry using brittle twigs. Here pottery and basketry skills have been combined. H 12$\frac{1}{2}$″ (32 cm)*

154 *Clay church with a Pucara bull on either side, placed on a roof in the village of Quinua, Peru, to ward off evil spirits*

155 *Shoe-mender modelled in the 'grotesque'*
style, from the Pucara region of Peru. The so-
called grotesque figures are usually left
unglazed and unpainted, incorporating
immense detail in the modelling alone.
H 7¾″ (20 cm)

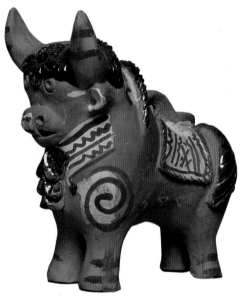

156 ABOVE *Pucara bull. This piece has*
become a symbol of a rich folk tradition, and
enjoys huge popularity throughout Peru.
H 7″ (18 cm)

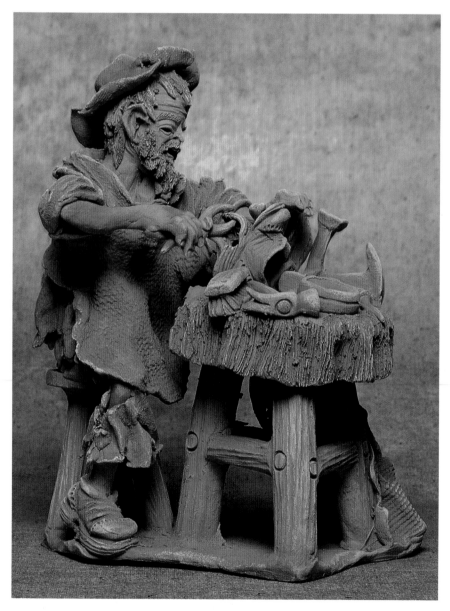

157 RIGHT *Casserole and bowl set from La*
Chamba, Tolima, Colombia. The pots have
been blackened by being placed in sealed
containers with burning dung, immediately
upon removal from the kiln. W of casserole 15″
(38 cm)

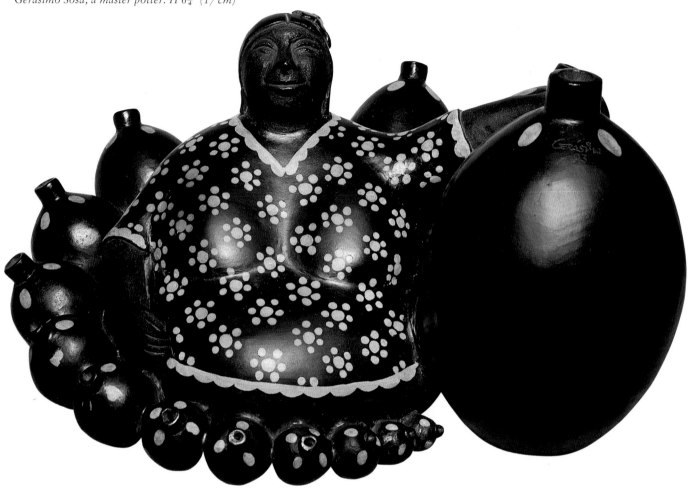

158 Chichera, *or woman selling* chicha *(fermented corn beer), one of the most characteristic of the figures made in Chulucanas, northern Peru. It is decorated using the negative painting technique, involving two separate firings, and was the work of Gerásimo Sosa, a master potter.* H 6¾" (17 cm)

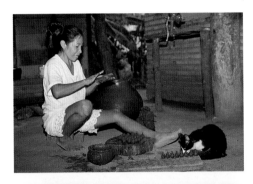

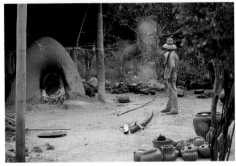

159 TOP *Making miniature pots in Compania 21 de Julio, Tobati, Paraguay. Figures of all sizes are made here, many on animal themes, though the best-known are the gorda figures (see pl. 165). Pieces are covered in a slip known in Guarani as tapyta to colour them terracotta, or else blackened by means of oxidization*

160 ABOVE *Fired pottery being removed from the enclosed bonfires used in La Chamba, Tolima, Colombia*

161 RIGHT *Ceramic sculpture from Cafayate, northern Argentina. Such pieces arise from the potter's creative imagination, owing little to tradition. They are blackened by firing in a reducing atmosphere. H 8" (20.5 cm)*

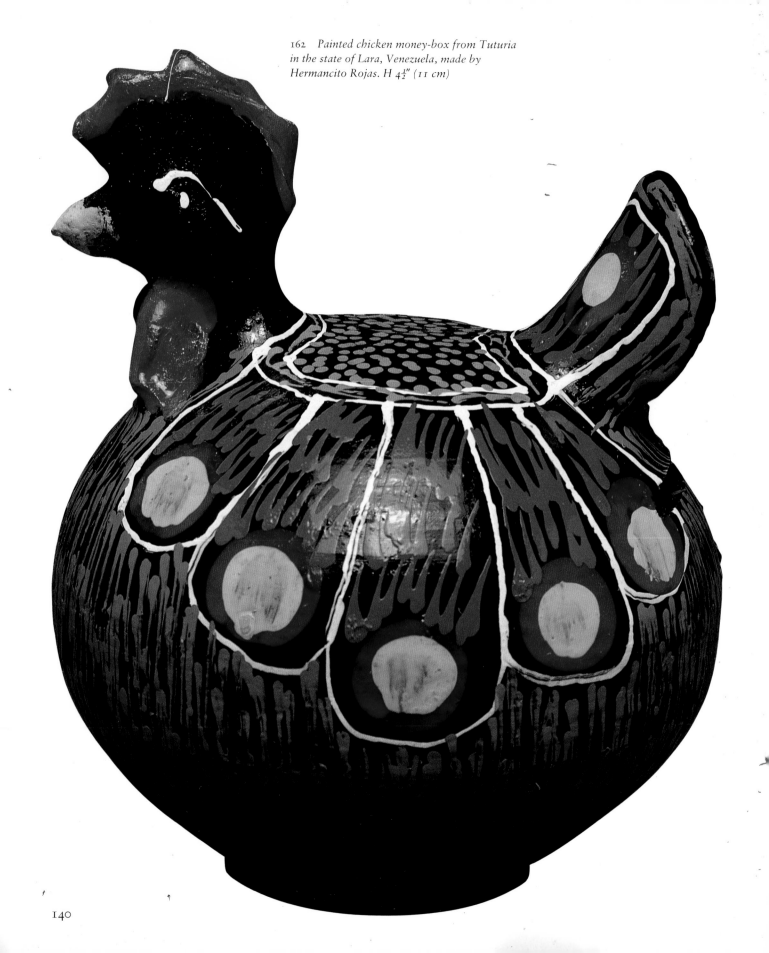

162 *Painted chicken money-box from Tuturia in the state of Lara, Venezuela, made by Hermancito Rojas. H 4½" (11 cm)*

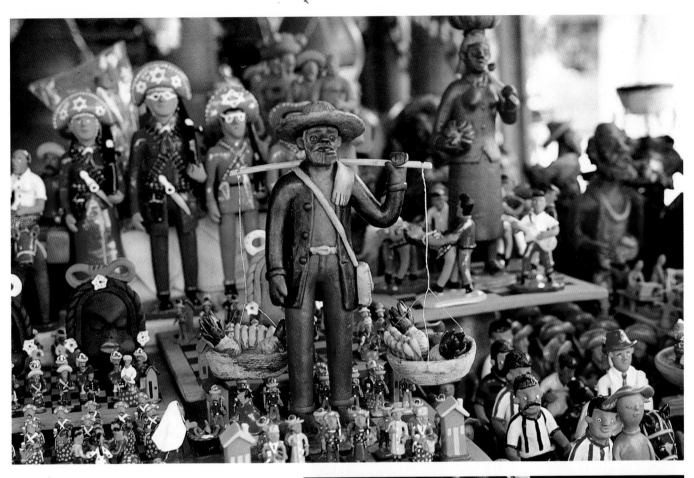

163 ABOVE *Miniature clay models of local and historical figures, including Portuguese soldiers and football players, hand-modelled and painted in Alto Do Moura, Pernambuco, Brazil*

164 RIGHT *Ceramic model of a traditional open-sided bus, or* chiva, *made in Pitalito, Huila, Colombia. H 5¼" (14 cm)*

165 Gorda *(fat woman)* figure created by the women potters of Tobatí, Paraguay. Originally a decorative detail on utilitarian war, gordas *have become popular as independent figures, and are sometimes made with a matching male partner.* H 12½″ (32 cm)

166 BELOW *Typical terracotta ware of Ráquira, Boyacá, Colombia*

167 BOTTOM *Chicken from Itá, Paraguay. Fat ceramic chickens have become the symbol of Paraguayan potters. H 16¼″ (42 cm)*

168 *Black sculpture from Tobati, Paraguay. During the last decade Tobati potters have started to apply their traditional skills to artistic and semi-abstract pieces. H 16¼″ (42 cm)*

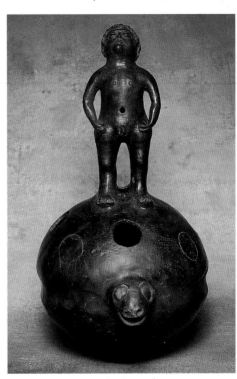

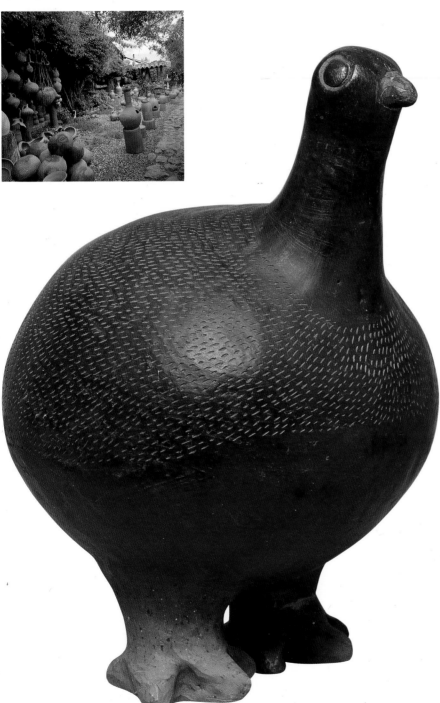

169 *Corpus Christi parade in Cuzco, Peru. Ornate carved and painted effigies of Catholic saints are paraded around the central plaza in a ceremony that dates back to the Inca period, when the mummified remains of the Inca ancestors were paraded in the same way. The Spanish prohibited the practice, but allowed the figures of saints to be carried instead. Today, like Peruvian crafts, the festival contains a mingling of Catholic and indigenous traditions*

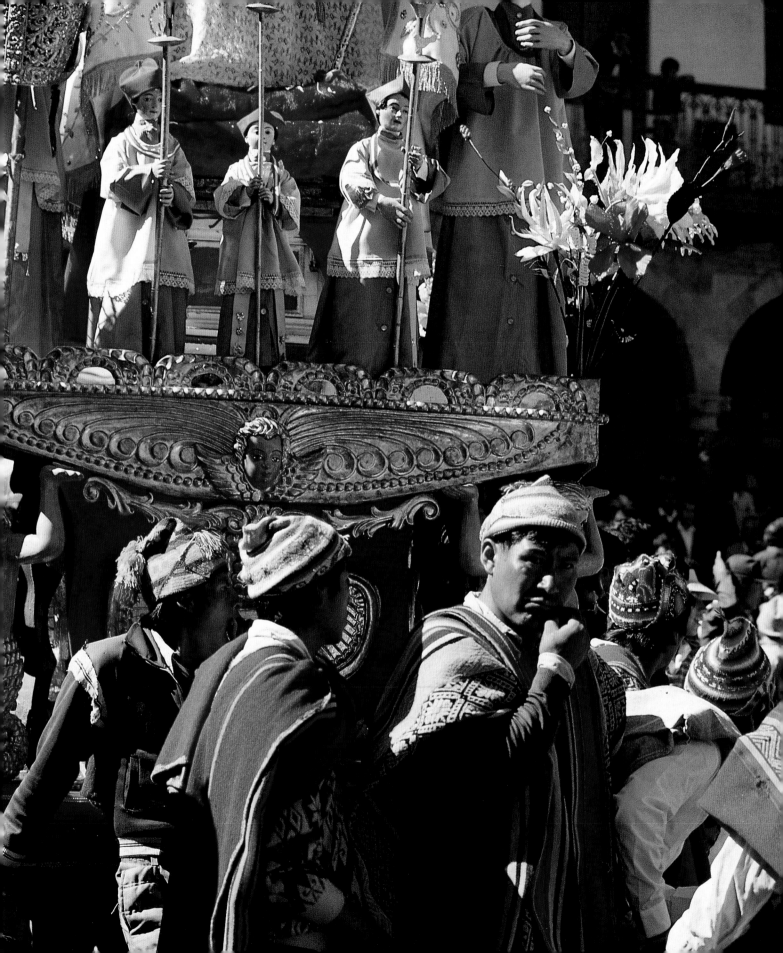

Collecting South American Arts and Crafts

To EXPLORE THE ARTS and crafts of so vast and diversified a region could take a lifetime. After fifteen years of travelling in South America we are still surprised to find remote villages practising a craft we have never heard of before. This, however, should not discourage the collector, for the very range of artefacts makes the search all the more rewarding.

Earlier in this book, we made a distinction between indigenous or traditional crafts with techniques passed on over generations, and crafts termed popular, often made with a more commercial motive, and frequently with a decorative rather than a utilitarian purpose in mind. The latter, however, still have cultural authenticity and often beauty, and of course the unique quality of any object made by hand. Nevertheless, the collector of popular arts and crafts cannot generally expect a financial return on his or her investment, but will simply collect for the pleasure of living with beautiful hand-crafted objects. The more traditional and older artefacts, on the other hand, can provide the collector with beautiful objects and some return on investment as well. For instance we once bought an early Colonial poncho in Pisac, Peru, for 10 US dollars, and a few years later, when it was shown in a display of textiles, we received an offer for it of 3,000 dollars. But we felt that the piece was too beautiful to sell.

Textiles and pottery are the two major crafts of South America, although as we have tried to show in this book, there are many other types of artefact that are well worth collecting; carved gourds from Peru, for instance. We have been collecting these for fifteen years now, and have more than a roomful, but no two are identical in shape, colour or design, and we feel sure that the gourds yet to grow and be carved will be just as varied.

Regardless of what you intend to collect, you will want to gather information about your subject. If you choose to collect Andean textiles, for example, you will want to know the geographical location of each of the communities, what language is spoken, the symbolism of the woven patterns, the materials and techniques used, and so on. Only then will you be able to judge the value of a piece – that is, the materials, traditions, time and skills that went into its making. It will help to have some basic Spanish, or Portuguese if you are going to Brazil; and if you are going to Peru, Bolivia or Ecuador you may like to learn a few phrases of the local language, Quechua, for then you will be received quite differently, and will be able to strike up a friendly relationship with a stallholder or perhaps a local weaver trying to sell her newly finished poncho.

If you are travelling independently, it may be helpful to contact the cultural section of the embassy of the country you intend to visit to enquire about regional traditions and handicrafts. If there is a shop selling crafts from that country in your area, you can see some examples before you go.

On arrival, a visit to the national crafts museum to try to identify the various products region by region will help you to buy crafts at source. To buy handicrafts in the places of origin and even to talk to the artisans who make them is one of the best ways to learn something of the local culture, and the prices will generally be lower.

Peru is exceptionally rich in handicrafts. One can spend several days in hot and noisy Lima looking at furniture, paintings, textiles and many other arts and crafts. First, however, you should get a guide to take you to the Museo de Arte, which has early Colonial and contemporary crafts, including

the first *retablos*. The Museo Nacional de Antropologia y Arqueologia has pre-Columbian textiles from Paracas and Nazca, and textiles from other early cultures can be seen in Museo Amano, in Miraflores, which also has a private collection of Chancay pots and textiles. Antiques can be bought in the Chorrillos suburb of Lima, where many houses are shops though they may not have shop windows.

If you are interested in collecting pre-Columbian textiles, Lima is the place to look. During the early 1980s we visited some pre-Columbian graves in Chancay, north of Lima, and literally picked up textiles in the desert. The *huaqueros* or grave robbers were only interested in the gold and silver, and had left the textiles behind. The craft market in the Avenida de la Marina, Lima, is an important textile source; but do not wear valuables and always take a guide.

Cuzco, Peru, is another place to buy textiles, known locally as *mantas*. To buy a *manta* is simple, but the wide variation in price of superficially similar pieces may surprise you. Generally speaking, the older pieces are more expensive, but a collector's judgement includes fineness of materials and weave, as well as age. Visits to craft museums will help you to distinguish the quality of pieces. Most pieces are from recent decades, and if you are offered a piece of early colonial vicuña cloth for a hundred US dollars, you are fortunate. Over the years we have collected hundreds of pieces from Peru and Bolivia, and have paid between 10 and 1,000 US dollars. The central market near the railway station in Cuzco has many shops selling *mantas*, and at the Sunday markets in Pisac and Chinchero you will find many of the same stallholders, but occasionally there will be a local stallholder selling an older piece.

Traditional weaving techniques can be seen practised and pre-Columbian textile symbols are still alive on the island of Taquile on Lake Titicaca, Peru, where *mantas* and *fajas* (ceremonial belts) are displayed for sale in the main plaza, and you can also see how the men knit their beautiful *chullos* or woollen hats. In Puno, visit the knitwear market along the railway, and make sure you distinguish the cheaper llama or even sheep's wool from the soft and fine alpaca wool.

The use of cochineal for dyeing is becoming less common in Andean textiles, but it is worth looking out for the soft colourings of natural dyes. With practice it is not difficult to tell natural fibres from the man-made fibres now sometimes used for Andean weaving. A test is to remove a loose thread and burn it. Wool leaves a ball of residue which smells like burnt bone, cotton leaves no residue and smells like burnt paper, man-made fibre leaves a hard residue, and smells like burnt plastic.

Bogotá, the capital of Colombia, has many craft shops, including those of Artesanía de Colombia, a government-subsidized crafts network. You will want to visit the Museo de Oro (gold museum) which, alongside a superb collection of pre-Hispanic gold, has informative displays on pre-Hispanic Colombian cultures and a shop selling replicas of gold pieces, as well as a good selection of books, many in English. The Museo de Arte y Tradiciones Populares, in a beautiful Colonial house, has craft exhibitions and a shop.

If you visit Ecuador, you can begin by strolling along the Avenida Amazonas in Quito, talking to the shopkeepers to try to identify the area of origin of the crafts that interest you. Visit the Saturday market in Otavalo, and if you can spend a few days around the neighbouring villages, especially Peguche, knock on any door or peep into a house through a crack and you will be sure to find a weaver at work. Probably he or she will invite you in, and if you are lucky, offer you a glass of *chicha*. Then you can talk at leisure, and eventually they will bring out their weavings. The price they propose will not be their final price, but by now you will have seen how textiles are sold in markets and shops, and will be able to offer a price that is mutually fair. Then seal the bargain by shaking hands or, as we do, by giving the weaver a hug and thanking him or her for the beautiful piece you have just bought.

Bolivia is an excellent source of textiles, and nowhere is better for *mantas* than the shops behind the church of San Fransisco in La Paz. Prices are lower, however, if you buy direct from the Tarabuco Indians from Sucre, who carry their loads of textiles up and down the street. Among many villages, the textiles of Candelaria, Charasani and Calcha are particularly sought after, and command higher prices.

There is a market in Tarabuco, near Sucre, and also a textile project called ASUR, based in Sucre, which works closely with the rural communities, bringing new life to traditional techniques and designs. If you are asked to pay 200–300 US dollars for a *manta*, this is a more realistic price than the 10–20 dollars

you can pay elsewhere. A *manta* will generally take about two months to weave.

The textiles you buy will not be moth-proofed, and you will need to treat them with crystals or camphor once a year, after airing them well outside. If you own any pre-Columbian pieces, it is vital to store them at correct humidity levels. Textile museums will be prepared to advise on such matters. The Smithsonian Institution in Washington, for example, has extensive collections of Andean textiles, especially Bolivian pieces. The British Museum and the Victoria and Albert Museum in London are also useful.

If a *manta* you buy has old stains on it, it is often easier to learn to live with them than to remove them, since in the process you could damage the textile. Generally speaking, however, Andean weavings are tough and can cope with washing, although the cooler the water used, the better. If you have bought a newly woven piece you will need to check whether the dyes are properly fixed before washing the whole piece. One easy way of doing this is to moisten a small part, then wipe it on white paper to see if any of the colours appear.

If you are a lover of ceramics, Ayacucho and Cuzco offer a wide range. Strolling around the San Blas area of Cuzco you can visit the many workshops, including the famous Mendivil workshop that specializes in religious figures. The pottery of Quinua, near Ayacucho, is always popular and is easily puchased in both Cuzco and Lima.

If you go to Chile, the Bellavista area of Santiago has numerous craft shops selling pottery, as well as the lapis lazuli for which Chile is famous. Collectors of miniature pottery should visit the village of Quinchamali, while cooking pots and casseroles are made in Pomaire. There you could visit the oldest potter still working, Olga Salinas, but leave plenty of time for her, for she has many tales to tell.

In Colombia, Ráquira in Boyacá offers a wide range of ceramics, from traditional utilitarian ware to mobiles and decorative pieces. Artesanía de Colombia has a centre open to the public, and a walk into the surrounding hills will bring you to the more traditional potters making their large pots.

In Asunción, Paraguay, a visit to the Museo del Barro provides a sound introduction to Paraguayan ceramics. To see the potters at work, a journey to the town of Tobati is necessary, followed by a visit to the hamlets surrounding the town. Tobati itself is an important centre for woodcarving. The Paez workshop is particularly impressive, with a wide range of figures. The town of Itá is also an important pottery centre, where the potters display their work along the roadside.

Pottery fired at low temperatures is especially liable to breakage, and it is well worth finding professional packing, or perhaps asking the seller to pack your pottery for you. If you are sending pottery rather than carrying it as hand-luggage, a sealed wooden box is essential.

Woodcarving is appreciated by everyone, and there are talented carvers all over South America. In northern Argentina, in the state of Salta, the Indians carve wood in a simple but unique style which shows off its qualities well. To see the carvers at work you take a local bus from Embarcación to Mission Chaqueña. In southern Chile the beautiful lakeside town of Villarica offers a wide selection of carved wooden items, including the ever-popular articulated animals. *Barniz*-work is best bought where it is made, in Pasto, southern Colombia. The cooperative the Casa del Barniz has a showroom and shop, and the elaborate technique is demonstrated.

The Paraguayan Toba and Guaraní Indians sell their carved animals and birds just north of Asunción. In Asunción itself there are several galleries specializing in both contemporary pottery and Indian artefacts, such as the gallery of Ysanne Gayet. If your interest is in Indian artefacts, then visit the Museo Guido Boggiani in San Lorenzo, which houses a large collection.

In Ecuador, San Antonio de Ibarra is the centre for woodcarving, and shop after shop displays a wide range, from traditional figures of old men to life-size sculptures in a more modern style. The woodcarvers can be seen at work behind the shops.

If you are interested in masks, copper replicas from the Moche culture can be found in and around Avenida de la Marina in Lima. In Pisac, near Cuzco, Peru, replicas of pre-Columbian masks are made from clay and handpainted. The most varied masks of all, however, are to be found in Paucartambo festival, near Cuzco, which takes place in July every year. Here literally thousands of people congregate to dance together, and the variety of masks is enormous. All the shops display masks for sale. Try to arrive a day early; it is a hard journey from Cuzco and there are no sleeping facilities during the festival.

In Altos, near Asunción in Paraguay, masks are carved in animal and bird forms. One can buy them from the artisans in Altos and also in Asunción. The Oruru festival in Bolivia and the Fiesta de la Virgin de Candelaria in Puno, Peru, are both good sources. Here countless different masks can be purchased. In Pasto, southern Colombia, the wooden masks of the nearby Sibundoy Indians are decorated with *barniz*. They are expensive and do not have any ritual use, but are beautiful decorative pieces.

Uruguay has relatively few handicrafts, but the craft market in the centre of Montevideo, and Manos del Uruguay, specializing in knitwear, are both worth visiting. In Buenos Aires, the capital of Argentina, there is a lively Sunday market in Plaza Dorrego (San Telmo) selling a wide range of antiques. There is also live music from buskers and public tango lessons for those brave enough. Artesanías Argentinas, a non-profit-making organiztion with a couple of shops, has the best selection of Argentine handicrafts as well as helpful and informative staff.

Brazil's production of precious and semi-precious stones gives rise to few handicrafts, for they are mostly exported in natural form and set elsewhere. In São Paulo, however, young artists and craftspeople gather on Sundays in the Praça da Republica, displaying a wide range of leather, stone and batik work. There is a friendly and relaxed atmosphere in this market, and you can chat to the craftworkers and artists. The Museo de Arte Popular in Ibirapuera has a splendid display of arts and crafts from all over Latin America in an enormous exhibition hall. Elsewhere, several villages around Recife, in the north east of Brazil, produce woven hammocks and pottery. In Alto Do Moura, near Caruaru, both men and women specialize in making miniature ceramic figures. Here you can walk into any house and be welcomed with open arms, but speaking a little Portuguese will increase your enjoyment.

Finally, Venezuela has relatively few handicrafts, but if you travel by road from Caracas to Mérida you will pass through various small craft villages, such as Tabay, where you will find fascinating naive figures carved and painted by talented arti-sans. Bocono, in the state of Trujillo, has a selection of crafts on sale in the centre of town, and utilitarian pottery is produced there by the Briceno family. A large weekend market is held outside Quibor, in the state of Lara, and sells pottery made in Quibor itself and smaller communities, as well as woodcarvings from nearby Guadalupe and textiles from Tintorero. Ismanda Correa, editor of the magazine *Artesanía y folklore de Venezuela*, has set up a permanent exhibition of national handicrafts in Caracas.

The growing demand for South American handicrafts has led to the opening of shops in the USA and Canada, the UK and Europe. Ever since our first Tumi shop opened in the UK in 1978, there has been a surge of shops opening all over Europe, America and far beyond. There are now Tumi shops specializing in Latin American artefacts in London, Bath, Bristol and Oxford. The demand for all aspects of arts has enabled us to venture into South American traditional music. Now not only can you buy most South American artefacts, you can also collect a wide range of rhythms on the Tumi (Music) label.

There are similar shops in Edinburgh, such as Azteca which specializes in Mexican artefacts but nevertheless has a good selection of South American crafts. In Brighton, Sussex, Tucan also specialize in South American products. There are many more non-specialist shops, such as Oxfam, Traidcraft, One World, Dartington Trading Company in Devon and War on Want in Belfast, Northern Ireland, that have a considerable range.

In the USA, among many there are Pier Import in Fort Worth, Kaiman Import-Export in Chicago and Third World Arts and Crafts in Florida. The Smithsonian Institution in Washington provides resources for research and holds excellent exhibitions of South American artefacts. Alongside these exhibitions, related handicrafts are sometimes sold. Shops scattered across Europe include El Tumi, which has various outlets in Switzerland; Boutique Rique Latine, Macchu Pichu, Andines and Cumbia in Paris, and many others, selling a variety of South American artefacts.

LIST OF SOUTH AMERICAN SOURCES

Argentina

Buenos Aires: Artesanía Argentinal, Montevideo 1386, Cordoba 770, craft shop. Plaza Dorrego (San Telmo), Sunday market. Tourist information offices for each province, often with exhibitions of regional crafts.

Bariloche (southern Argentina): craft market with pine artefacts.

Cafayate: craft cooperative in central square; workshop of potter Manuel Cruz.

Quilmes ruins and *Amaicha del Valle*: large craft shop at each, selling textiles and pottery of the region.

Santa Maria de Catamarca (near Amaicha del Valle): wallhangings.

Tucumán: Mercado Artesanal de la Provincia de Tucumán, Avenida 24 de Septiembre 565, San Miguel de Tucuman.

Salta, Tartagal (northern Argentina): Toba and Guaraní woodcarving for sale.

Bolivia

La Paz: Around church of San Fransisco, Colonial houses selling textiles and crafts. The street Sagarnaga, especially no. 288, for handicrafts generally. Andean music in the *penas* or night clubs.

Cochambamba: Mercado Artesanal.

Sucre: ASUR, Caseron de la capellania, San Alberto 413, textile exhibitions and shop.

Tarabuco, near Sucre: Saturday market.

Brazil

Brasilia: FUNAI, indigenous organization with craft shop.

Belo Horizonte, Minas Gerais: Gem Centre, Central Shopping Mall, Avenida Afonso Pena 1901, 5th floor.

Ouru Preto, Minas Gevais: Museo de Mineralogia e das pedras. Also stones and soapstone carvings for sale in shops and on the streets.

Recife: Casa da Cultura, with craft shops. *Alto Do Moura, Timbauba, Tracunhaem*: craft villages near Recife. *Ceramica Brennand*, suburb of Varzea, outside Recife.

Rio de Janeiro: Museo do Folklore Edison Carneiro, Rio do Catete 181. Museo do Indio, Rio das Palmeiras 55, Botafogo. Praça General Osorio, Ipanema, Sunday craft market.

São Paulo: Praça da Republica, weekend craft market. Ibirapuera Museo de Arte Popular. Embu village (near São Paulo), craft centre, best visited at the weekend.

Chile

Santiago: Mercado Central. Santa Lucia hill, craft market. Almacen Campesino Ltda, Purisima 303, Barrio Bellavista. Minga, cooperatives in Santiago and other cities.

Chiloe Island: knitwear, and Sunday market at Dalcahue.

Pomaire: pottery, numerous roadside shops.

Quinchamali: black pottery.

Rari: horsehair weavings.

Temuco: craft market selling Mapuche art.

Villarica: craft markets selling mainly woodwork.

Colombia

Bogotá: Artesanía de Colombia, state-owned company with many shops in Bogotá and craft centres across the country; in Bogotá, Almacen San Diego, Cra 10, no. 26–50. Museo de Arte y Tradiciones Populares, Cra 8, no. 7–21. Museo de Ora, Parque de Santander.

Pasto: Casa del Barniz, C 13, no. 24–29.

Ecuador

Quito: Avenida Amazonas, craft shops.

Otavalo: Saturday market, the centre for handicrafts in Ecuador.

Paraguay

Asunción: Plaza de los Heroes, craft market. Arte Popular, Pitiantuta, near Avenida Mariscal Lopez. Casa Viola, in front of Palacio de Lopez. Galleria de pintura naif y arte primitivo, Ysanne Gayet, General Santos 487. Museo del Barro, Centro de Artes Visuales, Calle uno y Emeterio Miranda y Molas Lopez (Isla de Francia). Museo Guido Boggiani, Coronel Bogado, nr prolongation of Avenida Mariscal Lopez, San Lorenzo.

Altos, near Asunción: masks.

Arequa: pottery, with shops on roadside.

Itá: pottery, with work displayed in the streets.

Tobati: woodcarving, especially religious figures, and pottery.

Peru

Lima: Museo Nacional de Antropologia y Arqueologia, Plaza Bolivar (San Martin with Antonio Polo), Pueblo Libre. Antisuyo, Jr Tacna 460, Miraflores, indigenous crafts. Avenida de la Marina, permanent craft markets.

Cuzco: market, post-Colonial textiles. St Blas district, religious figures. *Chinchero* and *Pisac*, near Cuzco: Sunday craft markets. Pisac: centre for ceramic bead production.

Uruguay

Montevideo: Manos del Uruguay, Reconquista 602/587 and San Jose 1111, craft organization with shop selling primarily knitwear. Plaza Cagancha, craft market.

Venezuela

Caracas: Artesanía Venezolana, Palacio de las Industrias, Pro-Venezuela. Ismanda Correa (editor of *Artesania y folklore de Venezuela*), exhibition Apt. 60.935 Chacao, Caracas 1060.

Quibor: weekend craft market.

SOURCES IN THE UK, USA, CANADA, EUROPE, AUSTRALIA

The UK
England

Dartington Trading Company Ltd, Shinners Bridge, Dartington, Totnes, South Devon, TQ9 6T4

Tucan, 29 Bond Street, Brighton, BN1 1RD

Tumi, 8/9 New Bond Street Place, Bath, Avon, BA1 1BH; 23 Chalk Farm Road, Camden Town, London, NW1; 1/2 Little Clarendon Street, Oxford, OX1 2HJ; 82 Park Street, Bristol, BS1 5LA

Scotland

Azteca, 16 Victoria Street, Edinburgh, EH1 2HG; 5 The Grassmarket, Edinburgh, EH1 2HY

Northern Ireland

War on Want (NI), 52 Botanic Avenue, Belfast, BT7 1JR

USA

Bergquist's Import, 1418 Highway 33, South Cloquet, Minnesota 55720

Casa Antigua de Palo Alto, 632 Emerson St, Palo Alto, California, CA 94301

Export/Import, PO Box 83, Aurora CO 80010-00R3

The Eyes Gallery, 402 South St, Philadelphia, PA 19147

Kaiman Import-Export, 4113 N. Damen, Chicago 1L 60618

Pier Import, 410 Houston St, Fort Worth, Texas

The Sojourner, c/o New Vista Traders, 1511 Rt. Rt. 179, Lambertwille, NJ 08530

Textile Museum, 2320 S Street, Northwest Washington DC, 2008

Third World Arts and Crafts, 1893 Clarcona-Ocoee Road, Ocoee, Florida 34761

Tucano, Ocean Avenue, between San Carlos and Dolores, PO Box 7108, Carmel, CA 93921

Canada

Antiquité et Artisanat Arauco, CP 386 Tour de la Bourse, Montreal, Que. H4Z 1J2

Bead Emporium of Montreal Inc. 364 Victoria Avenue, Montreal

Boutique Inca, 4094 St Denis, Montreal

Les Fourrures Pontian Inc, 3440 St Denis, Coin Sherbrooke, Montreal, Que. H2X 3L3

Rio, 3459 St Denis, Montreal H2X 3L1, Metro Sherbrooke

Europe
Austria

Walter Pfeiffer, Schalgasse 10, 7033 Pottsching

Luif, Gessllschafr Mbh, Osterleitengasse 7a, A-1190, Vienna

France

Boutique d'Amerique Latine, 64 Boulevard Pasteur, 75015 Paris

Germany

Paul Schrader U Co. Gutenbergstrasse 7, 28844 Weyhe, Dreye

Tucano, Rosgartensr. 6, D-78462 Konstanz

Holland

Secan, Droste Strasse 23–25, 3958 BK Amerongen

Portugal

Colecoes de galeria Ltda, Rua D. Fuas Roupinho, 35-A, 1900 Lisbon

Spain

Chevere, Avenida de las Playas No. 55, 35340, Lanzarote

Gullifer S.L., c/Cuntis, 59, Ferrol

Indoamerica, Calle Don Ramon de la Cruz No. 102, 28006, Madrid

Natura Selection S.L., Calle Consejo de Ciento No. 304, 8007, Barcelona

Switzerland

Boutique Artisanale 'La Chovette', CH-1663 Gruyères

El Indio, Schueupzenmapt Str 1, Basle 4051

El Tumi, Scheffelstrasse 7, 9500 Wil; Also shops in Zurich, Bern, Winterthur, Gallen

Orazio Berquier, Gafudernstrasse 3, 8908 Hedingen

Redes, City Passage, 4600 Olten

Scandinavia
Norway

Inca Wear, Husbikbeien 14–40, Droak

Finland

Africa Kauppa/Devaid Oy, Mannerheimintie 44, 00260 Helsinki

Australia

Andes Import Marketing, 11 Orphan Street, Daisy Hill, Brisbane, Queensland 4228

Artesania 28, Raglan Road, Mt Lowley, WA 6050

RIGHT *Map of South America showing locations mentioned in the text*

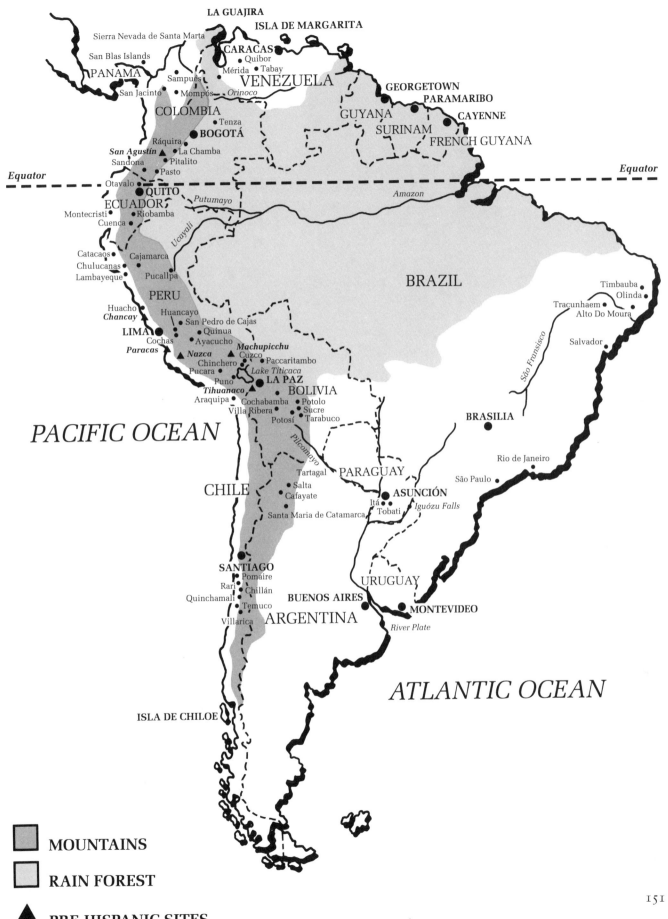

LA GUAJIRA

ISLA DE MARGARITA

Sierra Nevada de Santa Marta

San Blas Islands

CARACAS
• Quibor
• Mérida • Tabay

PANAMA

VENEZUELA

• Sampués

GEORGETOWN

PARAMARIBO

San Jacinto • Mompós — *Orinoco*

COLOMBIA

GUYANA

SURINAM

CAYENNE

FRENCH GUYANA

• Tenza

BOGOTÁ

Ráquira

San Agustín ▲ • La Chamba

Sandona • Pitalito

• Pasto

Equator - *Equator*

Otavalo •

QUITO

Amazon

ECUADOR

Putumayo

Montecristi • • Riobamba

Cuenca •

Ucayali

Catacaos •

Cajamarca •

BRAZIL

Timbauba

Olinda •

Chulucanas •

Tracunhaem •

Lambayeque • Pucallpa •

Alto Do Moura

PERU

Salvador

Huacho •

Huancayo •

Chancay

• San Pedro de Cajas

São Fransisco

LIMA •

• Quinua

Cochas • Ayacucho

Machupicchu

Paracas

Nazca ▲ Cuzco

Chinchero • • Paccaritambo

Pucara •

Lake Titicaca

Puno •

LA PAZ •

Tihuanaco ▲

BOLIVIA

Araquipa • Cochabamba • • Potolo

Villa Ribera • • Sucre

BRASILIA

Potosí • Tarabuco

PACIFIC OCEAN

Rio de Janeiro

Pilcomayo

São Paulo •

Tartagal •

PARAGUAY

CHILE

• Salta

• Cafayate

ASUNCIÓN

Itá • *Iguózu Falls*

Santa Maria de Catamarca

Tobati

SANTIAGO

• Pomaire

Rari •

URUGUAY

• Chillán

Quinchamali •

BUENOS AIRES

• Temuco

MONTEVIDEO

Villarica •

ARGENTINA

River Plate

ATLANTIC OCEAN

ISLA DE CHILOE

� MOUNTAINS

RAIN FOREST

▲ PRE-HISPANIC SITES

SOUTH AMERICA'S INDIGENOUS PEOPLES

Today, five centuries after the European 'discovery' of the continent and the ensuing destruction of Indian lives, there remain an estimated fifteen million indigenous people. Some eleven million live in the Andean highlands, one million are forest-dwellers who inhabit the Amazon basin, and the remaining peoples are scattered across South America and along the Pacific and Atlantic coasts. Despite the vast geographical diversity found in South America, all the indigenous people have shared a number of simple cultural features. The sun and moon have been looked upon as the 'great deities', and predatory animals such as the eagle, jaguar and anaconda have played an important symbolic role in their lives. Today, these aboriginal beliefs survive only in remoter areas where foreign influences have been minimal.

Since the Conquest intermarriage between indigenous and European peoples has blurred the concept of the 'pure Indian' to the extent that in most cases it is impossible to say who is 'Indian' and who is 'mestizo'. Nevertheless, in practice there is a clear distinction between the two, marked chiefly by language and lifestyle rather than physical characteristics. The Indians speak their native language rather than Spanish or Portuguese. Usually they maintain their traditional life of subsistence farming. They are mostly self-sufficient and wear their traditional clothes. The mestizos on the other hand speak both Spanish and their native language, and live predominantly in urban areas, becoming more and more important as a labour force in these newly industrialized countries.

Prior to the Conquest the Indians spoke a vast number of languages. Today, many languages have survived but only Aymara and Quechua are spoken by significant numbers of people.

AYMARA: *population 1¼ million*. High above the tropical forests of the Amazon basin, surrounded by the peaks of the Andes, lies a wide, barren and hostile plateau, the *altiplano*, with Lake Titicaca. Prior to Inca rule Tihuanaco on Lake Titicaca was a highly organized centre for one of the greatest cultures South America had ever witnessed: the Aymara people. Today the shores of this lake and the plains that surround it remain the homeland of the Aymara. The majority live in Bolivia, and some one-a-half million are scattered on the western side of Peru and northern Chile. The climate is so harsh that, though they are extremely hardworking, their lives are very poor. They speak their own unwritten language, Aymara. Aymara women weave the finest woollen textiles of all sorts on their small horizontal looms, consisting of four sticks in the ground.

GUAMBIANO: *population 15,000*. The Guambiano are among the few great Indian nations of sixteenth-century Colombia still surviving, living on fifty-seven reservations in the hills above the Cauca Valley, and unlike many other indigenous groups, they have maintained their traditional language, which is Chibcha. They practise subsistence agriculture, growing maize, potatoes and beans, and supplement their income by selling their craft goods. During the last four centuries the Guambiano have resisted both contact and change. Their religion and traditional medicine are not revealed to white visitors for fear that they will lose their power.

GUARANÍ: *population 20,000*. The Guaraní Indians are a group consisting of various tribes, most living in Paraguay but some in Argentina and Brazil. Since the arrival of European settlers the life of the Guaraní has changed radically.

Many of the Guaraní came under the influence of the Jesuit missionaries at an early stage of contact. Although there is often a veneer of Catholicism, the strong mysticism of original Guaraní culture is still distinctive. Shamans are priests and curers and are immersed in rituals and supernatural communication. Their language consists of several dialect groups, including Chiripa, Nandeva, the Karwa and the Mbya.

KOGI: *population 2,500*. The Arhuacan Kogi are a remnant of the Tairona people, a highly developed culture who were among the first Indians to come into contact with the Spanish. In the ensuing hostilities the Tairona were forced to retreat to the inaccessible slopes of the Sierra Nevada de Santa Marta in northern Colombia. They occupy much of their time with agriculture, growing corn, potatoes, beans and coca leaves. The men continually chew coca leaves, but women may not use coca. Their complex rituals are led by the 'moma' or priest, who is chosen at birth. Their universe is pictured in the form of an egg, with nine layers. The men and women live in separate dwellings, and may not enter eachother's houses. The conical root of the men's ceremonial house symbolizes both the universe and mountains, all of which are in the womb of the mother, the supreme goddess.

KUNA: *population 30,000*. The Kuna Indians live on the shores of the Caribbean sea of Colombia and Panama. The majority of them live on the San Blas Islands off the coast of Panama, while smaller groups are found around the Gulf of Uraba in Colombia. Like their neighbours the Noanoma, with whom they share many cultural characteristics, the Kuna spend much of their time in and around water.

They are famous for their *molas* or appliqué blouses, and the men are excellent craftsmen. They carve small figures of wood which are used in curing ceremonies.

MAPUCHE: population 500,000. The Mapuche Indians of southern Chile are among the most fierce of the Indian societies of South America. During their three-centuries-long struggle with the white settlers they were frequently victorious. After their eventual defeat in 1882, many thousands crossed the Andes into Argentina where they constitute a sizeable population today. Those who remained in Chile were forced to settle in reservations, yet they retained their native language, their religious beliefs and rituals. In the 1960s the reservation system was abolished, and the Mapuche were legally transformed into small landowners.

Today many Mapuche have blended into the *mestizo* population and live in cities such as Temuco, where they constitute the lower class of workers. Those who live in the countryside concentrate on subsistence farming, and help to support their lives by making excellent wooden carved figures, while the women weave belts, ponchos and shawls which are sold to visitors in and around Temuco.

OTAVALO: population 40,000. It is believed the Otavalans, originally known as the Cara Indians, came to Ecuador from southern Colombia about AD 900 and settled in and around Otavalo. When the Incas arrived, four centuries later, the Caras were well established in the region, already weaving and trading their products. Situated in a fertile valley, two hundred km north of Quito, Otavalo is a nucleus of trade for more than seventy-five scattered Otavalan communities.

One of South America's most famous indigenous groups, the Otavalans are distinctive people, renowned for their skilled weaving, and they have grown prosperous through their success as traders.

Among the few remaining self-governed groups left in South America, these people have consistently managed to adapt to negative external influences, successfully turning them to advantage. They travel extensively, to Colombia, Venezuela, North America and as far afield as Europe, in search of new markets for their products, and inevitably, possessions such as colour televisions and modern houses have altered their lifestyle. But they have absorbed change without abandoning their indigenous heritage. Following tradition, the Otavalan men, with their white trousers and patterned ponchos, still wear their hair long and plaited under a black trophy hat. The women's colourful costumes consist of embroidered blouses, headdresses and a plethora of coloured beads.

All families speak Quechua – the Inca language – as their first tongue, and Spanish as their second.

QUECHUA: population 3 million. According to an Inca legend, the Quechuas were a small group who originally lived near Lake Titicaca. They later moved to Cuzco, from where they expanded to create the Inca empire. Their culture and language soon spread from Quito in the north through present-day Ecuador, Peru and Bolivia to northern Chile. Predominantly an agricultural society, growing potatoes and corn as their basic diet, it was the Inca above all who mastered the art of textile weaving. Today there remain two enduring legacies of Inca rule: their magnificent architecture and their unwritten language, Quechua, which has given its name to the descendants of their subjects. Some eight million Quechua-speaking people live in the highlands of Peru, and the rest are scattered in the highlands of Ecuador and Bolivia.

WAYUU: population 50,000. The Wayuu are the only nomad desert tribe in South America. They live along the peninsula known as La Guajira in the north of Colombia and Venezuela. They speak Arawak, and are relatively prosperous, due to to their adaptability. They have increasingly become semi-nomadic, as they move in search of grazing and water, sometimes extracting sea salt to sell. Wayuu society is divided into thirty castes, each caste associated with well-defined territories. The Wayuu women grow patches of fast-growing corn, and spin and weave both cotton and wool for their hammocks and *mochilas* which they sell.

GLOSSARY

aksu Skirt woven as two pieces of cloth, worn overlapping at the sides and held up with a woven belt, by indigenous women in Bolivia.

alpaca Animal related to the llama with longer and softer hair, commonly spun for weaving and knitting in Peru and Bolivia. Also, the term for a metal alloy containing a low percentage of silver, used most commonly in jewelry, in the form of wire.

altiplano Barren region of Peru and Bolivia at an altitude at which few trees and plants can grow.

Amare Textile motif. Deity in the form of a two-headed snake, woven in pre-Columbian textiles in Peru.

anacos Loose woven skirt worn by the Guambiano men of southern Colombia.

aniltun Black earth used by Mapuche Indians of Chile as a textile dye.

antaras Musical instrument made of seven joined ceramic tubes, of pre-Hispanic origin, and played in Peru and Bolivia.

arybola Ceramic vessel dating from the Inca period designed to carry *chicha*, fermented corn beer, still made and used today.

bandurria Stringed guitar-like instrument, introduced to South America by the Spanish.

barniz Decorative work of pre-Hispanic origin, using thin sheets of dyed resin to create designs on wooden articles, practised in Pasto, southern Colombia.

barqueños Carved wooden cabinets with many drawers, originally made to hold accounting papers during the Colonial period. Today still made in Peru in Colonial style.

bayeta Plain cream woollen cloth woven in Peru and Bolivia.

berimbao Bow-like instrument played by being plucked, used in north-east Brazil to accompany a dance, the *capoeira*.

bombilla The silver hollow spoon, used like a straw to drink máte tea, usually from a gourd, in Uruguay, Paraguay and parts of Argentina and Brazil.

bombos Drums commonly played along the Caribbean coast, made from hollowed-out tree trunks.

Cajamarquiño In the style of Cajamarca, in northern Peru, a term used for a certain style of hand-painted mirror.

cantaro Pitcher.

carrancas Brazilian wooden carved head with grimacing expression, positioned on the prows of boats.

cha'jchas Llama hooves shaken as percussion instrument in the Andes.

charango A ten-stringed guitar-shaped instrument, smaller than the guitar and traditionally made from the shell of an armadillo, played in Peru and Bolivia.

chawai Silver earrings worn by the Mapuche women of Chile.

chichera A woman who sells *chicha* (fermented corn beer) in the streets. Also a traditional ceramic piece from Chulucanas, northern Peru.

chiclet Tiny *chiclet* (chewing gum) boxes are sometimes used for miniature *retablo* Nativity scenes in Peru.

chivas Popular name for the wooden open-sided buses of southern Colombia, reproduced in clay.

chodwekur Yellow earth used by the Mapuche weavers of Chile as a dye.

chukoo Black cloak worn by Taquile Island (Lake Titicaca) brides.

chullo Knitted woollen hat with ear flaps, commonly worn by indigenous men and women across the Andes.

chulpas Textile motifs. Creatures that inhabited the earth before the dawn of time, woven in the *aksus* or skirts of the Jal'qa people of Bolivia.

chumpi Quechua word for a woven belt.

ch'uspa Quechua word for a small bag woven with the specific purpose of carrying coca leaves to chew.

cochas Silver bowls used for ritual practices in the Andes.

Cruz del Sur The Southern Cross. When the constellation is visible at the begining of May an important festival is celebrated in the Andean world, known as *Fiesta del Cruz*.

Cruz de la Siembra Guardian of the fields, an important textile motif of pre-Hispanic origin.

cuatro Four-stringed guitar-like instrument popular in Venezuela.

encomienda A system set up by the Spanish by which Indians were allocated to Spanish landowners, from whom either tribute or labour could be demanded.

estera The beginning of a woven sombrero, in which two fibres are crossed, forming the centre of the crown.

faja General Spanish term for belt.

gaita Traditional band for *cumbia* music in Colombia, consisting of *gaita* flutes, drums and a single maraca.

Gaucho Latin American cowboy, in Argentina and parts of Paraguay and Uruguay.

gonna Wedding blouse of the brides on Taquile Island, Lake Titicaca, Peru.

guayuco Loincloth traditionally worn by the Wayuu men of La Guajira, northern Colombia and Venezuela.

Hatun Chaska Textile motif. Quechua name for the planet Venus, an important symbol, woven into belts in Taquile Island, Lake Titicaca.

huacrapucu Twisted horn played like a trumpet, a traditional Andean instrument.

huaka Woven belt worn by Aymara women.

huallquepo Coca bag used by the Aymara pre-Inca inhabitants of Peru.

huatana Narrow belt plaited into a woman's hair to show she is married.

huguna Decorated *bayeta* (cream woollen cloth) Inca blouse.

Inkari Textile motif. The spirit of the Inca king expected by many to return one day. Inkari is woven into Peruvian textiles as a frog with tadpoles.

Inti Textile motif. Quechua name for the sun.

iscayo Mantle worn by Aymara women prior to Inca settlement.

Iwouya Textile motif. The bright star, symbol used by the Wayuu Indians of northern Colombia and Venezuela.

Jailianaya Textile motif. Wayuu Indian symbol known as the 'mother of all motifs'.

janaa Wayuu term for a woven hammock.

Januleky Textile motif of the Wayuu. Double-headed fly.

Kalepsu Textile motif of the Wayuu, the shape of natural hooks.

kanaas The art of weaving symbols in the vertical looms of the Wayuu.

katana-oncoma Ritual cloth that covers hands of the bride during the three-day wedding ceremony of Taquile Island, Lake Titicaca, Peru.

k'epas Horn trumpets of the Andes.

keros Wooden vessels used by the Incas for drinking *chicha* (fermented corn beer).

kikai Silver discs worn on a cord around the neck by Mapuche women of Chile.

Las gordas Literally, fat women, the name given

to the ceramic figures of Tobati, Paraguay.

llacata Mantle, worn by Aymara men before the Incas settled Peru.

llahua Tunic, worn by Aymara men before the Incas settled Peru.

llicllas Quechua name for a woven carrying-cloth.

mapires Fibre bags woven on Margarita Island, off the Caribbean coast of Venezuela.

maguey Also hemp or *pita* fibre. A fibre from the American agave plant, used for weaving bags, sombreros, rope, twine, sacking, etc, in many parts of South America.

marimba Xylophone-like instrument from the Colombian Pacific coast.

máte burilado Carved gourd, such as those made in Cochas, near Huancayo, Peru.

makhnu General Quechua term for any natural dye used for textiles, but originally referring to cochineal.

mestizo Person of mixed indigenous and European descent.

Missiones Settlements formed by the Jesuit brothers in Paraguay, Argentina and Brazil in the seventeenth century, created to house the indigenous population. Many Indians continue to live in areas still referred to as *Missiones*, although there is not necessarily any religious element present.

mita Inca textile workshop.

mochila Spanish term for shoulder-bag.

mola Originally cotton blouses worn by the Kuna Indian women of the San Blas Islands and northern Colombia, now decorative panels.

montera Large wide-brimmed hat worn by indigenous women in some Andean communities.

mopa mopa Popular name for the tree whose seed-pods produce the resin used in the Colombian *barniz de Pasto*.

moseños Andean bamboo wind instruments blown from the side.

mudejar Spanish-Moorish style in carving and painting brought to South America during the Colonial period.

nopal Cactus on which the cochineal insect lives.

nunuma Textile motif. A duck symbol, woven on Taquile Island, Lake Titicaca, Peru; seen as the mother of the water and as representing the creator-deity Wiracocha. In Quechua, *nunu* means 'breast' and *uma* means 'leader'. In Aymara, *uma* means 'water'.

personaje Textile motifs. Supernatural beings that include some human attributes.

pinquillos Bamboo whistles of three octaves played in the altiplano of Peru and Bolivia.

pollera Wide gathered skirt commonly worn by indigenous women in Peru and Bolivia, thought to be of Spanish origin.

poporo Container for storing lime, used when chewing coca leaves by various indigenous communities.

porkura Yellow stone used by the Mapuche Indians of Chile to dye wool.

pututu Conch shell blown by Incas to announce the beginning of a ritual or ceremony, still blown in Andean ceremonies today.

quenachos A larger version of a *quena* (see below).

quena Bamboo flute, a traditional Andean instrument.

quincha Small white cloth symbolizing purity, hidden in a bride's skirt during weddings on Taquile Island, Lake Titicaca, Peru.

requintos Ten-stringed guitars.

retablo Originally a portable altar which came to the New World with the Spanish soldiers, now a popular craft object made in Peru.

sheii Funerary textiles of the Wayuu Indians of La Guajira, northern Colombia and Venezuela.

shigras Bags made from *maguey* (hemp or *pita*), fibre of the American agave plant, near Salcedo, Ecuador.

susu The shoulder-bags of the Wayuu Indians of northern Colombia and Venezuela.

suyos Textile motif. Circle showing division of land on Taquile Island, Lake Titicaca, Peru.

tapyta A terracotta slip used by the women potters of Tobati, Paraguay.

taruka Textile motif of a mountain deer, believed to carry the treasures of the mountain gods and spirits.

tarkas Square wooden flutes, emitting a shrill sound, a traditional Andean instrument.

tambor con charchillo War-drum with vibrating cactus spines.

totora Reeds used to weave mats and boats in Ecuador and around Lake Titicaca, Peru.

toyos Andean wind instrument, large bamboo pipes.

trarilonco Cord with suspended silver discs,

traditionally worn across the forehead by the Mapuche women of Chile.

trapelakucha Silver brooch with cross-symbol worn by the Mapuche women of Chile.

tumbaga Gold and copper alloy used by pre-Hispanic Colombian metalworkers.

tumi Sacrificial knife, originating with the Moche culture of Peru (200 BC–AD 600).

tupu Silver pin with decorative head used by women in Peru, Bolivia and Ecuador.

unkuna Small woven cloth for coca leaves, used in Peru and Bolivia.

urku Wrapped dress worn by Aymara women of the Peruvian Andes before the Inca period.

unku Male Inca tunic.

vicuña Rare cameloid wool of the llama and alpaca variety, highly valued for its softness.

walt'ana Soft *chumpi* or belt especially woven to wrap a baby to ensure proper growth in indigenous communities in Peru.

wayuusheein Also known as *manta guajira*, the full-length cotton dress worn by the Wayuu women of La Guajira.

wayuwaite Wide belt woven and worn by Wayuu women.

womo kots Sombreros woven and worn by the Wayuu Indians of La Guarija.

zampoñas Bamboo panpipes, with two rows of varying size and tonal range.

BIBLIOGRAPHY

Adelson, Laurie, and Arthur Tracht, *Aymara Weavings. Ceremonial Textiles of Colonial and Nineteenth Century Bolivia.* New Haven, Conn., 1983.

Alva Alva, Walter and Maiken Fecht, Peter Schauer, Michael Tellenbach, *La Tumba del Señor de Sipan, Descubrimiento y Restauracion,* Mainz, 1989.

Aretz, Isabel, *La Artesania Folklorica de Venezuela,* Caracas, 1978.

Bankes, George, *Peruvian Pottery,* Aylesbury, 1989.

—, *Moche Pottery from Peru,* London, 1980.

Bawden, Garth, and Geoffrey W. Conrad, *The Andean Heritage,* Cambridge, Mass., 1982.

Box, Ben (ed.), *1994 South American Handbook,* Bath, 1993.

Bridges, Marilyn, *Markings, Aerial Views of Sacred Landscapes,* Oxford, 1986.

Burger, Julian, *The Gaia Atlas of First Peoples,* London, 1990.

Coe, Michael, Dean Snow, Elizabeth Benson, *Atlas of Ancient America,* New York, Oxford, 1986.

Escobar, Ticio, *Una Interpretacion de las Artes Visuales en el Paraguay,* vol. 1, Asunción, 1982.

Fini, M., *The Weavers of Ancient Peru,* Bath, 1985.

Fuente, Maria del Carmen de la, Maria Josefa Nolte, Lucy Nunez Rebaza, Roberto Villegas Robles, *Peruvian Crafts, Origins and Evolution,* Lima, 1992.

Guaman Poma de Ayala (Waman Puma), Felipe, *El Primer Nueva Coronica y Buen Gobierno,* vols 2, 3, Mexico City, 1980.

Harlow, Eve (ed.), *The Art of Knitting,* Glasgow and London, 1977.

Hemming, John, *The Conquest of the Incas,* London, 1970.

Hernandez, Daria, and Cecilia Fuentes, *Fiestas Tradicionales de Venezuela,* Caracas.

Iregui de Holguin, Cecilia (Direccion), *El Hombre y su oficio, Ceramica, Cesteria y tejidos en Boyaca,* Colombia, 1983.

Jaramillo Cisneros, Hernan, *Textiles y Tintes,* Quito, 1988.

Kauffmann Doig, Federico, *Manual de arqueologia Peruana,* Lima, 1969.

Langeback, Carl Henrik, *Gold and Precolumbian Cultures,* Bogotá, 1992.

Meisch, Lynn, *Otavalo Weaving, Costume and the Market,* Quito, 1987.

Moseley, Michael E., *The Incas and their Ancestors,* London, 1992.

Osborne, Harold, *South American Mythology,* Middlesex, 1968.

Pekic, Vojislav, *Brazil,* London, 1990.

Razzeto, Mario, *Don Joaquin, testimonio de un artista popular andino,* Lima, 1982.

Rebolledo G. Loreto, *Artesanas de Rari Tramas en Crin,* Santiago, 1991.

Salerno, Osvaldo, *Paraguay: artesania y arte popular,* Asunción, 1983.

Salvat Editores, *Arte Precolombino de Ecuador,* Quito, 1985.

Stastny, Francisco, *Las Artes populares del Peru,* Madrid, 1981.

Sweeney, Philip, *Directory of World Music,* London, 1991.

Tumi Journal, No. 2, Tumi, Bath, 1992.

Villegas, Liliana y Alberto Rivera, *IWOUYA, La Guajira a traves del tejido,* Bogotá, 1982.

Villegas, Liliana y Benjamin, *Artefactos,* New York, 1992.

Willson, Angelica, *Textileria Mapuche, Arte de Mujeres,* Santiago, 1992.

Index

ACKNOWLEDGMENTS

Studio photography is by Richard Laing except for the colour plates appearing on pages 98 and 99, which are by Simon Dodd. All remaining photography is by Mo Fini. The drawings are by Heather King; the map is drawn by John Andrews. Illustrations on pages 18 and 58 are taken from the sixteenth-century pictorial chronicle by Felipe Guman Poma de Ayala, a contemporary record of Inca life and the immediate effect of the Conquest. The earrings illustrated on page 102, pl. 115, are reproduced by courtesy of Jenny Morales. The remaining pieces illustrated are the property of the authors.

The authors would like to thank the following people across South America, both artisans and others, without whose help and support this book would not have been possible:

Argentina
Sergio and Carmen Guitan, Juan Francisco Ocamp and Jovita Guitian, Santa Maria de Catamarca. Hector Cruz, Amaicha del Valle. Manuel Cruz, Cafayate. Ramón Guido Kutipa, Cafayate. Juan Carlos Lemos, Cafayate. Fransisco Juan Fernandez and family, Santa Maria, Tartagal. Petrona Lomero and family, Santa Maria, Tartagal. Losi Graciela Monteagudo, Buenos Aires. Fransisco Justiano and family, Tartagal. Alejandro Dean, Mission Chaqueña, Embarcación. Dardo Marcelo Caillou, Tucumán.

Bolivia
Carminia Otono, Huayculi. Zenón Cocacastro, Favio Guillén and Inés Coca Ascaraga, Villa Ribera. Saturnin Bonifáz Vilka, Potolo. Sylviria Villca Viuda de Bonifáz, Potolo. Martín and family, La Paz. Gonzalo Realuna, La Paz. Verónica Cereceda, Gabriel Martinez, Ryan Taylor, Santiago Porcél. G and Jaime of ASUR, Sucre. Feli Ocsachoque and family, La Paz.

Brazil
Mendes family, São Paulo. Jose Florencio, Recife. Bob Nadkarni and family, Rio de Janeiro.

Chile
Ruperto Monsalve and family, Villarica. José Quintriquero, Temuco. Gabriela Parada, Rari. Olga Salinas, Pomaire. Praxedes Caro, Quinchamali. René Muñoz Castillo, Villarica. Carlos Ramón Rojas, Otarola. Luis, Paula, Joanna and Leonora Fuentes, Santiago. Patricia Martinez Riedberger, Sercotec, Temuco. July Lloa Corrillo, Quinchamali.

Colombia
Ana Cecilia Carbal, La Chamba. Noé Aviléz, La Chamba. Cecilia Vargas, Pitalito. Lara Montes family, San Jacinto. Rafael Torres, Nabusimake, Sierra Nevada de Santa Marta. Jose Maria Obando and his mother, Pasto. Lilian del Carmen Rosero, Sandona. Luz Alsida Riascos, Sandona. Guillermo Hurtado Cruz, Sandona. Lucio Enrique Obando. Riano family, Tenza. Mercedes Bautista, Ráquira. Ana Rosa Velero and family, Ráquira. Carlos Aponte and Marlene Sierra, Ráquira. Cooperativa Empresa Asociativa el Sombrero, Sampués. Iris Aguilar Ipoama and family, La Guajira. Guillermo Trias, Bogotá. Raul Quinjano and Isabel of Fedanp, Pasto. Delia Lucia Rodriguez, Sandona. Marbel Lora de Trujillo, San Jacinto. Ligia de Wiesner, Museo de Arte Popular y Tradiciones, Bogotá.

Ecuador
Gabriel Cevallos, San Antonio de Ibarra. Samuel Quinatua, Puyo. Morales family, Otavalo. La Galeria de la Mujer de Salasaca. Rosa Elena Taipi, Salcedo. Pedro Fausto Mero, Montecristi. Graciela Gordón and family, Calderón. Patricio de la Torre A and family, Quito.

Paraguay
Familia Caceres, Aregua. Alicia Falabella, Aregua. Teodolina and Victoria Esquivel de Areco, Compania 21 de Julio, Tobati. Virginia Yegros de Solis, Compania 21 de Julio, Tobati. Zenón Paez and Hermina Gonzalez de Paez, Tobati. Ysanne Gayet, Asunción.

Peru
Leoncio Llamoca and family, Cuzco. Cezar Quinde Renteria, Catacaos. Alberto Quinde Campoverde, Catacaos. Cristina Villegas Namuche, Narihuala. Santodio Paz Juarez, Chulucanas. Gerásimo Sosa Alache, Chulucanas. Virgilio Ore and family, Quinua. Choque family, Pucara. Joaquín Ouispe and family, Juliaca. Moisés Alejandro, Lima. Humberto Urquizo, Lima. Daria Laureano, Cochas. Teófila Canchomuni, Cochas. Felix Ore, Lima. Eladio Infantas. Marcos Luzalde. Krikor Alarcón, Lima. Pablo Quilla, Huancane. Máximo and Sebastian Quinto, Pisac. Félix Huaraca, Quinua. Virginia Galvez. Flor Azul. Romulo Marcarina. Alejandrino Altamirano. Marcos Martines. Guadalupe Martines. Luis Martines. Elvira de Bustamante. Cirila Ciscneros. Godelio and Gilberto Palomino and families, San Pedro de Cajas. Monia Pagliaro. Aida Gazzo. Pilar Saona. Isabel Montero. Julia Llagento. Eladio Barrientos. Eduardo Vilca Cornejo. Florentino Quispe and family, Pisac. Saturnina Huamán. Alfonso Champi. Cesar Bellido. Wilfredo Zamalloa. Alejandro Flores Huatta and family and many other friends and conpadres on Taquile Island, Lake Titicaca. Julio Montes, Lima. Joaqín Lopez and family, Lima. Manuel and Carmen Eguiguren, Lima. American Trading, Lima. Orlando Magno and family, Lima. Plácido and Ruth Quilla, Pisac. Victor Garrafa and family, Cuzco. Quinto family, Pisac. Samaya, Pisac. Wilburt Sotomayor and family, Cuzco.

Uruguay
Karina Trias, Nelly Suárez and Blanca Ortiz of Artesania Intendencia de Rocha, Montevideo. Magdalena P. C. de Supervielle and colleagues of Manos del Uruguay, Montevideo.

Venezuela
Francisco Ranjel, Tabay. Gervacio Marquina. Briceño family, Bocono. Rogelio Chavez, Guadalupe. Hermancito Rojas, Tuturia. Balcazar Silva, Guadalupe. Belkys Mota de Torres, Caracas. Ismanda Correa, Caracas.

The authors would also like to thank the following people:

All the staff of Tumi UK for helping to run Tumi while we were writing this book. Lesley Gillilan and Simon Roiser.
Cori and Nina Fini and Edgar Villaroel for travelling with us in South America.

Finally, a special thanks to the spirit of Pachamama.